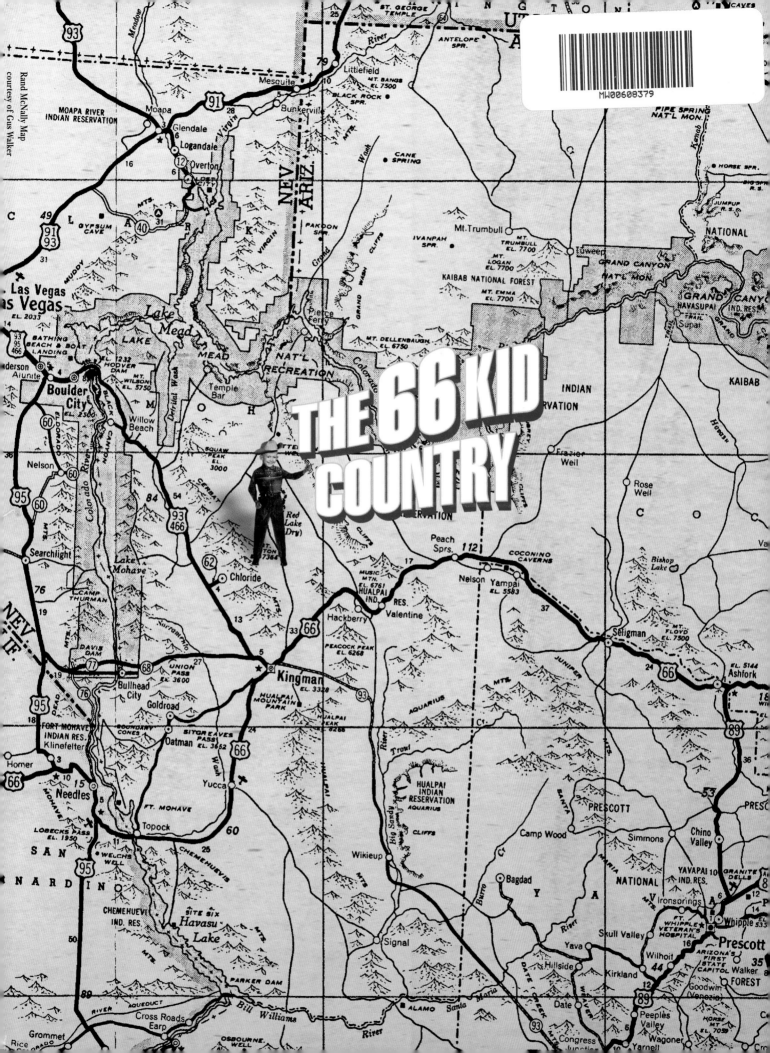

THE 66 KID COUNTRY

RAISED ON THE MOTHER ROAD

BOB BOZE BELL

BOOK DESIGN
DAN HARSHBERGER

Voyageur
Press

First published in 2014 by Voyageur Press, an imprint of
Quarto Publishing Group USA Inc., 400 First Avenue North,
Suite 400, Minneapolis, MN 55401 USA

Voyageur Press titles are also available at discounts in
bulk quantity for industrial or sales-promotional use.
For details write to Special Sales Manager at Quarto
Publishing Group USA Inc., 400 First Avenue North,
Suite 400, Minneapolis, MN 55401 USA.

To find out more about our books, visit us online at
www.voyageurpress.com.

ISBN: 978-0-7603-4695-2

Library of Congress Control Number: 2014936962

On the title page: Robert Bell, 1955

Printed in China

10 9 8 7 6 5 4 3 2 1

A PROMISSORY NOTE

It took me 66 years to discover why Route 66
is the most famous highway in the world.
I must admit that for the longest time I was confounded,
even irritated, by its notoriety. But in my defense,
it's hard to see legends from the side of the road.
Especially when you grow up traveling it every day and your
mom and dad make their living from it. When I was nine
years old, I started getting interested in Old West history.
And when I read my favorite magazine, *True West*,
my hometown was never mentioned.
So I concluded that nothing ever happened there.
I couldn't wait to grow up and leave the God-forsaken place.
I had much to learn.

My Earliest 66 Memory

We are westbound on Route 66 near
the Painted Desert. It's hot and my dad is
driving with his hands precisely at 10 and 2
on the wheel. My mom is in the passenger
seat, talking about something I don't
understand, when over the dash I see a
shimmering apparition floating on the
horizon. Heat waves distort and bend the
image into strange designs until it turns
into an oncoming car, which blasts past us
on the narrow blacktop.
On the next ridge another car
takes its place,
dancing in the
sunlight.

THE ORIGINAL GUESS GIRL

Bobbi Guess was born in Lordsburg, New Mexico, in 1925, and grew up at a ranch on the Gila River near Duncan, Arizona. The middle child of Louise and Bob Guess, Bobbi and her four sisters rode horses and worked cattle as their father tried to make his ranch a success.

Busted by the Depression in 1936, Bob walked away from the ranch and returned to Mohave County and northwest Arizona, where he had worked 25 years earlier as a cowboy for legendary cowman Tap Duncan.

The Guess family arrived that summer at the Diamond Bar Ranch, north of Route 66 in the Hackberry region, and started over. (The photo on opposite page is Bobbi, then 13, astride her father's car and looking pensive but hopeful after they arrived.)

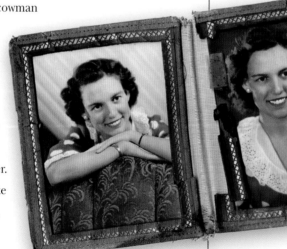

Lillie Louise Guess, better known as Bobbi, after high school graduation in 1939.

Bobbi graduated from Mohave County Union High School in 1939 and worked for the school district in Valentine.

When World War II broke out, the Kingman Air Base was hastily built and some 10,000 GIs were sent there to train and man the fort. At that time, Mohave County had about 500 available women, so every fair-haired—and even the not-so-fair—maiden could afford to be choosy.

According to her sister, Jean, Bobbi dated captains and lieutenants. After breaking off an engagement to a prominent rancher, however, she ultimately chose a buck private from Thompson, Iowa.

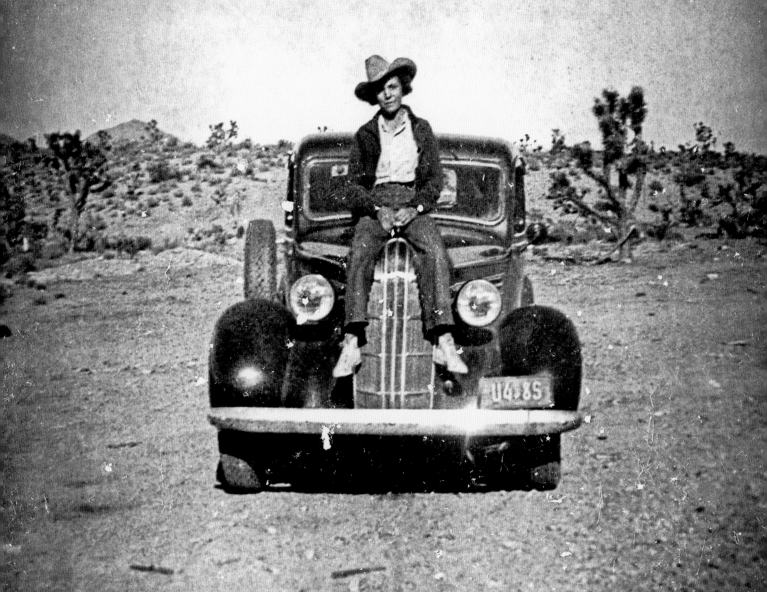

"What's your name?"
"Guess."
"I don't know—*Mildred*?"

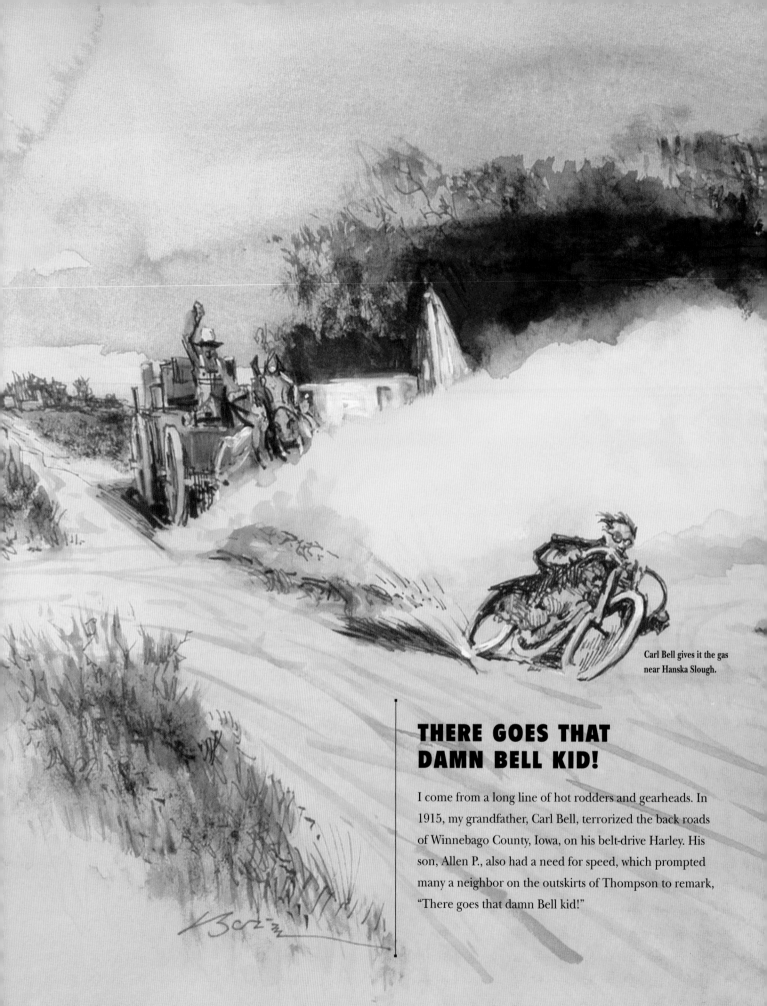

Carl Bell gives it the gas near Hanska Slough.

THERE GOES THAT DAMN BELL KID!

I come from a long line of hot rodders and gearheads. In 1915, my grandfather, Carl Bell, terrorized the back roads of Winnebago County, Iowa, on his belt-drive Harley. His son, Allen P., also had a need for speed, which prompted many a neighbor on the outskirts of Thompson to remark, "There goes that damn Bell kid!"

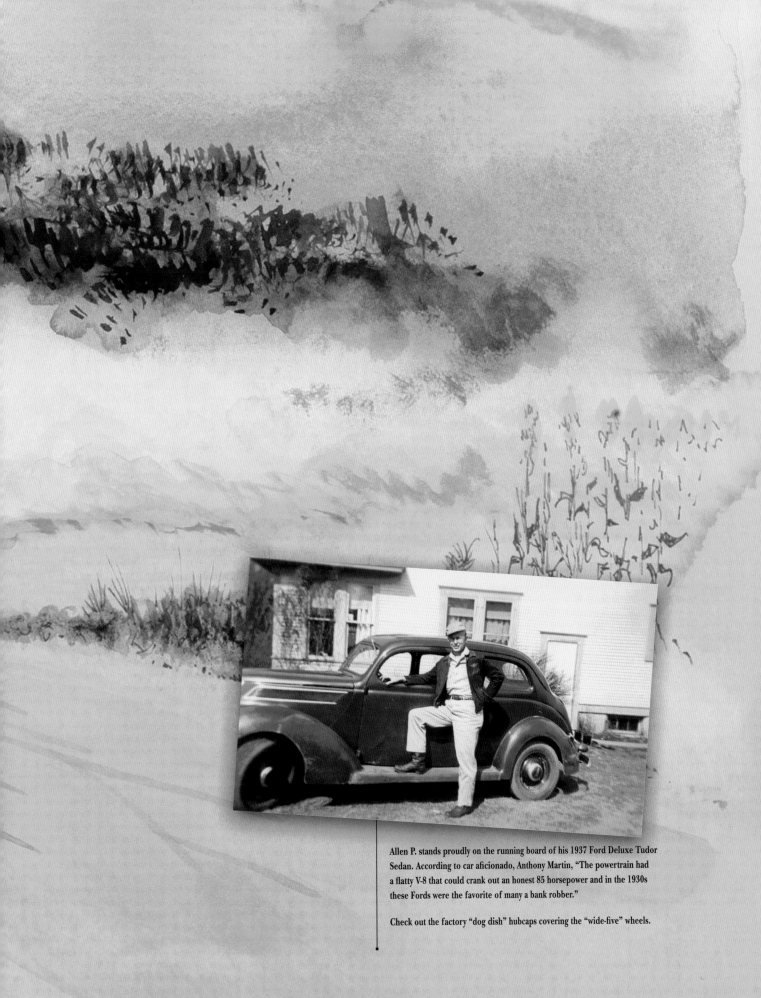

Allen P. stands proudly on the running board of his 1937 Ford Deluxe Tudor Sedan. According to car aficionado, Anthony Martin, "The powertrain had a flatty V-8 that could crank out an honest 85 horsepower and in the 1930s these Fords were the favorite of many a bank robber."

Check out the factory "dog dish" hubcaps covering the "wide-five" wheels.

> ## "Sometimes you find yourself in the middle of nowhere; and sometimes, in the middle of nowhere, you find yourself."
>
> —good ol' Ben Rux

A BIRTH THAT WILL LIVE IN INFAMY

Born on a tabletop in the family farmhouse, Allen Peter Bell grew up milking cows, feeding pigs, and picking corn. *(As a child he became sensitive to incessant teasing about his middle name, so he always styled it with just the initial "P.")*

Like his father, Carl Marvelle Bell, Allen loved cars and built his first car out of a junker in the grove. Also like his dad, Al became known for driving fast. Many a neighbor would say, as they saw a rooster tail of dust coming down the lane, "There goes that damn Bell kid!"

After the sneak attack on Pearl Harbor, the farm kid from Thompson, Iowa, was drafted and sent to Alabama for basic training. He later shipped by train to Kingman, where the unloading troops sagged from the summer heat as they paraded down Route 66 with duffle bags over their shoulders. It was, in fact, Allen P. Bell's 21st birthday, and he muttered under his breath that August 27 day, "I'll never come back to this hellhole!"

But he would meet his future wife there, on a blind date. When he asked her name, she replied "Guess." He shrugged and said, "I don't know—*Mildred?*" Bobbi Guess and Allen P. Bell were married at Saint John's Methodist Church in August 1945. They had their first child, a boy, in December 1946. And all because of a sneak attack.

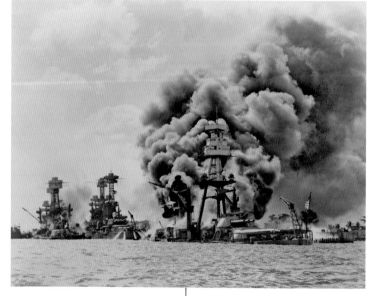

Battleship Row at Pearl Harbor during the Japanese attack on December 7, 1941. The USS *Arizona* burns and sinks (center). To the left of the *Arizona*, is the USS *Tennessee* and the sunken USS *West Virginia*. *National Archives*

Army Air Corpsman Allen P. Bell photographed in Forest City, Iowa. This photo was sent to Bobbi Guess before they were married.

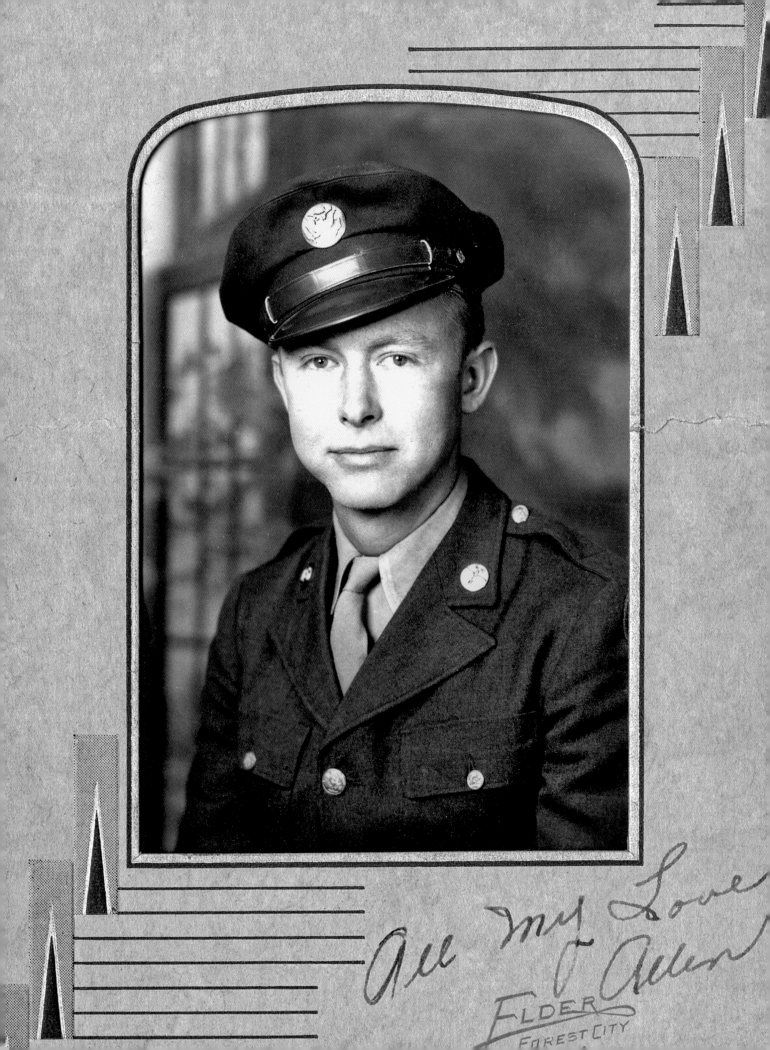

All my Love

Allen

"Nobody gets it how they want it to be."

–Jackson Brown

LET THE PING-PONGIN' BEGIN

With their marriage in 1945, my mom and dad began a long-running ping-pong game between northern Iowa and Mohave County. My father couldn't seem to make up his mind which place he wanted to be. He worked as a mechanic in Albert Lea, Minnesota, and Thompson, Iowa. We moved to Kingman and he worked for Biddulph-Dunton Motors. He ran a gas station in Peach Springs and a Whiting Brothers in McConnico. We later moved back to Iowa, where he ran a Phillips 66 and then sold Fords at Gabby Motors, both in Swea City. Like so many Americans of this era, we moved almost every two years, and most of it involved traveling on Route 66.

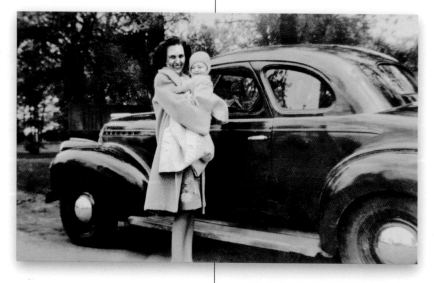

BBB and Bobbi standing in front of Allen's 1940 Ford Master Deluxe Coup. According to Kenny Peterson, of Swea City, Iowa, Allen installed dual tailpipes and you could hear him coming four blocks away.

Mr. and Mrs. Allen P. Bell (at right) on their wedding day in 1945. The couple were married in Saint John's Methodist Church (above) in Kingman, Arizona. Clark Gable and Carole Lombard were wed in the same church not long before and allegedly spent their honeymoon in Oatman, Arizona.

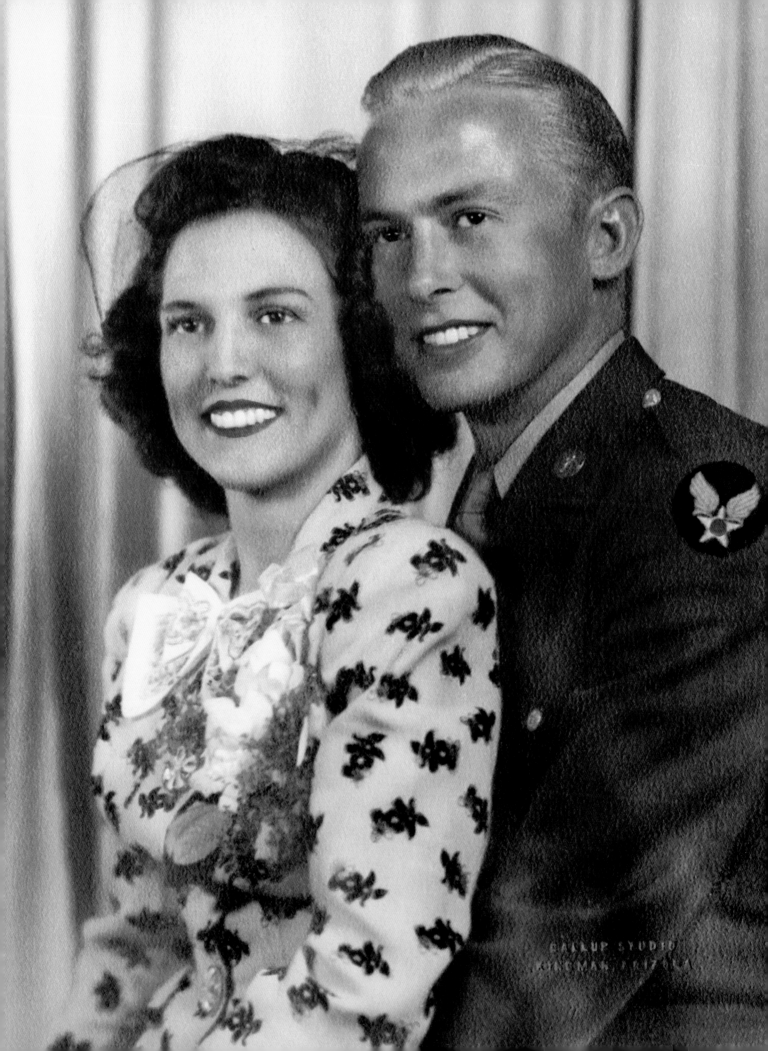

Eye on the Sky

We saw ominous clouds on the horizon,

rolling toward us like a giant B-52.

But we had our hopes and our dreams and places to go,

so we motored on.

CAUGHT IN THE RINGER

My father's first gas station was in Peach Springs, Arizona, on the Hualapai Indian Reservation. Traffic was picking up in 1947 and business was brisk—so brisk my mom had to take the night shift and work for several hours while my dad caught some Zs. They also had a couple of small cabins in the back, which they rented for $5 a night.

It was also here that, unfortunately, my curiosity got the better of me. My mom had warned me to stay away from the ringer on her washing machine, but I put my hand in it anyway.

The ringer ate up my left arm to the elbow, where it ground along until my terrified mother got my father to stop it. He rushed me the 55 miles to Kingman, where Doc Arnold grafted skin off my butt and put my arm back together.

I had a big cast, and some predicted I'd be converted to a right-hander. (In those days it was believed you could change a child's preference of a predominant hand.) But my dad always told the story of how I pounded my cast into my high-chair tray and ate right off the cast.

So much for being right-handed.

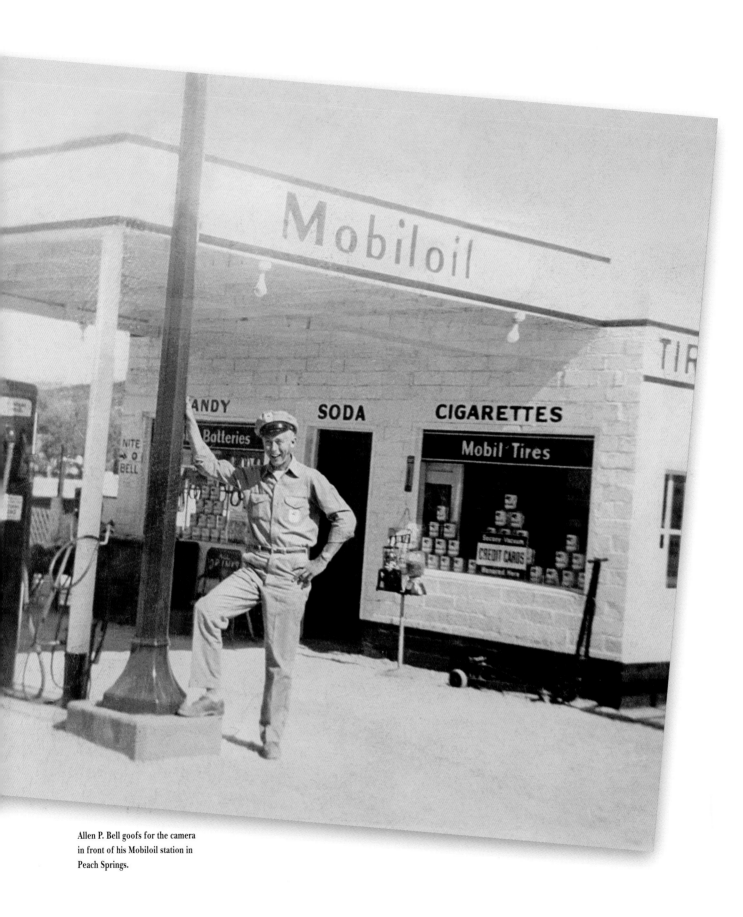

Allen P. Bell goofs for the camera
in front of his Mobiloil station in
Peach Springs.

PUMP JOCKEYS

The Mobiloil service station in Peach Springs was open 24/7 and my father often had to catch naps, while my mother manned the pumps.

Carl and Minnie Bell, my dad's parents, drove out from Iowa to visit us and these photos come from their photo album. That's my grandmother Minnie standing next to the pumps (bottom left) and my grandfather Carl is sitting by the pop machine (bottom right). As I grew up, they would visit us almost every year and I fondly remember him sitting there all day at our station and talking to the tourists while my father worked the pumps. As a farmer who lived in the country, he really enjoyed the exotic nature of tourists on the road, I think.

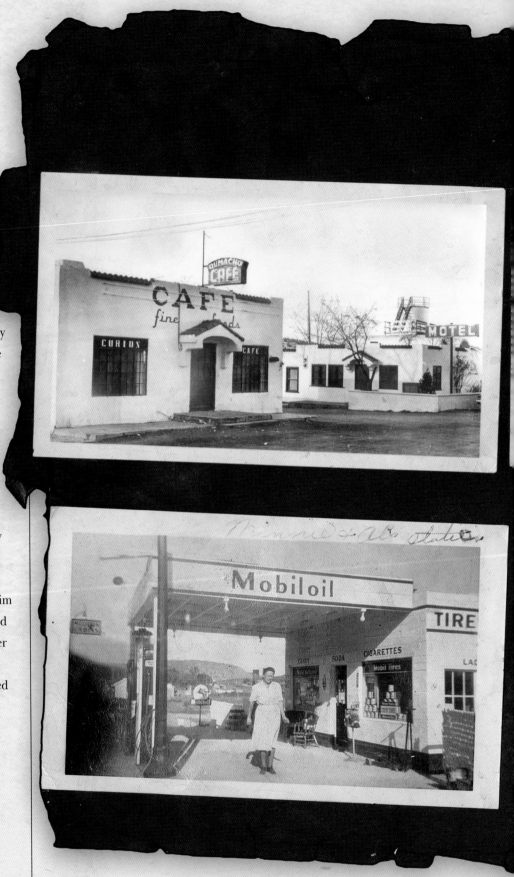

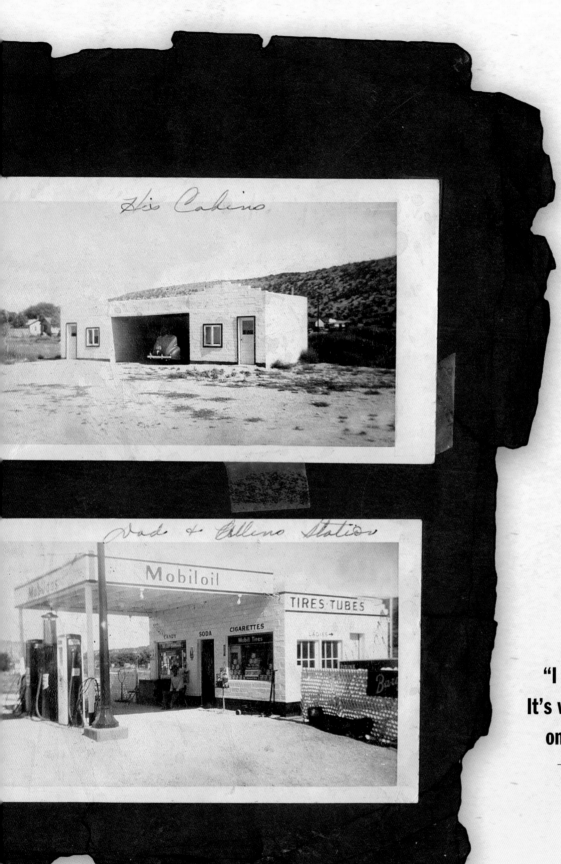

His Cabins

Dad & Collins Station

"I hate snow.
It's white and it's
on my land."

—OLD HUALAPAI JOKE

This 10½ x 7½ envelope full of photos was addressed simply to Mr. & Mrs. Allen Bell, Peach Springs, Arizona. It was a much simpler time.

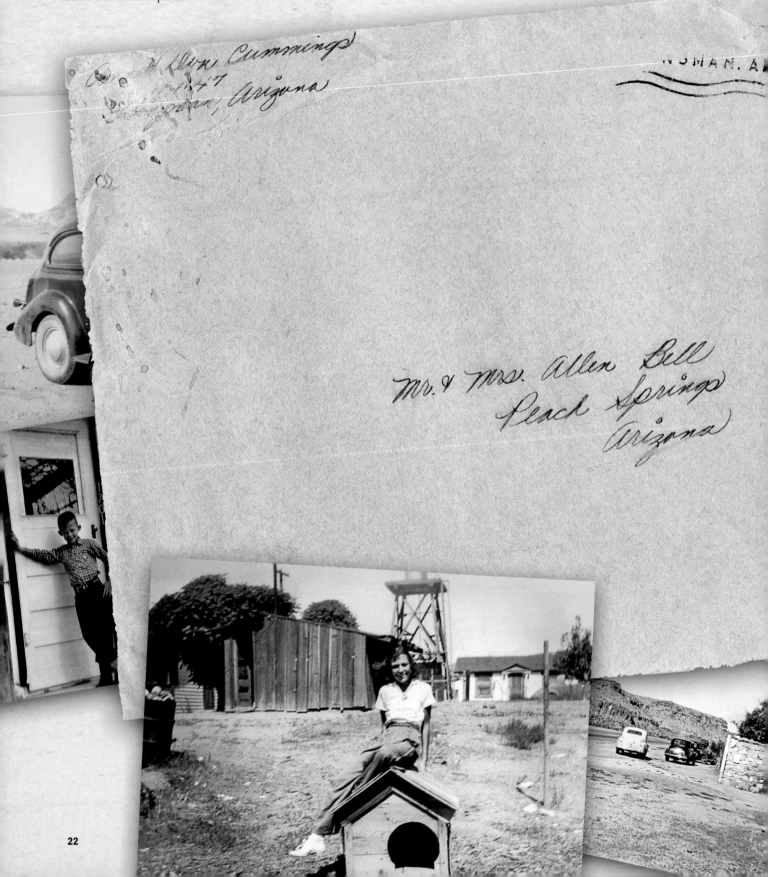

"History is a combination of reality and lies.
The reality of history becomes a lie.
The unreality of the fable becomes the truth."

—Jean Cocteau

PEOPLE OF THE TALL PINES

The Hualapais (also styled as Walapai and Haulpi) live on a 108-mile stretch of high desert south of the Grand Canyon. The tribe is small, with about 600 members living in the area. Peach Springs is the tribe's administrative headquarters.

While both my parents worked at the gas station in Peach Springs, they hired a woman from the Hualapai tribe to look after me. My mom said I was very taken with the woman, and I believe she instilled in me a love of the Hualapai people. Although her name is lost to history, the children and members of her clan would later become my friends and teammates in Kingman. The Havatones, the Whatanames, the Nishes, the Majentes, the Suathogamies, and the Tapijas were very talented folk whom I have always admired immensely.

HISTORY DETOUR

Gettin' Heavy with Levi-Levi

In the 1860s miners and trappers began to invade northwestern Arizona. This did not make the Hualapai tribe happy and resulted in the Hualapai War (1865–1870). Consequently, an estimated third of the Hualapai people were killed in battles or by disease. One of the chiefs who not only survived the war, but also led his people to a peaceful solution and the establishment of the Hualapai Reservation, was the legendary Levi-Levi (also styled Leve-Leve, and pronounced like "levee levee"). Levi-Levi was of the Hualapai Mountains band of the tribe, and he was respected by both sides in the tragic war.

FROM INDIANS TO IN-DINS

One of the most ridiculous words in the English language
is "Indian." How could something so stupid—the Spanish
thought the people they encountered in the New World
were from India—still be in use? Fortunately, the Hualapais
have made the word their own, bending it into "In-din,"
which when you hear it rolling off the tongue of a
Hualapai speaker is a thing of beauty and joy.

GREETINGS FROM THE
INDIAN COUNTRY
OF THE GREAT SOUTHWEST
Writing You From _____

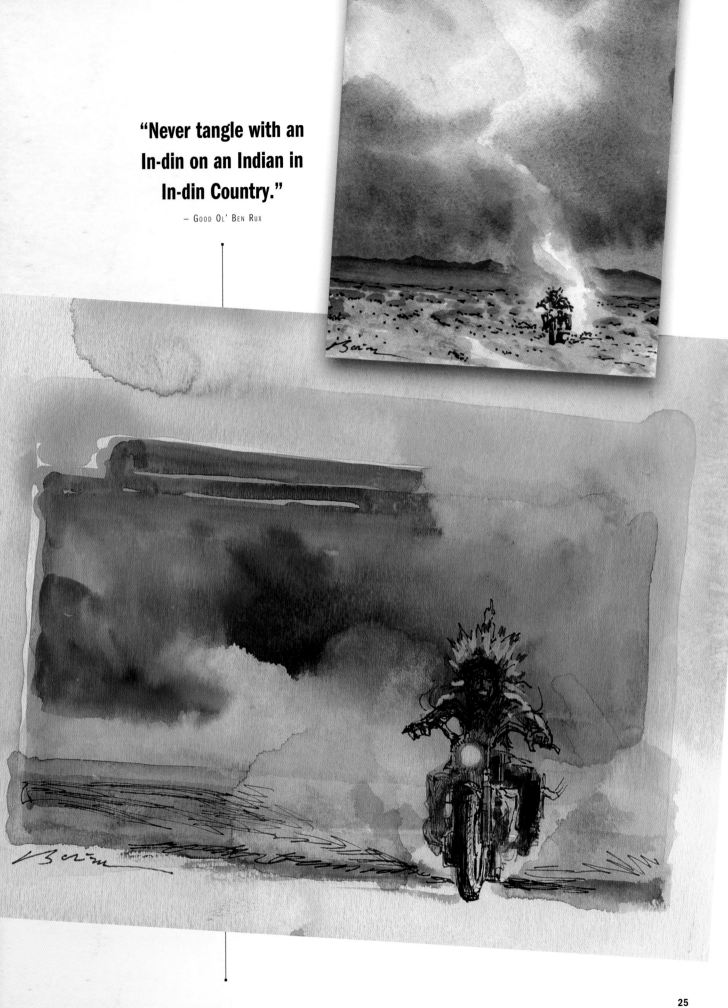

"Never tangle with an In-din on an Indian in In-din Country."

– Good Ol' Ben Rux

TRES HOMBRES ON THE ROAD

While Al Bell was pumping gas in Peach Springs, a songwriter, an author, and a photographer were loose on the same road.

A former Marine captain from Pennsylvania, Bobby Troup, was driving to California and, inspired by the scenery, came up with the lyric "Get your kicks on Route 66." He later claimed the rest of the lyrics eluded him, so in frustration he simply filled up the song with the names of the towns and cities he was driving through: St. Louis, Missouri; Oklahoma City, Oklahoma; Amarillo, Texas; Gallup, New Mexico; Flagstaff, Arizona; Winona, Arizona (the only town out of sequence and a reach to find something to rhyme with Flagstaff, Arizona); Kingman, Arizona; and Barstow and San Bernardino, California.

> **"I thought I was writing about a road, not a legend."**
>
> —Bobby Troup

Nat King Cole recorded the song in 1946. Troup enjoyed its success but claimed he never dreamed it would become a classic. In his words, "I thought I was writing about a road, not a legend."

About this same time (1947), another East Coast boy was hitchhiking across the country and he, too, was struck with the road and the wide-open spaces. Jack Kerouac wrote what would become a classic tome, *On the Road*. In Kerouac's case, it took 10 years to get the book published as publishers were afraid of the sex and drug use related in the original "scroll version."

New York photographer Andreas Feininger was also on Route 66 and he stopped a half hour east of Al Bell's Mobiloil station to take a photograph of the road and summer clouds.

Feininger's art philosophy was to capture the height of things. For example, he drove to New Jersey to photograph the Empire State Building because he wanted to see it in context to the skyline. He used the same dynamic in Seligman to capture the flat-bottomed, sky-high clouds. His subsequent *Life* magazine cover photo is a classic image of early Route 66.

All three dudes contributed to the lore and the legend of the Mother Road, and all about the same time.

Jack Kerouac's hand-drawn map.

Feininger Troup Kerouac

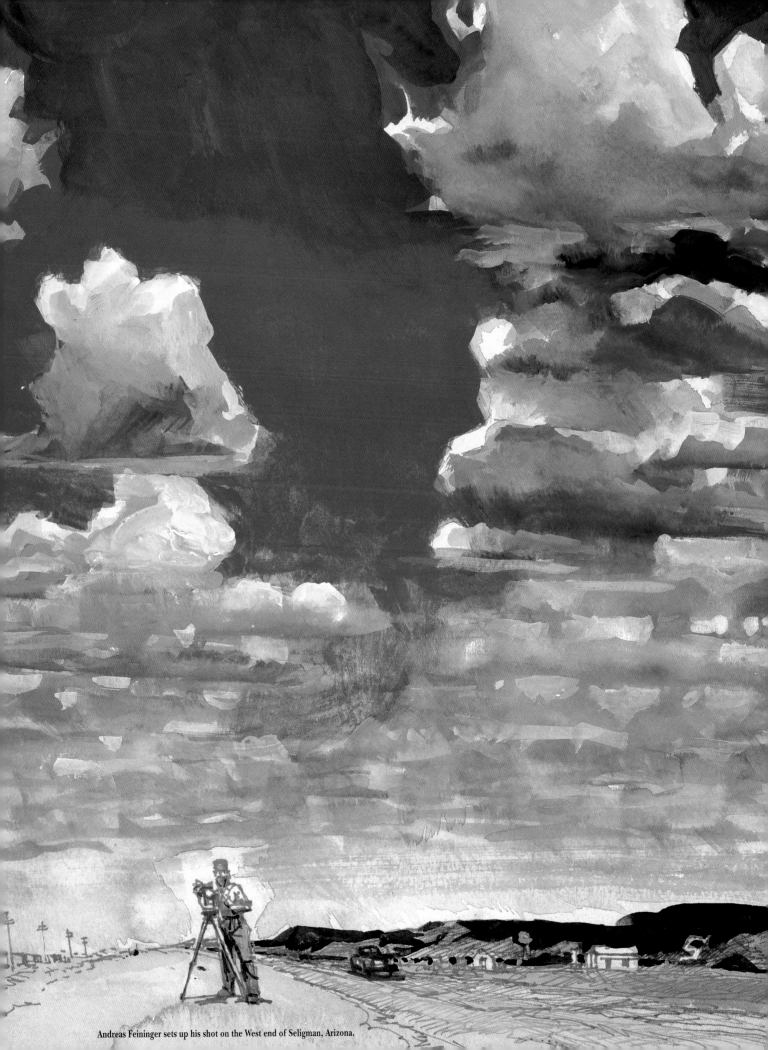

Andreas Feininger sets up his shot on the West end of Seligman, Arizona.

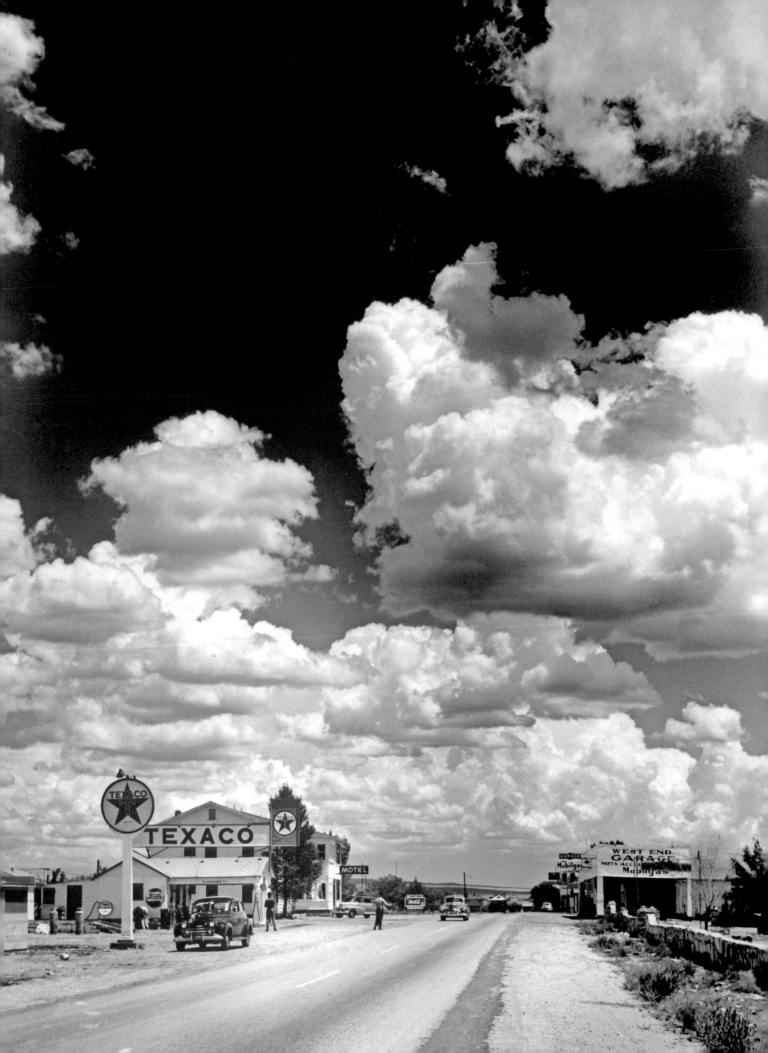

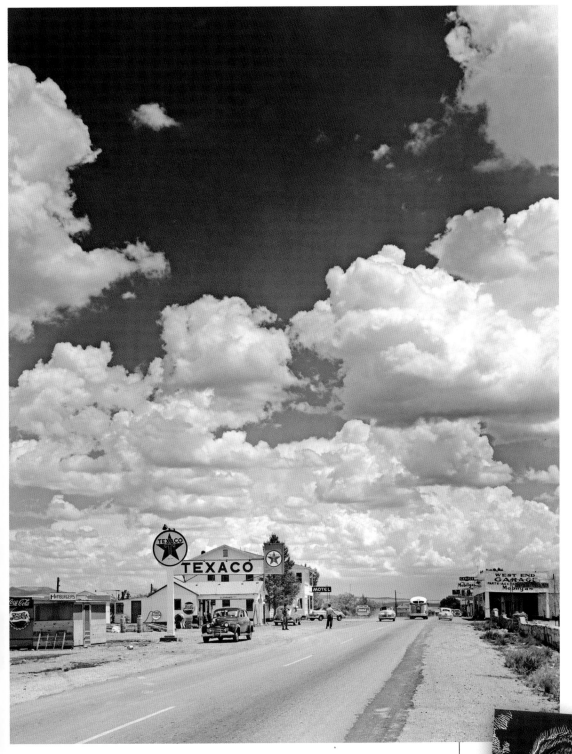

EYE ON THE SKY

Born in Paris, raised in Germany, and schooled in the Bauhaus as an architect, Andreas Feininger immigrated to New York where he became a celebrated photographer. On assignment for *Life* magazine in 1947, Feininger stopped in Seligman and took these iconic photos. For Andreas, it was all about scale, and in the Bauhaus tradition he shot it with the sky being dominant. Camera buffs will be interested to know Andreas used a Tessar 15 cm – Wratten K2 filter and Super XX film in a 4x5 camera.

GETTING HIS CLICKS ON ROUTE 66

Feininger took several shots in Seligman, including the one above, with a bus and several more cars. He evidently moved just a smidge and waited for fewer cars on the road. The difference between the two frames is striking. Both have the right feel, but the classic shot, at left, is sparse and weighted just right.

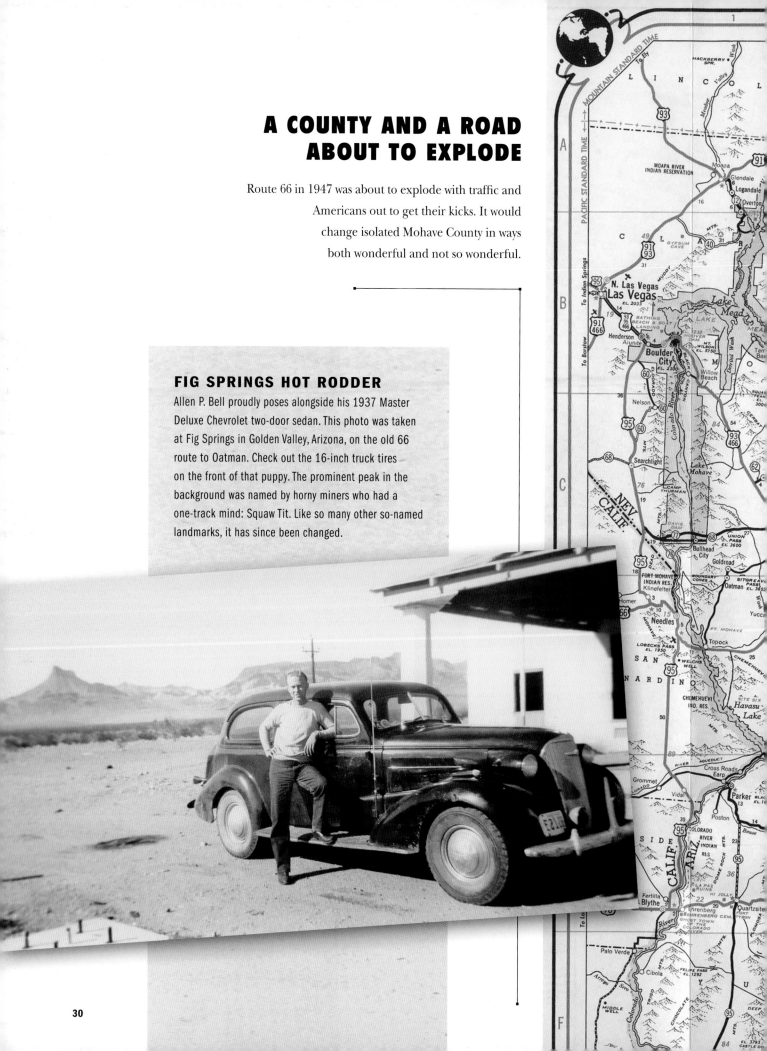

A COUNTY AND A ROAD ABOUT TO EXPLODE

Route 66 in 1947 was about to explode with traffic and Americans out to get their kicks. It would change isolated Mohave County in ways both wonderful and not so wonderful.

FIG SPRINGS HOT RODDER

Allen P. Bell proudly poses alongside his 1937 Master Deluxe Chevrolet two-door sedan. This photo was taken at Fig Springs in Golden Valley, Arizona, on the old 66 route to Oatman. Check out the 16-inch truck tires on the front of that puppy. The prominent peak in the background was named by horny miners who had a one-track mind: Squaw Tit. Like so many other so-named landmarks, it has since been changed.

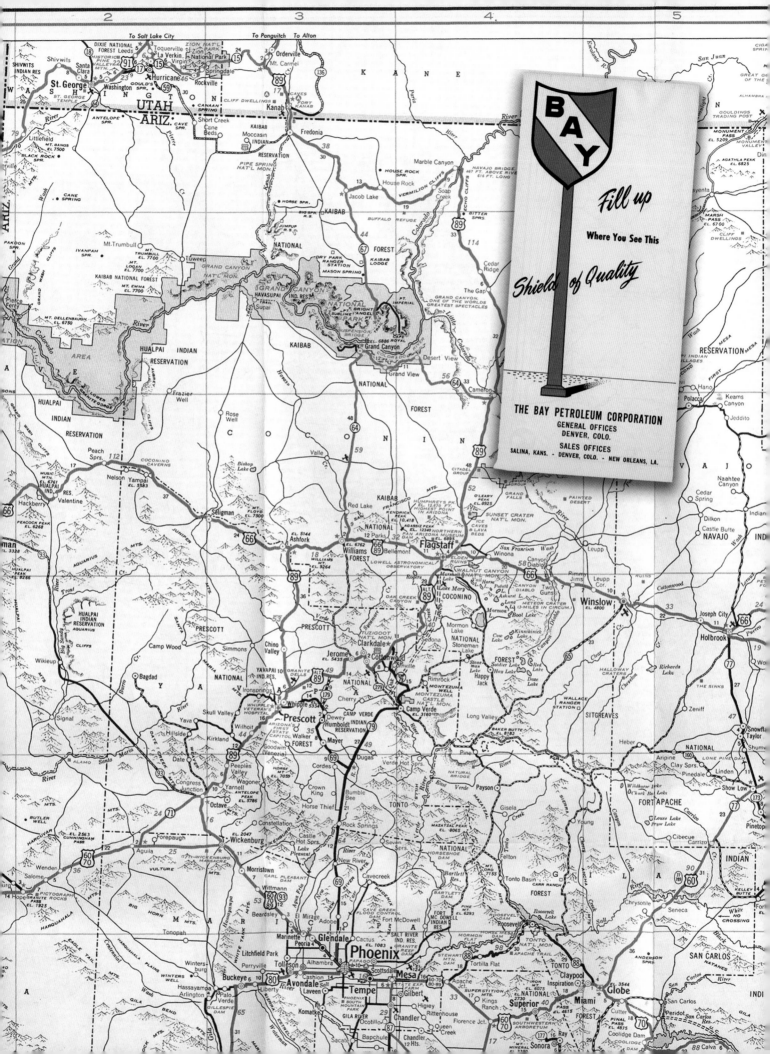

"Our journey began in
the drizzling rain, and a
mysterious shroud hung
upon the land."

—BBB

We Were Headed Straight into the Storm

Tragedy and sadness awaited us, but we drove on, oblivious.

KINGMAN BEGINS TO PROSPER FROM THE ROAD

At an elevation of 3,200 feet, Kingman, Arizona, traditionally gets at least one snow dusting a year. By the late 1940s, the town had emerged as the commercial center of mammoth Mohave County. As the county seat—it allegedly stole that honor from nearby Mineral Park by carting off the files in the middle of the night—Kingman prospered as a railhead center and now was seeing increased business from the new and improving Route 66.

By 1950, Kingman had just over 3,300 residents and its downtown had at least two hotels (the Beale and the Brunswick), several drugstores, gas stations, and a handful of cafes—Richey's being the most prominent.

After my dad's stint at operating the Mobil gas station in Peach Springs, we moved to Kingman, where he worked at Dunton Motors as a mechanic. He also worked at a Union station at Fifth and Front Street.

We lived south of the railroad tracks in a small, one-room rental house, next door to the Holmes on the east and the Coffmans on the west. When my parents were working, Mrs. Holmes often babysat me. I remember her taking me out in the yard when the trains came through town and I would run to the corner of their yard and climb the fence support to wave and yell at the trains as they chugged through town.

HISTORY DETOUR

His Vision? Not So Grand.

Lieutenant Joseph Ives explored Arizona's waterways in 1858. Trekking to a remote canyon with native guides, he made a bold prediction: "Ours has been the first, and doubtless the last, party of whites to visit this profitless locality." The area was later named Grand Canyon National Park.

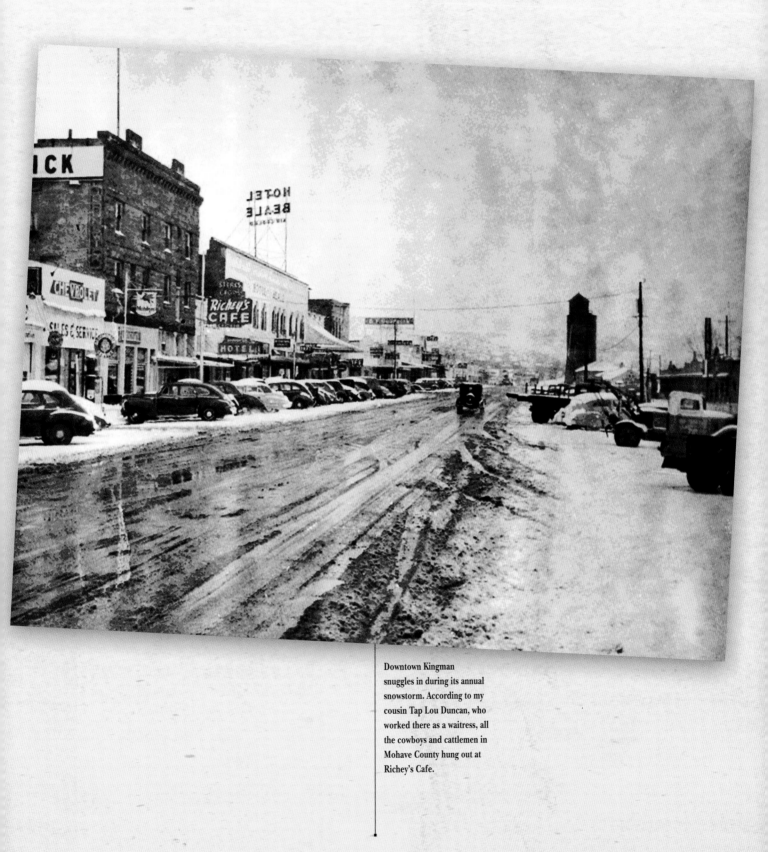

Downtown Kingman snuggles in during its annual snowstorm. According to my cousin Tap Lou Duncan, who worked there as a waitress, all the cowboys and cattlemen in Mohave County hung out at Richey's Cafe.

A HELL-ON-WHEELS LAWMAN

When he hung up his badge, he had 47 years of law enforcement under his belt, including a nine-year stint as county sheriff. A native of Hastings, Nebraska, Floyd Cisney started his law enforcement career at age 22 in 1938 as a deputy sheriff in Coolidge, Arizona. He joined the Arizona Highway Patrol in 1942, moving to Holbrook. 4 years later, Cisney took control of the Kingman Highway Patrol district, a post he held for 17 years where he was responsible for the apprehension of some 5,000 stolen cars.

Kingman is the crossroads where old Route 66 and Highway 93 intersect, and with an inspection station just outside town, it became a bottleneck road block for stolen cars. Cisney was involved in several high-speed chases when criminals tried to run the inspection station and escape. In one, two teenagers were arrested with a hot car, and on the way to the courthouse, one of them pulled a knife and, from the backseat, put it against the neck of the patrolman driving and told him to keep going on Route 66. When Cisney, following behind, saw the patrol car go straight ahead from Fourth Street, he gave chase, sized up the situation, and passed the patrol car with the hostage driver. He then hooked the front bumper with his own, and spun the car to a stop, a lesson he learned while driving in jalopy races at the Kingman Fairgrounds.

The stunned punk with the knife surrendered immediately.

It was another stolen car incident that landed him, tragically, into the sheriff's office. The Highway Patrol was having a training session at the courthouse on apprehension protocol when a call came in of a suspicious car at the Highway 93 inspection station. With Cisney and his men in the seminar, the call went to County Sheriff Bob Tarr, who drove out and asked the two teenagers in the car to open the trunk. When they nervously complied, Sheriff Tarr saw stolen contraband and turned to see one of the boys with a pistol pointed at the lawman. The sheriff told the kid not to do anything stupid and reached for his firearm. The kid fired, hitting Tarr in the abdomen. He died on the operating table at Kingman Hospital several hours later.

Cisney was appointed sheriff and was reelected twice more, in 1964 and 1968.

Cisney was also a U.S. Marshal. He retired from active duty in 1984 and died of heart failure at age 69 in 1985.

A Snapshot of Kingman in the '50s

At the Dairy Queen, a banana split cost 50 cents and all cones were hand-dipped. The latest rock 'n' roll records could be purchased for a dollar at Central Commercial or across the street at Mohave Radio Electric. (I was shocked when we went to Phoenix for the Little League Championship and I found "La Bamba" by Richie Valens for 78 cents at a Skagg's Drugstore in Glendale). Milk could be ordered for home delivery from McCall's Canyon Dairy—leave the empties on the front porch for pickup.

There was a 10 p.m. curfew nightly, and a siren would go off to warn kids to go home. Admission to the State Theater was 15 cents for ages 12 and under, and 25 cents for over. Many of my teenage friends tried to fudge in as 12 to save a dime. Popcorn was 10 cents.

Dogs were allowed in class at the junior high. Mary Kay Hokanson remembers her dog Tootsie being in every class except Mrs. Hands'. Mary Kay even remembers Tootsie graduating with her.

We got all of our mail at the main post office and our box number was 470. Once, at a party, Arnold D. Thomas, who worked at the post office, regaled everyone by telling each of us our box number. As you might guess, we were easily entertained.

Our telephone number was Blue 549 and there was no dialing. You picked up the phone, and an operator came on the line and asked for the number you were calling. I'd say I was calling the Harshbergers at Blue 427, and she would make the connection. We were all on party lines, so if you picked up the phone and people were talking, you had to wait until they got off. Sometimes my father would tell certain yackers to quit hogging the phone lines and to get off. That always went over well.

It was a dirt road to Wikieup and Phoenix. According to some accounts, the first pavement came after a Kingman group embarrassed then-Governor Ernest McFarland. The group publicized a movement to secede from Arizona and become a part of Nevada, and some of the group protested the governor's appearance at a Frontier Days Rodeo Parade in Prescott. The deal was cut that day for the first stretch of paved highway in exchange for stopping the secession movement.

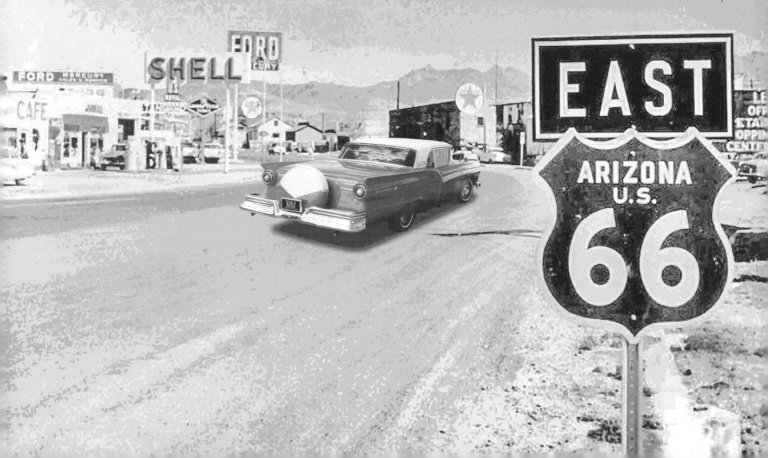

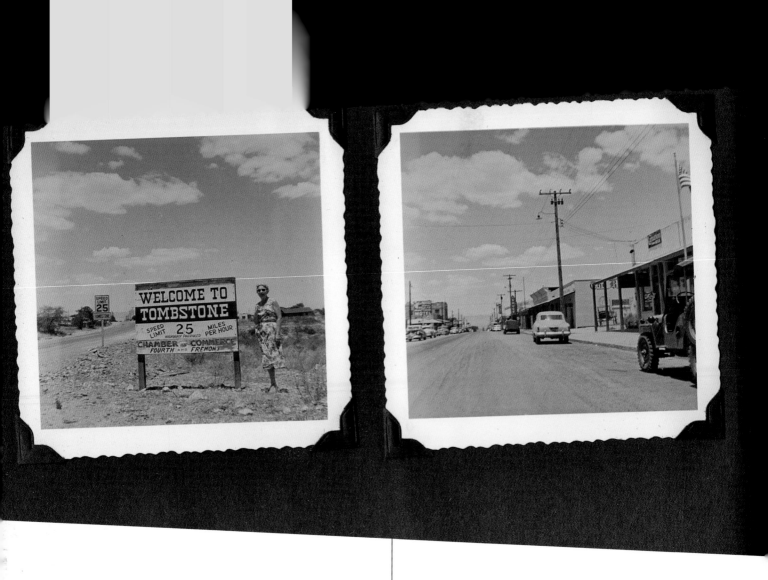

ON THE ROAD AGAIN

During this period, my grandparents from Iowa visited and we took a car trip to see the rest of Arizona. As we motored down Highway 93, we stopped to look at a strange cactus alongside the roadway. This was my first encounter with saguaros and I've had a passionate interest in them since.

We passed through Phoenix, where my grandfather and I got sick from a fruit stand on Camelback Road. Motoring on, we took off for southern Arizona and visited the Town Too Tough to Die: Tombstone. I was too young—about four—to understand the importance of this historic place at that time, and it would take me

some 22 years to make it back. Strangely, I have no memory of being there, though the photographs say we were.

From Tombstone we visited the historic mining town of Bisbee, then drove to Nogales and actually went across the border to the Mexican side, driving along Obregon Street and parking in front of a curios store. Many kids harassed my father, begging to wash our car for a quarter. I remember my dad giving one of the kids 50 cents to NOT wash his car. He also helped a local merchant move a door. Funny what we remember. Nothing about Tombstone, but Obregon Street stuck in my mind.

> **"Silver made Tombstone rich. Wyatt Earp made it famous."**
>
> —John Gilchriese, historian and collector

TOMBSTONE ARIZ WORLD'S LARGEST

ROSE BUSH

STREETS IN NOGALES MEXICO

 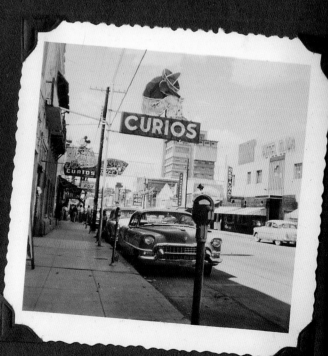

> **"Lena, I'm having one more beer with Sven.**
> **If I'm not home in one hour,**
> **read this message again."**
>
> —Old Swedish joke

SWEA CITY SOJOURN

Ever restless, my dad decided Kingman wasn't working out. So in 1950 we once again pulled up stakes and headed back to Iowa on Route 66. He leased a Phillips 66 gas station in Swea City, Iowa, which my grandfather had read about in an ad in the Thompson newspaper. It was located on prime real estate, smack dab in the center of the small Swedish town about a half hour west of Thompson. The station was owned by Al Collins, who had several stations and a bulk plant in the area. My father would attempt to make a business where others had failed.

My parents found an old farmhouse on the outskirts of town and we settled in. After a year or so there, we moved to another rental not far from the small school. (Kindergarten was in the basement and high school on the top floor.) I started kindergarten and soon learned to count to 100. (See clipping my mother kept.)

It was in 1954 when I first realized what the year 1954 actually meant. I finally got the concept. Before this, it was a random blur of memories, but from 1954 on, I can track our movements in my mind with some consistency.

In addition to counting to 100, I first learned to ride a bike in Swea City, on Andy Opsal's lawn. I attended the first three grades and remember the usual activities: dodgeball in the gym on snow days, or, black-and-white movies, such as the *Bowery Boys* or, my favorite, the documentary series *Victory at Sea*. My drawings gravitated to kamikazes and war pictures.

People often ask me if I have always drawn. The answer is no.

My dad said I was about five when I started asking him to draw trains so I could copy them. Soon, he said, I could outdraw him and I'd become frustrated with his lack of perspective. Truth be known, I drew to get his attention. While my mom gave me too much attention, he was the stoic Norwegian and I desperately wanted his approval. So I drew pictures constantly—and still do.

Why do I draw to this day? I need the attention!

KINDERGARTEN NEWS—
Fifteen of us have now counted to 100. Our names are Robert Bell, Paul Danielson, Robert Johnson, Cheryl Kvamsdale, Johnny Martin, Larry Thoen, Anita Youngquist, Bonnie Jean Berg, Patty Hardt, Johnnie O'Green, Rodney Smith, Andrea Stefanski, Sharon Lee Svendsen, Petrea Thoreson and Vivian Thorson.
We were happy to have Lorraine Youngquist, Mrs. Irvin Bathe and sons, Mrs. Claude Haag and Mrs. Schreiber visit us.
We enjoyed the birthday treats Vivian Thorson and Anita Youngquist gave us. Their mothers came to the party.

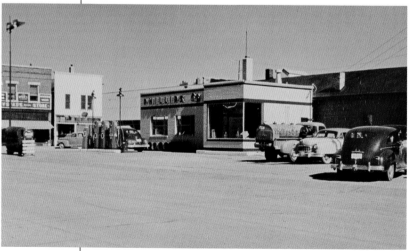

Al Bell's Phillips 66 in the center of Swea City, Iowa. My father ran the station for several years before walking away.

(A) 75.95 (B) 65.95

ALL WARDS HAWTHORNE BIKES FEATU

REAR TURN SAFETY SIGNALS. Combination stop-tail-directional safety light (at left) is standard equipment on bicycles (A) and (B). Four lights in one —turn signals, stoplight, reflector, and taillight—built into massive streamlined luggage carrier. Like combination on the latest automobiles. Flip the lever on top frame bar to right to signal right turn, to left for left turn—arrow points in direction of turn and alerts cars behind you. Red taillight glows constantly when switch is snapped on. Stimsonite rear reflector mounted in center of light automatically flashes warning to passing autos, offers greater night riding safety.

COIL SPRING FORK absorbs road shocks. The Hawthorne coil spring fork (at left) is standard equipment on bicycles shown on this page and is included to increase your riding pleasure. Coil spring suspension is designed like coil spring action on modern automobiles to absorb all shocks and jars. Smoothes out the bumps on the roughest roads. Construction of this fork allows the wheels to give with road shocks instead of leading into them—you enjoy new cushioned comfort and a floating ride regardless of the road conditions. The spring fork holds your wheel straight—wheel can't rub against the fork or fender and cause damage to your tire.

BIKE PEDAL BLOCKS 69c

(F) Helps youngsters reach their bike pedals—gives them easier riding. No tools needed to put these blocks on —clamps slip easily over bike pedals as shown in small illustration at left. Sturdy steel construction covered with long-wearing rubber.

60 C 3654—Ship. wt. 1 lb. 8 oz. . .69c

BIKE-BALANCER 3.89

(G) Give your youngster the thrill of riding a two-wheeled bike with the added safety of a tricycle. Just the thing for a child learning to ride. Makes bike easier to start, stop, and to control. Protects bike from damaging scratches, spills too. Mounts easily on any 16, 20, or 24-inch bicycle in a few minutes. All parts, instructions included. New adjustments can be made easily as soon as your child's cycling skill improves. Built-in step plates. Durable cadmium plated steel construction with 5¼-inch solid steel tired wheels with nickeled... h. Wheels are painted red.
...—Ship. wt. 4 lbs....

LOW-PRICED HAWTHORNES HAVE FEATURES USUALLY FOUND ON HIGHER-PRICED BICYCL

NATIONALLY-KNOWN EQUIPMENT on every Hawthorne makes your riding safer, easier. All ho Troxel or Lobdell saddles for extra riding comfort. New Departure or Bendix coaster bra eliminate brake drag for longer coasting, safer rides. All have Torrington or Magna ped Diamond roller chain and Lobdell steel rims—equipment found only on quality bikes.

STRONG, RUGGED FRAMES . . . welded tubular steel construction results in a frame that will g years of hard usage. Exposed enameled parts of a Hawthorne frame are Bonderized to pro against rust—even underside of the fenders! Then they're finished with 2 coats of automo enamel, proved by Wards Bureau of Standards to be 9 times harder than ordinary ena Important moving parts operate on smooth ball bearings. Dustproof housings seal out—

WARDS WILL NOT SELL A BIKE that does not include all the standard mechanical and-so features. With each Hawthorne you get an enameled chain guard, kick stand, and a H thorne-engineered triple plate crown fork. All have Wards Riverside balloon tires give a smoother, safer rides. Tires are made from a scientific combination of crude and synthetic ber. Riverside Butyl tubes hold air up to 10 times longer than pre-war natural rubber tu

"ALL AMERICAN" 26-IN. BIKE 75.95

(A) You'll be the king of the neighborhood with this brand new Hawthorne chrome-finished bike. It even has protective bumpers on both front and rear fenders—and just like the latest sport cars, chrome plating has been lavishly used on the headlight, fork springs, fenders, bumpers, rims, sprocket, crank . . . and tank trim, too. Shining chromed styling flows smoothly from front to rear and is highlighted by a handsome black enameled frame with red trim, and the white saddle, white grips, and Riverside white sidewall tires.

CENTRAL POWER PACK. Only one battery to buy or replace. Single lantern type battery is carried in the streamlined tank (Order battery from Page 698). It operates the following electrical units:

SEALED BEAM CHROME PLATED HEADLIGHT engineered by General Electric, it's similar to sealed beam units used on automobiles. Throws a brilliant beam 30 to 50 feet ahead for safer night riding. Air, dust, and moistureproof reflector cannot tarnish. Curved truss rods protect lamp.

4-WAY DIRECTIONAL, TAIL, STOP LIGHTS and Stimsonite reflector built into rear carrier for added safety. (See picture at left for details).

DELTA ELECTRIC HORN has push button on side of tank that sounds warning to clear the road.

COIL SPRING FORK gives you cushioned comfort riding—absorbs road shocks.

RIVERSIDE WHITE SIDEWALL TIRES (size 26x2.125) add beauty to your bike and combined with Butyl inner tubes give you smoother riding.

CRASH RAIL SADDLE with double coil chrome springs has waterproof Vinyl plastic covering. Equipped with heavy duty pedals plus all the outstanding features described at top of page.

MEN'S AND BOYS' MODEL ONLY. Black frame with Red and Chromed trim as described above. Act. wt. 58 lbs. Shipped promptly from Stock by Frt., Truck or Exp. State transportation. Ship. wt. 68 lbs.
60 C 3086 R—.... wn.............. Cash $75.95

HAWTHORNE DE LUXE MODELS 65.9

(B) A de luxe quality bike that has all fort and safety "extras" built i maximum road performance tank model bike with its bri gleaming white sidewall tir

DE LUXE MOTORCYCLE TYPE H fender. Adjustable, throws power light on road ahead wherever you wish plated lens ring, green lens visor to shi from approaching traffic. Greater pow beam mean more night-riding so

COMBINATION STOP-TAIL-DIRECTIONAL LI Stimsonite reflector is built into sturdy carrier (see picture at left for details

DE LUXE ELECTRIC HORN built into st tank with modern style horn grill. P on side of tank sounds clear warning light each operate on 2 flashlight c cluded—order from Page 641).

COIL SPRING FORK gives you cushioned and a floating ride. See picture at le scription and details of construction.

CRASH RAIL SADDLE WITH CHROME PLATE coil springs has waterproof vinyl plas ing. Chrome plated crash rail protect saddle from scuffing. Double coil sprin road shocks, give a more comforta Springs chrome plated to resist r

RIVERSIDE WHITE SIDEWALL T give added beauty and m riding. See "Shipping Notic

(B) DE LUXE TANK MODEL enameled frame, metall ders, tank, trim. For me Wt. 58 lbs. $7 Dn. See P
60 C 3084 R—.wn.

WOMEN'S AND GIRLS Metallic Blue Gray a and girls over 12. F
........Ship. w

Like every kid in America, I was crazy about bikes and finally got one when my dad surprised me by wheeling it out while we were visiting my grandparents' farm on my birthday in 1954.

> **"I prefer drawing to talking.
> Drawing is faster, and leaves
> less room for lies."**
>
> —Le Corbusier

CONFESSIONS OF AN ONLY CHILD

I started a gang and we wore face masks like the guys in the serial *The Black Commandos*, even though I had only seen one episode.

I had a schoolboy crush on Cheryl Kvamsdale, and I stole a toy boat from the tiny department store just off the main street. I claimed Art Collins bought it for me, and though I got away with the lie, I was so uncomfortable with the guilt I never did it again.

I pulled the chair out behind a young girl in front of me in the basement of the Lutheran church. We were standing to pray and when the prayer was over, much to my horror, she splattered on the floor. All the adults were terribly upset.

At our farmhouse, I yelled at kids a block away to come play with me, but they never came. I went fishing with my dad at Clear Lake. When I was about six, my parents teamed with another couple (who had a young daughter) for a Halloween contest at the firehouse. They used directions in a magazine to make giant papier-mâché heads of Mickey and Minnie Mouse for us to wear. I spent the entire evening inside the giant Mickey head in a kind of Boo Radley daze. We were introduced to the crowd at a high school football game and then were paraded around the firehouse. We were a big hit with the crowds, but we didn't win. A Cub Scout troop who dressed up like Robin Hood and His Merry Men (with overshoes for boots!) won and it probably didn't hurt that one of the mothers of the boys was a judge.

My father bought me an American Flyer train set, and once, when my mother took me shopping in Mason City, I saw a real fancy train set in the window of a department store. The elaborate layout had mountains and streams and a little town with street lights glowing. The train even belched real smoke. It was snowing out on the street and the Christmas lights and the Christmas music and the train all combined to etch a permanent and almost perfect Norman Rockwell moment in my brain.

Oh, and I mouthed off to a neighborhood kid who threatened me with a snow shovel. I cockily told him to go ahead and throw it. He did and I ducked, but the shovel arced down and hit me on the upper lip, creating a huge gash that scared my poor mother half to death when her bawling son walked into the house. She called my dad, who came home to drive me in a snowstorm to the emergency room in Estherville. But the roads were icy beyond Armstrong and no one could make it up a steep hill, so he turned around. We went back into Armstrong, which didn't have a hospital or a doctor, and a "local" recommended a veterinarian who was "good with a needle."

He sewed my lip back together with 30-some stitches. The vet did a real good job but predicted I would be quiet for some time and have a permanent hairlip.

He was wrong twice.

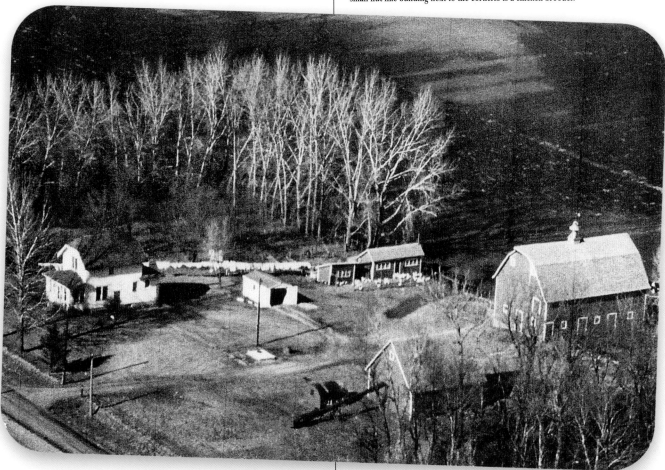

An aerial view of the Carl and Minnie Bell farm from the 1950s. The clothesline that I was tied to can clearly be seen beyond the house, as can the conveyor belt that runs into the corncrib. The small hut-like building next to the corncrib is a chicken brooder.

It's probably also a good time to talk about my constant flirtations with death and dismemberment. In addition to getting my hand in the ringer at Peach Springs, I also came very close to drowning in the stock tank at my grandfather's farm. It looked so inviting and I just kept leaning over until I fell right in, head first. I was only saved because my grandmother was having a Ladies Aid meeting and someone was in the kitchen and saw me go in. I remember the Ladies Aid women holding me and patting my head as they carried me, walking across the lawn as I sputtered and cried.

Another time, my grandfather was loading oats into the corncrib on a conveyor belt, and I kept looking at it with the idea of riding that sucker up into the top of the corncrib. My grandfather warned me several times to stand back and not do anything stupid, but I wouldn't be dissuaded and kept hanging around at the foot of the contraption looking for an opening. Finally, my grandfather grabbed my hand, walked me down to the house, and, with my grandmother's help, attached a rope to the back of my overalls and tied me to the clothesline. For years, my grandmother laughed like crazy when she told the story about how I wailed and wailed as I ran up and down the line like a monkey on a string.

> **"Remember—if the monster or movie shocks you, it might be because it's only a reflection of where we are— or where we're going."**
>
> —JAN STACY, *THE GREAT BOOK OF MOVIE MONSTERS*

THE CREATURE FROM SWEA CITY, IOWA

Swea City, Iowa had a ramshackle movie theater that used to be an opera house. In 1955, the theater was on its last legs because of television. In its heyday, the theater would show a Swedish film once a year to cater to the Scandinavian old-timers who still missed the old country.

One night when I was eight, I went with some friends to see *The Creature from the Black Lagoon*. We were the only people in the audience. About a third of the way in, my friends bailed on me and went home. I was all alone in the creepy old place and the Creature was knocking off people right and left. During one of the scariest parts, the projectionist came down and tapped me on the shoulder. He said he was going to shut off the movie because he wanted to go home.

I had to walk four blocks to my house. Giant trees lined the street, swaying ominously overhead, casting long, shadowy tentacles at my feet. I have never been so scared in my life.

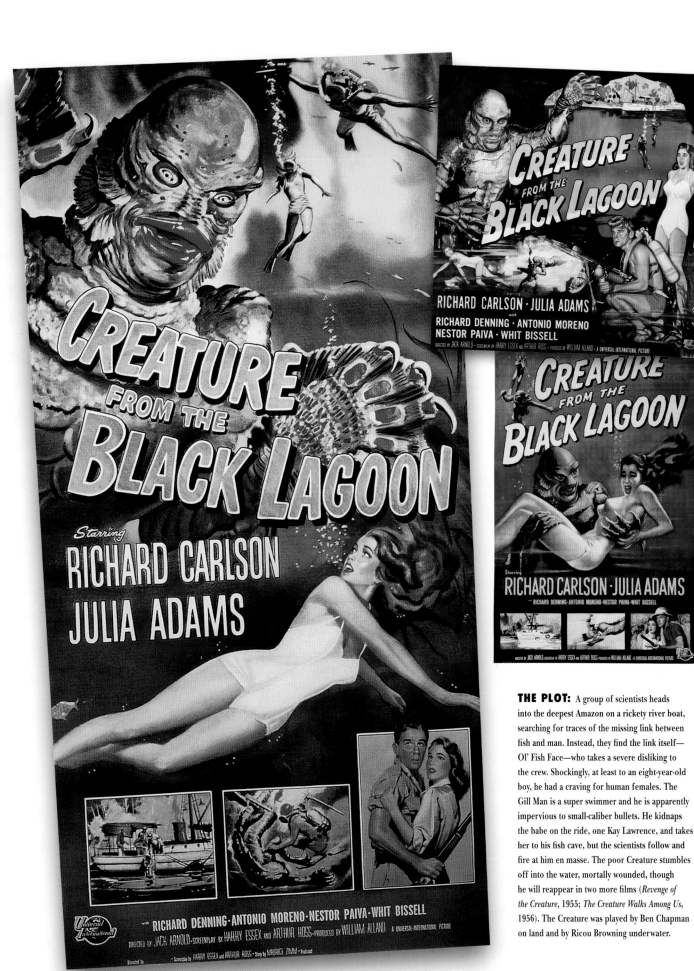

THE PLOT: A group of scientists heads into the deepest Amazon on a rickety river boat, searching for traces of the missing link between fish and man. Instead, they find the link itself— Ol' Fish Face—who takes a severe disliking to the crew. Shockingly, at least to an eight-year-old boy, he had a craving for human females. The Gill Man is a super swimmer and he is apparently impervious to small-caliber bullets. He kidnaps the babe on the ride, one Kay Lawrence, and takes her to his fish cave, but the scientists follow and fire at him en masse. The poor Creature stumbles off into the water, mortally wounded, though he will reappear in two more films (*Revenge of the Creature*, 1955; *The Creature Walks Among Us*, 1956). The Creature was played by Ben Chapman on land and by Ricou Browning underwater.

A FUTURE FORD MAN GETS A RIDE

My Grandfather Bell was always a Ford man. I remember standing in the showroom of the Gabby Ford Dealership in Swea City, looking at the new 1954 Fords. "Grandpa, I don't think they can make anything more modern than this," I said. He just smiled. We both thought that '54 was pretty Space Age.

But for the 1955 model year, much to my surprise, Ford Motor Company produced the ultimate dream car: the Thunderbird. The first time I saw one was in a Wheaties box. A model of the new sports car came in every box and I studied it for days. I wondered aloud to my dad if we would somehow ever actually see a Thunderbird.

My father had quit the service station because of the backbreaking snow shoveling required to stay open in the winter and Swedish farmers who wouldn't pay their gas bills. (He would later tell me that he was carrying some $10,000 on the books and couldn't sustain the business any longer.) By 1955, my dad was trying his stint at selling cars at the Gabby dealership. Ironically, a previous owner of the dealership was Bob Bell, no relation.

That summer, a Korean War hero from Swea City was coming home. Lieutenant Harold Fischer, Jr. had been awarded the Air Medal for meritorious achievement and the Distinguished Flying Cross. While piloting an Air Force F-80 jet fighter in 1951, he was shot down and captured by the North Koreans. He was finally released in 1955 and on June 9 he was to be honored with a big parade in our little town.

Ford Motor Company sent a brand-new Thunderbird convertible for Fischer to ride in. The car was delivered to the Gabby Ford dealership and on June 8 my dad, the incorrigible hot-rodder, brought it home for lunch. On summer vacation, my neighborhood friends (Dicky Thompson and Robert Johnson) and I were playing catch in the front yard when the sleek convertible pulled up at our house.

"Hop in," my dad said brightly. "Let's take this little baby for a spin." All three of us boys crowded in the small front seat area and my dad took off through town and to Highway 9 toward Armstrong. Normally, when you drive on those old concrete sections it sounds like a train with the rhythmic clicking of the tires hitting the separations of concrete in a methodical, lazy clip. On this day, however, it sounded like a drum machine set on berserk. My dad hit 115 miles per hour in no time and all three of us kids were wide-eyed. Now THAT was a ride to remember. Oh, and no seat belts. Ha.

I marched in the Fischer parade as a Cub Scout and it was my first. I couldn't believe how loopy and unorganized our troop was as we meandered down the main street like a bunch of nervous house cats. The next day the papers said there were 7,000 people along the parade route, but I wasn't nervous at all. I rather enjoyed the attention.

I also couldn't help but notice Captain Fischer riding in the Thunderbird, and I wondered if anybody knew what my father had done to that car the day before. I also have a hunch we weren't the only people he took for a ride that day.

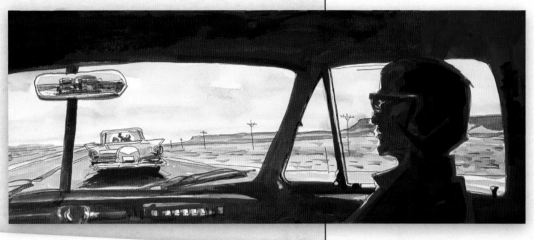

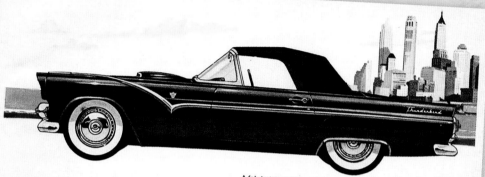

A fabric top whisks into place in seconds—to protect you from sudden rainstorms. It's completely out of sight when not in use.

Enchantment unlimited . . . the new Ford THUNDERBIRD

A distinguished kind of personal car that combines high performance and high style for a whole new world of driving fun.

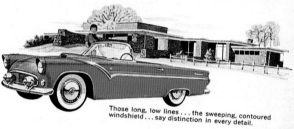

Those long, low lines . . . the sweeping, contoured windshield . . . say distinction in every detail.

THE Thunderbird's long, low, thoroughbred lines say "action"! And they speak the truth.

A toe-touch on the gas pedal means *no waiting.*

There's breath-taking Trigger-Torque performance with the new Thunderbird Special V-8 that's specially mated with transmission and rear axle.

With a low center of gravity (from cowl to ground is just over three feet) and Ford's Ball-Joint Front Suspension, the Thunderbird corners as if on rails.

The fun doesn't stop here, for the Thunderbird is *long* on convenience.

Two tops are available. There's a removable glass-fibre hard top . . . and a smart convertible fabric top. Windows *roll* up. The extra-wide foam-rubber-cushioned seat moves forward or back, up or down, at the touch of a button. The baggage compartment is ample. There's a telescoping steering wheel. And you can have power steering, power brakes, and power windows . . . Fordomatic or Overdrive.

Why not call on your Ford Dealer today and get complete details on this new and distinctive personal car? First deliveries of the thrilling Thunderbird are now being made.

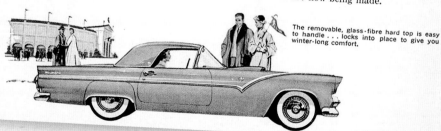

The removable, glass-fibre hard top is easy to handle . . . locks into place to give you winter-long comfort.

THE BACKSEAT PERFORMER

I spent a lot of time on car trips in the back seat. I learned to amuse myself by putting on plays for the cars behind us. I was a robot. I strangled myself and did impressions of cowboys riding as fast as the car. I pretended I had a giant scythe, which I could hold out the window and take off the tops of the telephone poles, treetops, and farm silos. Then I worked the other side and kept that up for miles. Then I went back to my robot in the back window, choking an unseen enemy and dying by sliding down the seat until, at just the right time, I would lurch to the window and press my jaw against it like a bad guy drooling in spasmodic death jolts. As the car I was performing for passed us, all the people inside gave my father funny looks.

FRINGE PRESENTS

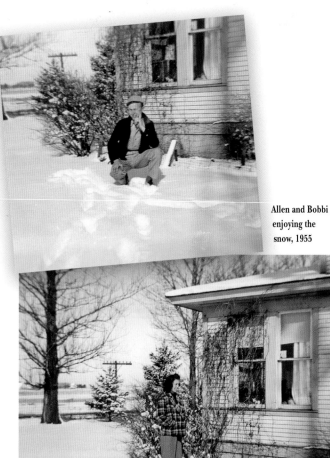

Allen and Bobbi enjoying the snow, 1955

Every Christmas we would go to the Bell family farm, and in 1955 it actually snowed on Christmas Eve. My cousin Mike and I tried to catch Santa, but when we tried to sneak down the stairs, of course, Mike's mom, Doris, caught us rounding the corner into the living room in our pajamas and made us go back upstairs to bed.

Next morning, the snow was so bright that it lit up the front room where the Christmas tree was. I opened Santa's present to find a complete Lone Ranger outfit. Mike got a steam shovel, which I thought was cool, but we couldn't enjoy it. We had to go into town to visit the Hauans. There, I invariably got a pair of socks. One sock was for my birthday (December 19) and the other was for Christmas.

My mom would later drive me to Estherville to have my picture taken in my Lone Ranger get-up. And she made me a promise: "Someday, we'll go to Arizona and I'll buy you a real cowboy outfit."

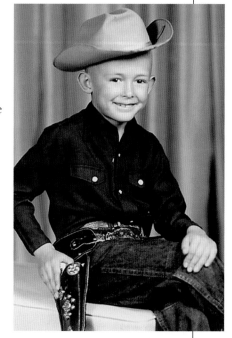

The Estherville Kid: Robert Allen, 1955

In 1954, my dad brought home a new TV, one of the first in our neighborhood. It took him most of one evening to get a signal, but everything was very fuzzy for what seemed like a long time and because there wasn't much of a picture, we more or less just listened to the voices. By the weekend, we had kids from several blocks around lying on the floor of our living room and watching live television from Mason City. Almost right off the bat, my favorite show was *The Range Rider*, and I vowed that someday I'd get a fringe pullover shirt like Jock Mahoney wore in every episode.

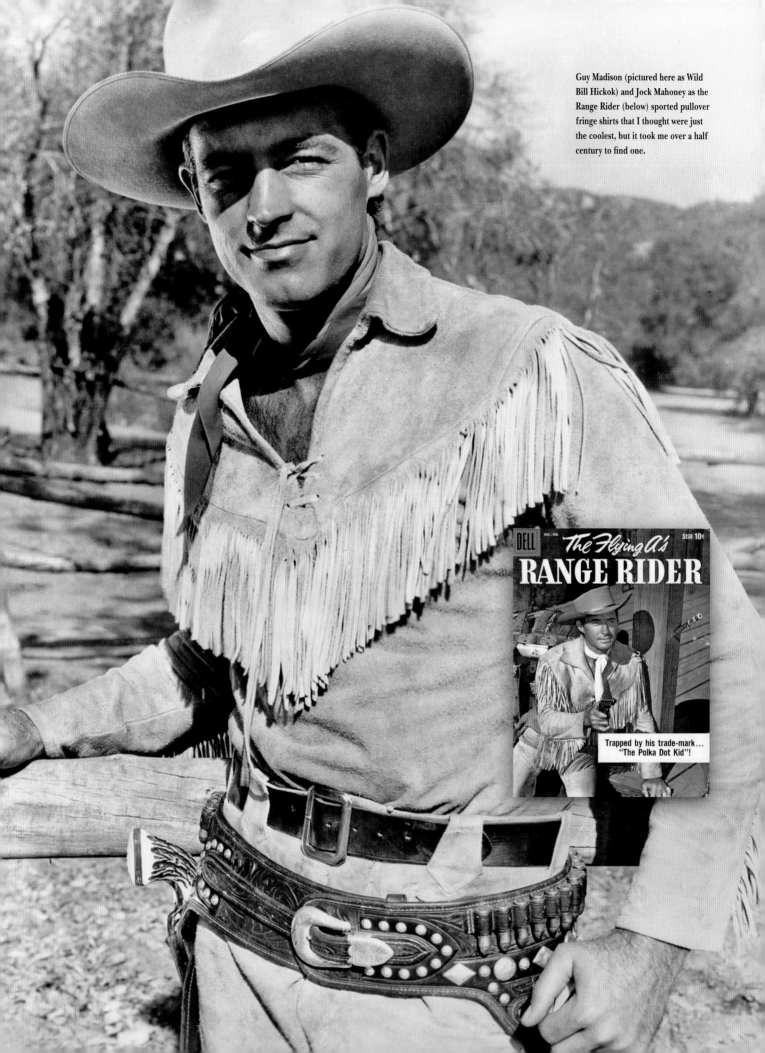

Guy Madison (pictured here as Wild Bill Hickok) and Jock Mahoney as the Range Rider (below) sported pullover fringe shirts that I thought were just the coolest, but it took me over a half century to find one.

**"Born on a tabletop in Joe's Cafe
Dirtiest place in the USA
Got drunk in a bar when he was only three
Went out in the woods and pee'd on ev'ry tree
Davy, Davy Crockett, king of the wild frontier!"**

—THE KINGMAN PARODY OF THE DAVY CROCKETT THEME SONG BY BOXLIP DARRELL

COONSKIN MADNESS

Like every other kid in the country, I was swept up in the Hopalong Cassidy and Davy Crockett crazes. The fledgling television stations throughout the country were starving for content and the first wave phenom was Hopalong Cassidy starring William Boyd, a fading B western star who saw the marketing potential before almost everyone else and wisely bought up all of the rights to his old westerns (for a reported $350,000). Of course, we kids had no idea the B serials featuring Hopalong were retreads; we took them at straight value as NEW entertainment and soon enough every kid in the country wanted to be a cowboy like Hopalong. Boyd earned millions from endorsements, including the first lunchbox to bear an image, which caused the lunchbox company's sales to jump from 50,000 units to 600,000 units. One of those units was mine.

Picking up on this incredible new media phenom, Walt Disney launched Davy Crockett in 1954 and soon enough we all wanted coonskin caps.

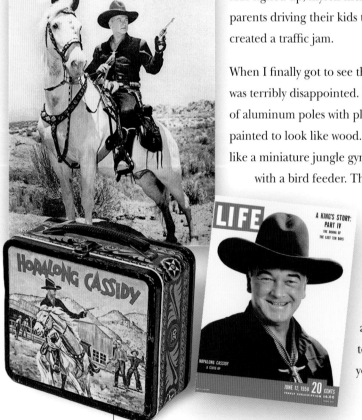

Crockett hysteria resulted in $100 million in sales of Davy merchandise. Disney smartly followed up with a movie of the same name starring Fess Parker, and we lined up around the block. My cousin, Mike Richards of Osage, actually won a Davy Crockett cabin from the local theater that launched a campaign. Thousands of kids signed up, myself included, and the parents driving their kids to the theater created a traffic jam.

When I finally got to see the "cabin," I was terribly disappointed. It was made of aluminum poles with plastic panels painted to look like wood. It looked like a miniature jungle gym crossed with a bird feeder. This was one of my first exposures to the reality of media hype: it rarely turns out to be anything close to the image in your head.

Opposite page: Retailers scrambled to find enough fur to meet the demand for coonskin caps. One report has venders tearing up raccoon coats and turning them into Davy Crockett caps. Here we see a slew of mini-crockets converging on the actual Alamo in the mid-1950s.

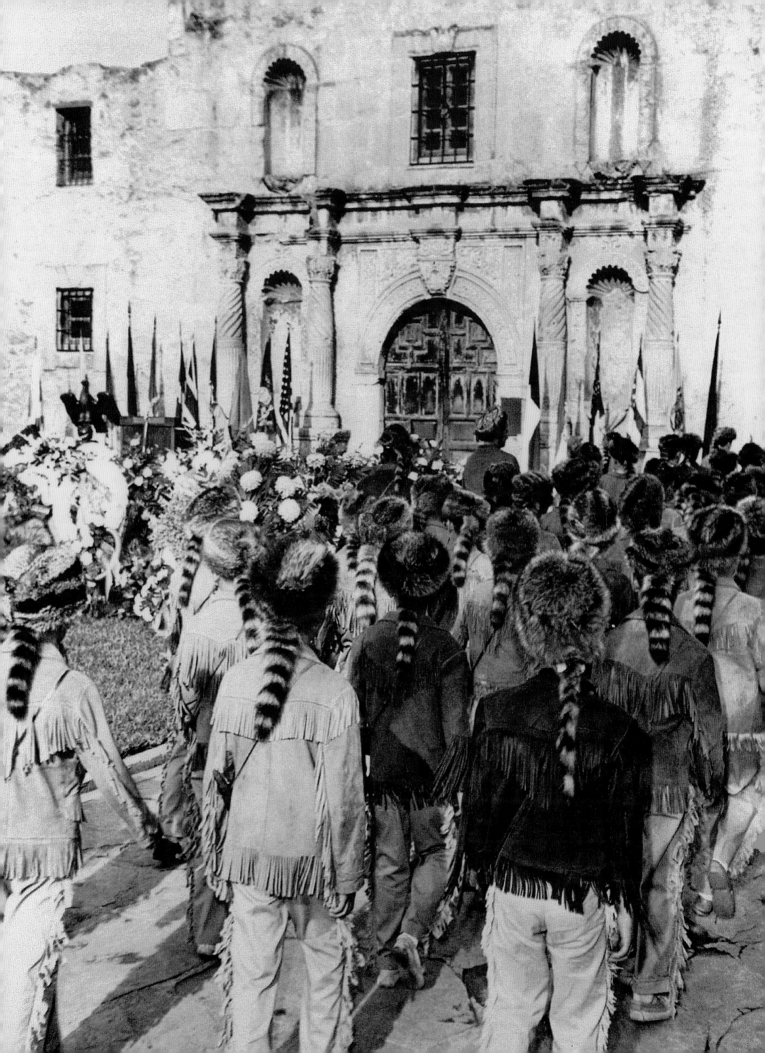

> **"For this is what America is all about.**
> **It is the uncrossed desert and the unclimbed ridge.**
> **It is the star that is not reached and the harvest**
> **that is sleeping in the unplowed ground."**
>
> —Lyndon Baines Johnson

DREAMS MY FATHER SOLD ME

Almost every Sunday my father would take my mother and me for a drive. First to my grandparents' farm north of Thompson, and then from there to see gas stations, or other businesses for sale. Sometimes they would be combination gas station-cafes, and, even more ideal, one such combo at Leland had a small gas station with a cafe next door behind a white-picket fence and the house was above the cafe. My father would stop the car and let it idle and tell my mother and me how happy we would be with this three-in-one dreamboat property. I've always had a vivid imagination and I always bought what he was selling, or, in this case, trying to buy.

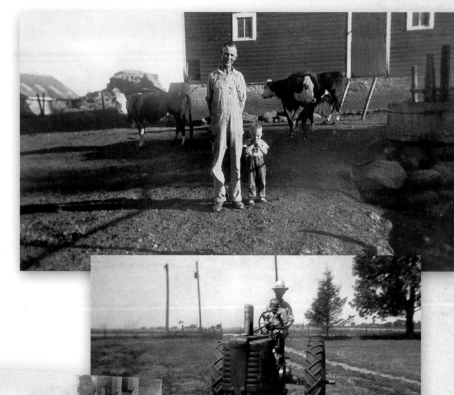

Top: Here I am with my grandfather in the stock pen at the family farm. To the right in the picture is the stock tank I fell into and almost drowned.

Middle: I'm with my grandfather on his Series D 1940 John Deere tractor. I loved to ride out with him to feed the livestock every morning. The tractor is still in the family.

Left: My father pumping gas at his Phillips 66 station in Swea City. After a second snowstorm buried his driveway shortly after shoveling the first snowbank by hand, my father reached the end of his rope there.

The Swea City Gang

We were quite the posse in second grade. Top row, from left: Robert Bell, Robert Johnson, Larry Berg; bottom row: Claude Haag, Dickie Johnson, and Reid Farland.

SCHOOL DAYS 54-55

SCHOOL DAYS 54-55

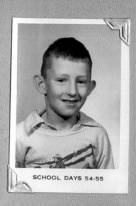

SCHOOL DAYS 54-55

SCHOOL DAYS 54-55

SCHOOL DAYS 54-55

SCHOOL DAYS 54-55

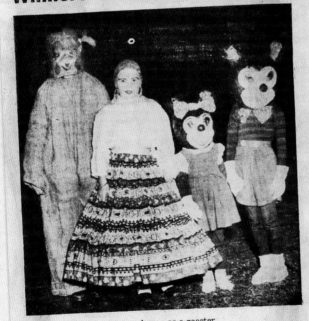

Winners in Costume Event

Dorothy Engholm, pictured second from left as a gypsy, copped first prize at the Halloween party here Saturday night.

Other winners were Robert Allen Bell and Karma Johnson, extreme right, as Mickey and Minnie Mouse and Larry Simmonsmeier as a rooster.

Judges for the event were Mesdames J. A. Sanftner, R. F. Snyder and Harold Fischer. Again, this party was even bigger than in previous years with a full night of fun and prizes by the Swea City Lions Club.

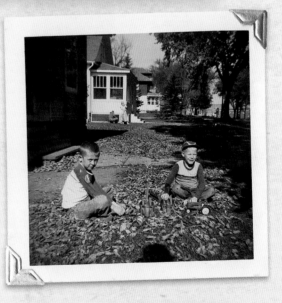

Above: Me playing with mini John Deere tractors along with neighborhood pal Robert Thompson.

Left: The Halloween costume party where Karma Johnson and I walked around town in a Boo Radley haze.

53

STORM WARNING

About a year after we arrived in Iowa, my grandmother Guess (now Swafford) and her youngest daughter, Jean, came to visit us in Iowa. A lifelong desert rat, my grandmother had never been to the Midwest, and, although she enjoyed meeting her daughter's in-laws, she was not impressed with Iowa itself: "Too green," she said with some amazement. "It hurts my eyes."

There were other downsides to living in such flat land. My mother and I were coming back from Osage one day when it started to rain. Then it really started to rain. So hard the windshield wipers could not keep up. My mother became very concerned. This is when I said, "I wish my father were here. He'd know what to do." My mother pulled over and we felt the torrential rain actually rock the car. And then, abruptly, it stopped and became deathly quiet. We heard the freight train roar. We were in the eye of the storm. A tornado, actually. In about two minutes, it was over and we drove on. A half mile beyond where we had stopped we

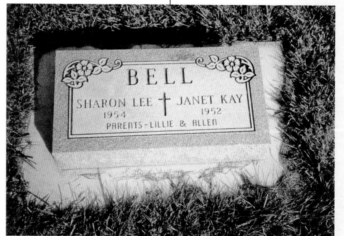

came upon a shattered brick barn with bricks scattered all over the roadway. People were walking about in the ditch in a daze. Once again, we had just missed it. We were lucky that time, but our luck was about to run out.

In 1952 my mother gave birth to a healthy baby girl—Janet Kay—in the Estherville, Iowa, hospital. Mysteriously, three days later, she died. The nurses and doctors assured my mother it was a fluke and to try again. Two years later Sharon Lee was stillborn. I was not privy to my parents' conversations, and they kept the darkness away from me, but as I got older and had my own children, I quickly realized how devastating that twin loss would have been. It's every parent's nightmare to lose a child, but to lose two is unfathomable. At the time, the cause was a mystery, but we would later find out the cause, which only made it sadder.

By 1955 I believe my parents needed to get away from the sadness in Swea City. And so they began to plan a new start in a familiar place.

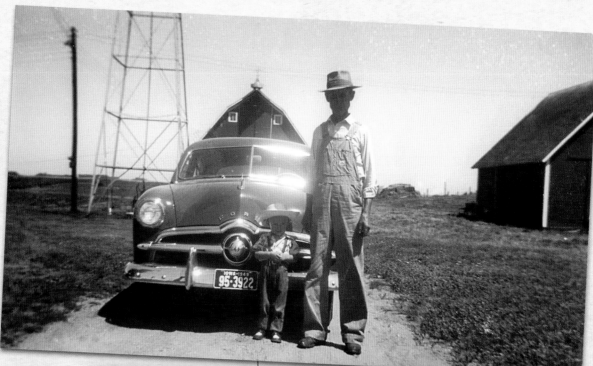

Me, 3, posing with my grandpa Carl Bell in front of a '49 Ford on the Bell family farm. This is the time frame when I was tied to the clothesline.

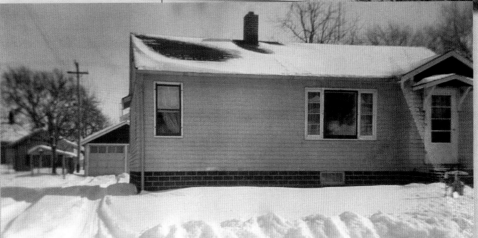

Our second rental house in Swea City, Iowa, photographed when we were getting set to move back to Arizona. The sled in the yard is mine.

Mrs. Allen Bell entertained at a birthday party for their son, Robert Allen, on his 6th birthday last Friday afternoon. Guests at the party were Anita Youngquist, Pamela and Sharon Svendsen, Madeline Krumm, Robert Thompson, Larry Thoen, Andre Opsal, Richard Johnson, Donald Runge and John Guyer. Mrs. Richard Pehrson and Doris Nelson assisted Mrs. Bell with the party.

The local paper covered exciting news of birthday parties. Note that the married women are acknowledged by their husbands' names.

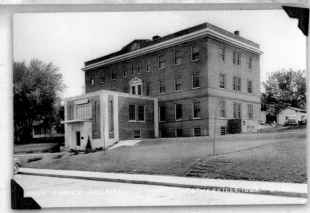

The Estherville, Iowa, hospital where Bobbi had Janet Kay. Three days after the birth, mother and baby were moved to the Buffalo Center hospital where the baby died. My second sister was stillborn at Buffalo Center.

"Tiny caskets in the
snow. Who were these
little girls we'll never
get to know?"

—BBB

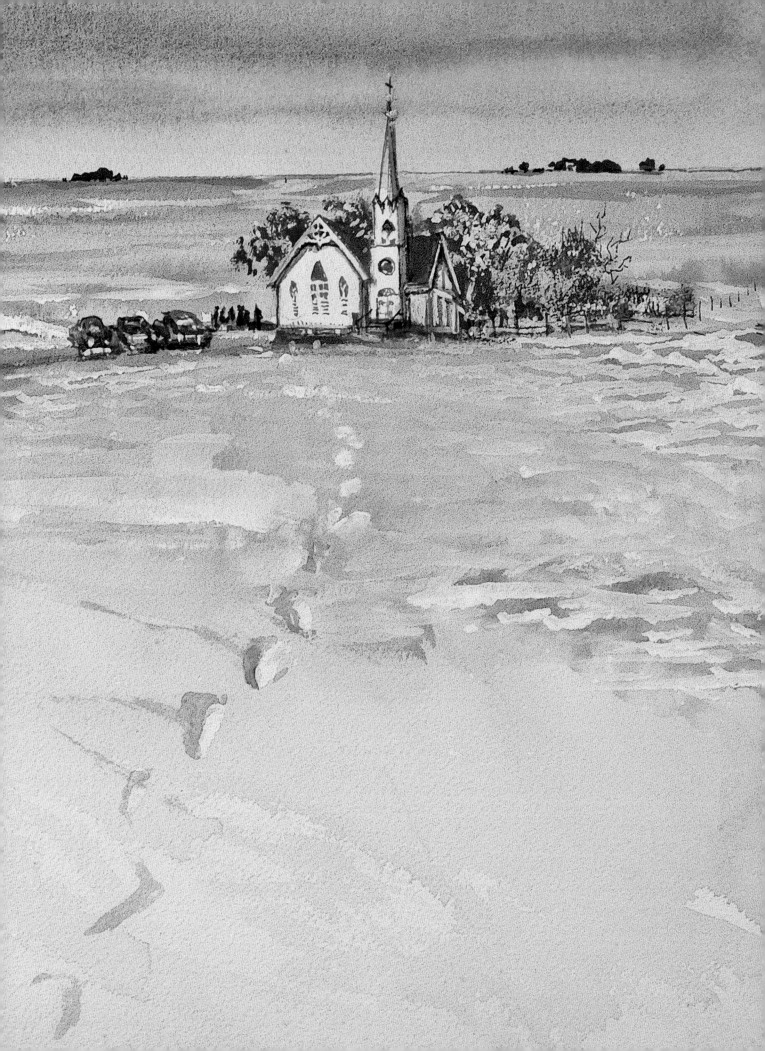

THE TAIL END OF STEAM AND
THE BEGINNING OF A NEW DREAM

In the fall of 1955 my mother made plans to take me out of school for a train trip back to Arizona. My mom wanted to see her mother and sisters and my father was interested in, once again, getting a gas station on Route 66. My Grandmother Guess found a gas station just down the street from her new home on Jefferson Street on Hilltop, outside Kingman, Arizona. And we couldn't wait to see it.

Instead of taking the train south to get on the Santa Fe Railway and a direct route into Kingman, for some reason (probably price and connections), my parents chose a route from Webster City, Iowa, to Kansas City, then out on the Northern Pacific to Salt Lake City, and down to Las Vegas, Nevada, where my grandmother and step-grandfather, Ernie Swafford, would pick us up and drive us back to Kingman.

I remember being quite excited about arriving at the train station in Webster City as it became apparent the passenger train we were going to ride in was being pulled by a steam engine! It was one of the last in service. As I grew up, my father often told the story of standing on the platform to watch us depart when the whistle blew, the call for "All Aboard!" echoed down the line and then the first chugs, and the delayed lurch of the cars, when my eyes got as "big as saucers," he said with a laugh.

We got into Kansas City terminal late at night and my mother was very concerned about making the connection. I was helping her with bags and I wasn't doing a very good job of it. She had to ask several people where to go and I had never seen so many people or trains or commotion in one place. We fought our way through the terminal, out on the tracks, and across several long trains parked in the dark with tentacles of steam wafting up into the air. Finally, we found the right train: a sleek and modern diesel with an observation car would take us across the plains. We no sooner got aboard before we were on our way.

As we sped through the small Kansas towns, I watched the rolling scenery out the window and marveled at the steady, melodic pattern of the wheels on the rails.

My mother and I played cards, Old Maid as I remember, and we ate a lunch of bologna sandwiches she had packed. The seats folded back and I slept with a blanket my mother had brought along. The next morning we ate breakfast in the dining car and my mother couldn't believe how expensive it was (75 cents for orange juice!). I scouted the train and went up into the observation car where the view was spectacular in all directions. After a time an announcer came on and said we would be meeting one of the last

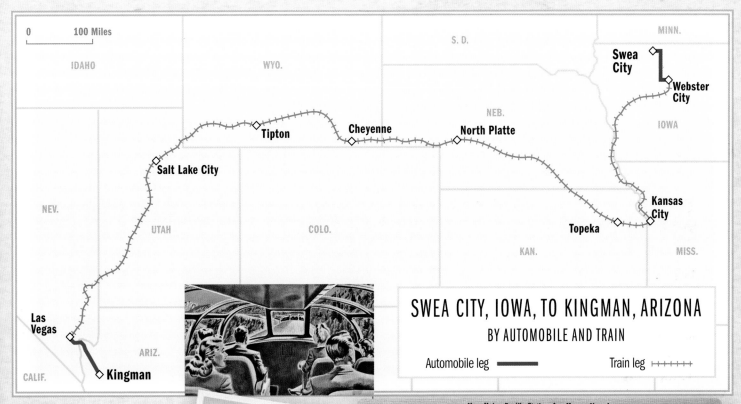

SWEA CITY, IOWA, TO KINGMAN, ARIZONA
BY AUTOMOBILE AND TRAIN

Automobile leg ——— Train leg ++++++

New Union Pacific Station, Las Vegas, Nevada

Gateway to Boulder Dam

steam engines on the line and I got on the right side and pressed my face against the glass to get a better view. Sure enough, a fast-chugging steam engine came down the line, passing us with the smoke going up over and twisting around the observation car with a violent slipstream created by the two speeding trains.

After a long layover in Salt Lake City, we finally headed south and I slept. When I awoke, somewhere near St. George, Utah, I looked out the window at the harsh desert and said to myself, "Now THIS is the West."

We came into Las Vegas and glided to a stop. We literally got off where my grandparents were standing and we hugged and walked to the car, several feet away.

Next stop, a western clothing store on Fremont Street in the heart of the downtown gambling district, so my mother could make good on her promise to buy me a complete western outfit. I loved the smell of leather in that store. Now I was going to get to dress up like a real cowboy.

HAIR-RAISING HAIRPINS ON THE BOULDER DAM HIGHWAY

My grandmother Guess and her new husband, Ernie Swafford, met us at the Las Vegas train station. Ernie was a mysterious guy and claimed to have worked in "pictures." He smoked cigarettes in an FDR holder, which made him look like a villain in a bad melodrama. He was always good to me, but my mother didn't like him much. In her mind, no one could replace her father.

Anyway, Ernie was the designated driver on this trip. Unfortunately, he drove a stick shift in his GMC pickup, but he needed to borrow Bill Stockbridge's '55 Oldsmobile to come pick us up and drive us back to Kingman. Because of the three-on-the-tree shifter on the Olds, Ernie struggled to shift and keep the car on the road and his cigarette in his mouth all at the same time. The upshot was we careened around all the narrow curves on the approach to Boulder Dam on the wrong side of the road. It was hair-raising, to say the least. He kept driving all over the road all the way across the dam and into Arizona. People were honking and screaming at us and pulling off to avoid a head-on. It was one of the scariest road trips I have ever been on in my entire life. But, somehow, we made it to Kingman alive.

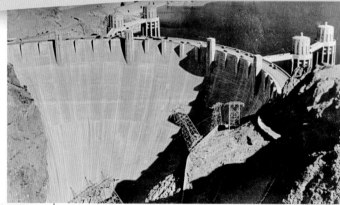

The narrow, winding roads leading up to and going out the other side of Boulder Dam (later named Hoover Dam) can be quite terrifying if someone in your car is driving on the wrong side of the road.

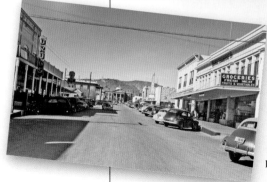

Downtown Kingman from Route 66 looking north.

Driving through
the "Cut."

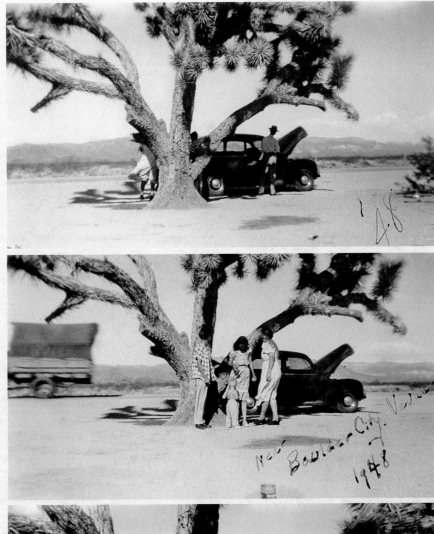

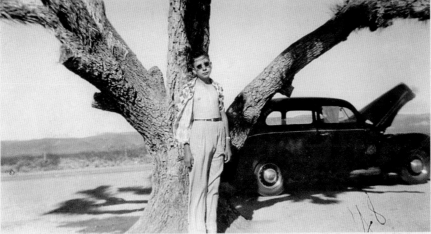

Heatwaves on Highway 93

We were no strangers to Highway 93 and the road to Boulder Dam and Las Vegas. Here we are in 1948 on a
trip with Carl and Minnie Bell and their youngest son, Glenn Marvin (the young kid with his shirt open). This
appears to be taken near Dolan Springs. That's me, the little tow-headed guy in the center photo. Everyone looks
miserable from the heat and I believe the hood was up because of radiator problems.

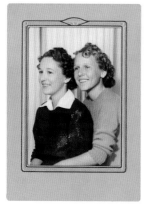

Patsy and Jean Guess

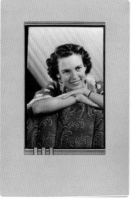

Bobbi Guess

Mary Guess

Sadie Pearl Guess

ROUGH–AND–READY COWGIRLS AND THE COWBOYS WHO LOVED THEM

When we landed in Arizona, I discovered my mother's cowboy relatives were a little wilder and rougher than anything I ever saw in the Midwest (or on TV westerns for that matter). First of all, my mother had four sisters and they all attracted big, strapping cowboy types. And when they would come blasting into my grandmother's house, it was a whirlwind of smoking and loud talking.

I had two grandfathers, and both were quite influential in my life. One by his presence and one by his absence. My mother's father, Bob Guess, died unexpectedly, during an ulcer operation at Kingman Regional Hospital in 1945, the year before I was born. He was 55. I was named for him, as was Patsy's son, Robert Jerl. I was referred to in the family as Robert Allen to avoid confusion. No matter where I went in Mohave County, cowboys and oldtimers would give me a pass for the simple reason I was Bob Guess's grandson. This was heavy stuff to a 10-year-old.

Besides my grandfather, the hero of my mother's family was Billy Hamilton, my Aunt Mary's only son. He was at that time on his way to becoming a world champion steer roper. In the middle photo below, I am posing with him in the side yard of my grandmother's house. Oh, and he is tucking his boots in because, as he later put it, "I wanted to look like Toots Mansfield," a rodeo star of that era. This drove his father, Choc Hamilton, to distraction, because in those days to tuck in your boots was considered the height of dudeness.

I may be wearing cowboy clothes, but I'm looking more Iowa than cowboy.

Upper left: Bob Guess on Shamrock, circa 1944.

Above: Billy Hamilton and BBB, 1956.

Left: Wildcatter and heavy construction man Bill Stockbridge and his then-girlfriend, Patsy Guess, K-I-S-S-I-N-G at White Tanks, a makeout spot I later frequented myself.

"He who has daughters is always a shepherd."

—OLD VAQUERO SAYING

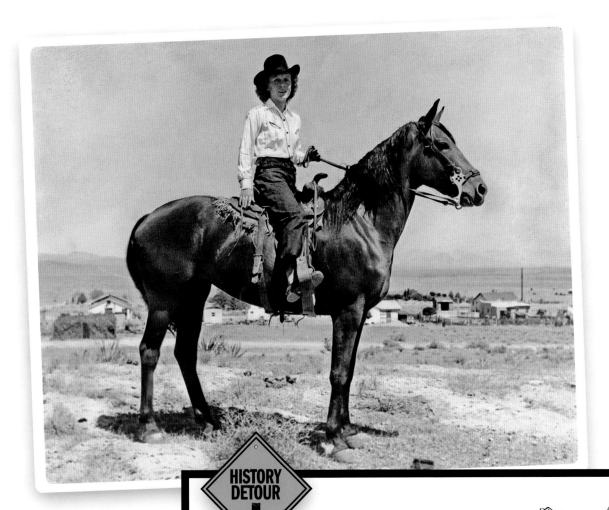

Jean Guess, rodeo queen, aboard Sooner, 1947.

HISTORY DETOUR

One Tough Arizona Woman

In 1977 I created a cartoon character based on the tough women I knew growing up in Mohave County, including my rodeo queen aunt, Jean Guess Linn. The cartoon strip *Honkytonk Sue* first ran in *National Lampoon* and then for several years in the Phoenix *New Times* and was bought by Columbia Pictures in 1983 as a vehicle for Goldie Hawn. Several scripts were written, including two by Larry McMurtry, but the film was never made.

"You'll wonder where the yellow went
When you brush your teeth with Pepsodent."

—MADISON AVENUE DITTY

THE AMERICAN ROAD TRIP HITS OVERDRIVE

Ike said, "Buy." And Americans said, "Buy what?" And Madison Avenue said, "See the USA in your Chevrolet."

The great, big American road trip was on—Big Time.

In 1956, President Eisenhower signed the act that established the 41,000-mile Interstate Highway System. It was pushed through with national security in mind: Stretches of the proposed roadway were mandated to be straight enough for aircraft to land on in case military air bases were knocked out of commission, and there was concern that if a nuclear attack hit big cities, there would be gridlock during escape. The country needed to prepare for the worst.

The act authorized funding for what's known as "the greatest public work project since the pyramids." The irony is that while the interstate project encouraged travel, in the end it killed The Mother Road.

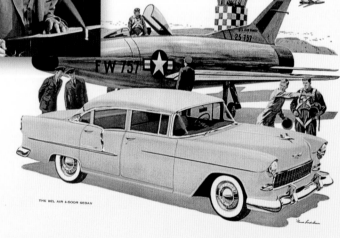

THE BEL AIR 4-DOOR SEDAN

Chevrolet's 3 new engines put new fun under your foot and a great big grin on your face!

You'll want to read about the new V8 and two new 6's here.

But it's even better to let them speak for themselves on the road.

You've got the greatest choice going in the Motoramic Chevrolet! Would you like to boss the new "Turbo-Fire V8" around ... strictly in charge when the light flashes green ... calm and confident when the road snakes up a steep grade? (Easy does it—you're handling 162 "horses" with an 8 to 1 compression ratio!) Or would you prefer the equally thrilling performance of one of the two new 6's? There's the new "Blue-Flame 136" teamed with the extra-cost option of a smoother Powerglide. And the new "Blue-Flame 123" with either the new standard transmission or the extra-cost option of new Touch-Down Overdrive. See why Chevrolet is stealing the thunder from the high-priced cars? It has that high-priced, high-fashion look and everything good that goes with it—power, drives, ride, handling ease, everything. Let your Chevrolet dealer demonstrate how Chevrolet and General Motors have started a whole new age of low-cost motoring! ... Chevrolet Division of General Motors, Detroit 2, Michigan.

Motoramic **CHEVROLET** More than a new car ... a new **concept** of low-cost motoring!

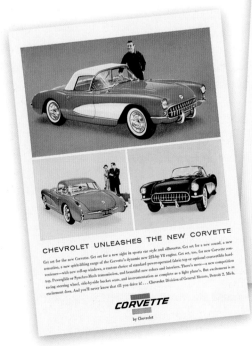

CHEVROLET UNLEASHES THE NEW CORVETTE

Get set for the new Corvette. Get set for a new sight in sports car style and silhouette. Get set for a new sound, a new sensation, a new spirit-lifting surge of the Corvette's dynamic new 225-hp V8 engine. Get set, too, for new Corvette conveniences—with new roll-up windows, a custom choice of standard power-operated fabric top or optional convertible hardtop, Powerglide or Synchro-Mesh transmission, and beautiful new colors and interiors. There's more—a new competition racing steering wheel, side-by-side bucket seats, and instrumentation as complete as a light plane's. But excitement is an excitement does. And you'll never know that till you drive it! ... Chevrolet Division of General Motors, Detroit 2, Mich.

CORVETTE
by Chevrolet

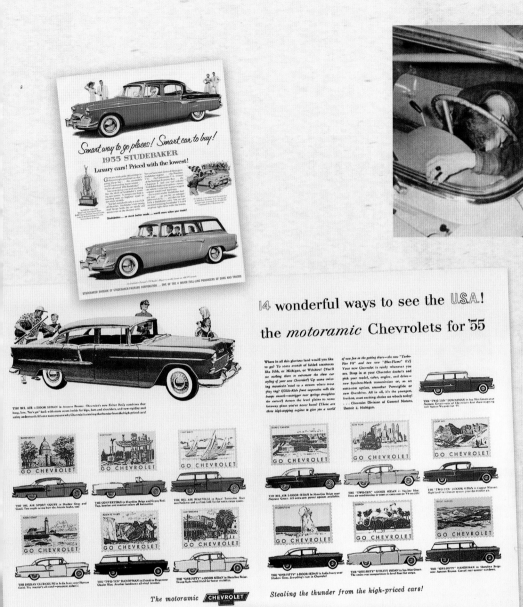

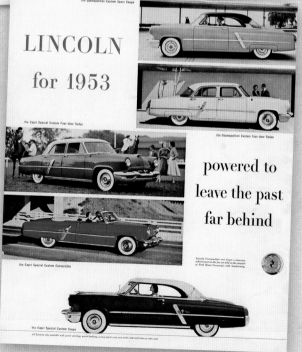

MECHANIZED DEATH

Someone in the U.S. school system got the demented idea to put together horrific footage of actual traffic accidents and force high school students to watch the compilation carnage as a solution against teenagers driving fast. I believe there were several versions of this school-sponsored horror picture show, but the one we were subjected to in Kingman was *Mechanized Death*.

I remember gross closeups of accident victims at the scene of the crash: a shoe in the middle of the road, moaning people thrown through the windshield, people impaled on spear-pointed radio dials on metal dashboards. This film had about as much of an effect on our driving habits as, oh say, the VD films they also showed when a nice kid (who we were supposed to relate to as being us) says with a pained look on his face, "I think those girls had something," and his friend misses the meaning and says enthusiastically, "You bet they did!" This exchange produced a raucous laugh in the boys' assembly (we were shown the film separately, with the girls seeing it first in the main auditorium and then the boys).

When we got out of the assembly, one of the girls in my typing class, said "What were you guys laughing at? We didn't think any of it was funny." That alone speaks volumes about the very problem they were trying to head off. Sorry, bad metaphor.

Yes, I was in typing class for one simple reason: to meet girls. Today, as I type this, 50 years later, I marvel at the stupidness of the intent vs. the practicality of the essential lifetime skill I gained. Which leads to a brilliant observation by Joel Stein: "Getting laid is the only reason men do anything."

AMERICA GOES HUGE

As the nation warmed up to the big American road trip, Detroit led the way. Many Motor City cars were coming out in 1953 with overhead cam engines and much bigger pistons. The engines were "souped up" with modified manifolds and carburetors. They went to four-barrel carbs and electric fuel pumps for more power. To go faster, Detroit engineers increased the bore and shortened the stroke, and added hotter cams. They polished the exhaust systems for slicker relief of back pressure and offered dual tailpipes.

The artists who drew the cars for the fancy brochures started getting notes from management, telling them to make the cars look even larger than they were, to increase the scope, and, incredibly, to decrease the size of the people in the cars. This became almost as comedic as the cars altered by Dan "Huge" Harshberger on these pages. Although not actual car ads, they are not far from the real deal and, more importantly, capture the spirit of those heady car days.

One man saw that this behemoth trend could not continue. American Motors chief George Romney (yes, Mitt's dad) gave a speech in 1955 about "The Dinosaur in the Driveway." He said, in part, "Cars 19 feet long, weighing two tons, are used to run a 118-pound housewife three blocks to the drugstore for a package of bobby pins and lipstick."

He was right, of course, but what a great big ride we had for another 10 years.

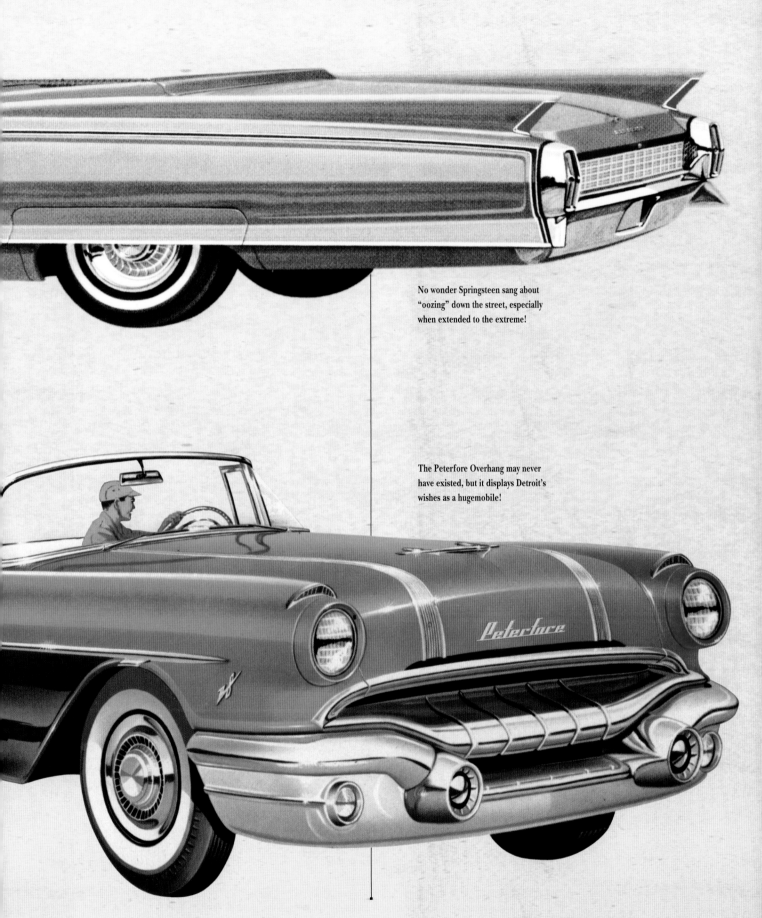

No wonder Springsteen sang about "oozing" down the street, especially when extended to the extreme!

The Peterfore Overhang may never have existed, but it displays Detroit's wishes as a hugemobile!

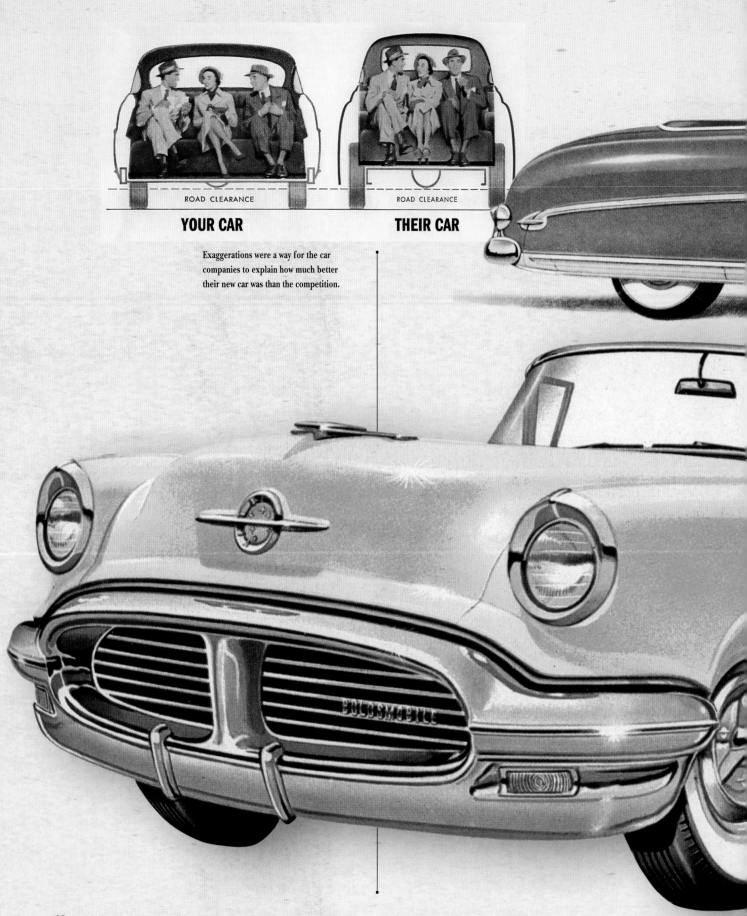

ROAD CLEARANCE

ROAD CLEARANCE

YOUR CAR

THEIR CAR

Exaggerations were a way for the car companies to explain how much better their new car was than the competition.

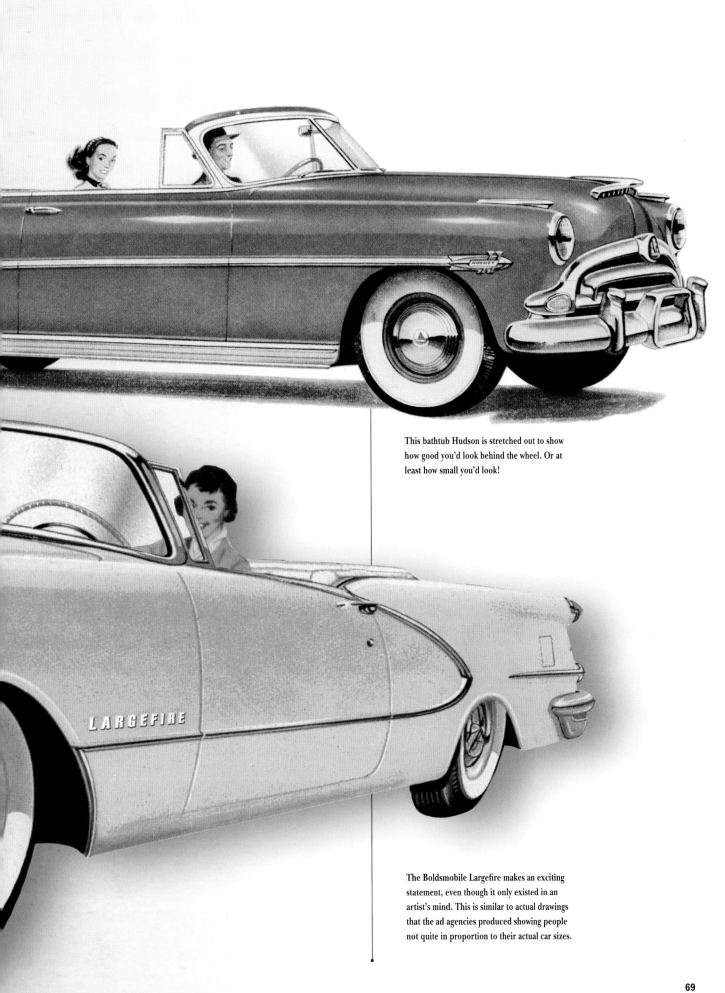

This bathtub Hudson is stretched out to show how good you'd look behind the wheel. Or at least how small you'd look!

The Boldsmobile Largefire makes an exciting statement, even though it only existed in an artist's mind. This is similar to actual drawings that the ad agencies produced showing people not quite in proportion to their actual car sizes.

LIFE LESSONS IN THE SNOW

Before we left Swea City, I got one more life lesson on my last day there.

Just north of the school, the sidewalk buckled from the root of a big ol' tree. And it was there—in the snow and with my arms full of going-away mementos signed by everyone in my third-grade class—that I met the school bully. (I won't use his real name, but it rhymes with BaBrogie.)

He, of course, saw an easy mark and pushed me down in the snow, humiliating me in front of the girls walking with me.

It was an early lesson that has repeated itself with depressing regularity in my life. No matter what accolades you receive, there will always be a jerk who comes along to cut you down to size. The bigger the prize, the bigger the jerk. It never fails.

I call it The BaBrogie Law.

While we were spending our last Christmas in Iowa, another family, in Saginaw, Michigan, was sending out Christmas cards with this photo on it. From left: Kathy Sue, Betty, baby Don, and Earl Radina.

"YOU'LL NEVER MAKE IT"

My father always gravitated to big cars. He bought a Roadmaster Buick (with the three portholes on the side) in Fort Dodge in 1953, and later a cigar-shaped 1962 Olds, but for our drive back out to Arizona my father bought a beautiful 1956 Ford Fairlane.

When we got down into Kansas, a valve started knocking. It sounded pretty bad so my father pulled into a gas station in the next town and had it checked. The service station guy said it was a shot valve, but it was a Sunday and nobody could fix it until the next day. My dad closed the hood and said, "I won't be here tomorrow; I'm on my way to a job in Arizona."

The guy scoffed and said, "You'll never make it."

"Wanna bet?" my dad said as we roared off down Route 66 with the busted valve knocking like a tin can in a wind tunnel. Personally, I had my doubts, but we drove straight through and made it to Kingman in time for him to take over a 10-pump Flying A on Hilltop.

One of the first things my dad did in Kingman was trade in that '56 Ford for a 1957 and that wasn't big enough, so he bought a continental kit and he and another ex–Swea City kid, Kenny Peterson, jerry-rigged that contraption onto that already very long car. Now we were really stylin'.

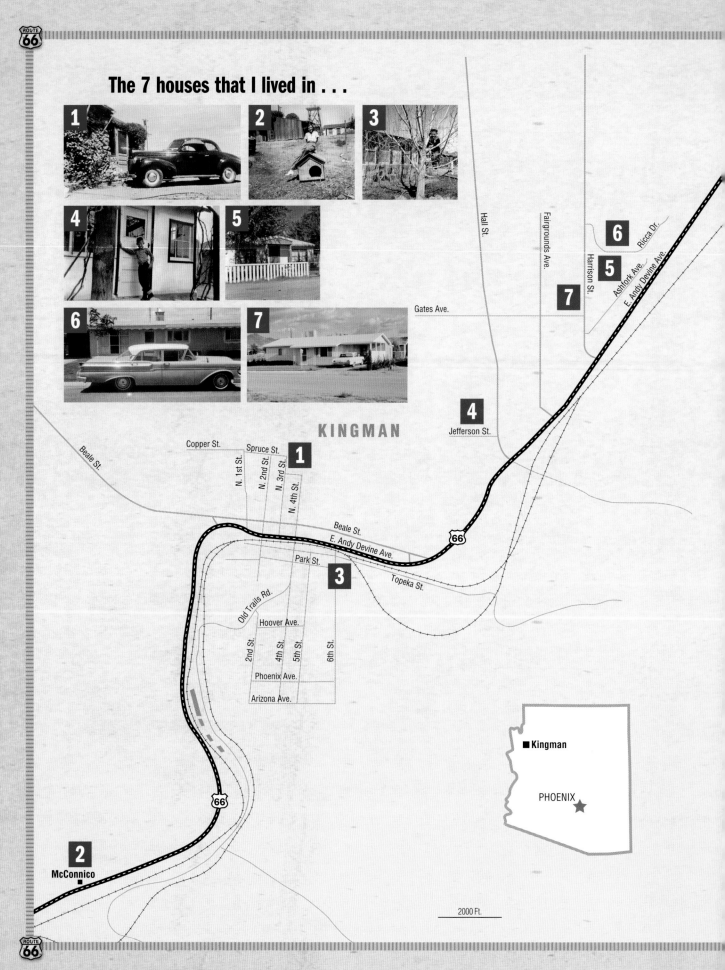

The 7 houses that I lived in . . .

KINGMAN

OFFICIAL MAP OF

ROUTE 66

AS IT WINDS THRU
KINGMAN
AND VICINITY

1955–1965
THE GLORY YEARS

Greetings from colorful KINGMAN

Where the wind does not blow _all_ the time

HISTORY DETOUR ▼

A Siding Gets Sidetracked

A mining promoter, Samuel McConnico, created the Sacramento Valley Railway Co. in 1898 to build a branch line from four miles south of Kingman to the mining town of Chloride. After numerous setbacks, the rails finally arrived in Chloride in 1912, but after a series of floods and the decline of mining, by 1931 the spur railroad was history. But to this day, the Santa Fe siding south of Kingman is still called McConnico.

DIRECTORY

Perfume Pass Sewer Ponds
Black Bridge
Whiting Brothers
McConnico

Old Trails Rd.

Hoover Ave.

66

2nd St.

4th St.

5th St.

2

Phoenix Ave.

Kingman sewer
treatment plant.

Arizona Ave.

KINGMAN

6

Perfume Pass.
Named after the
treatment plant.

Black Bridge. A
favorite make-out
spot for teenagers.

66

McConnico

W
B WHITING BROS 7

Whiting Brothers

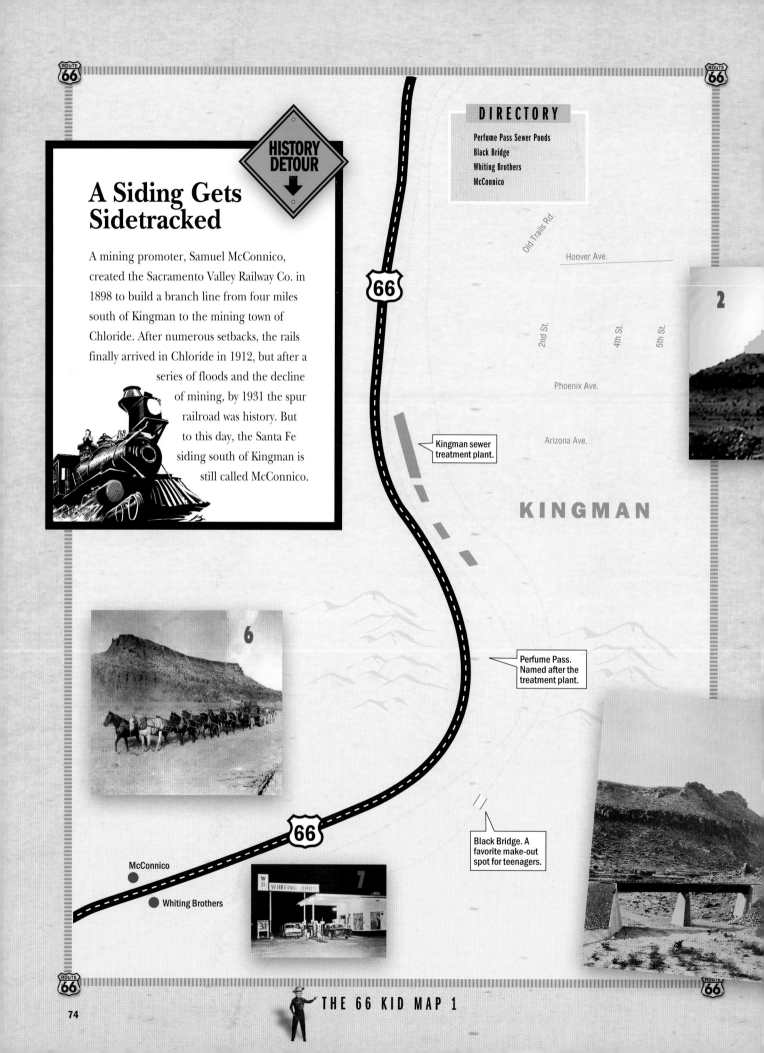

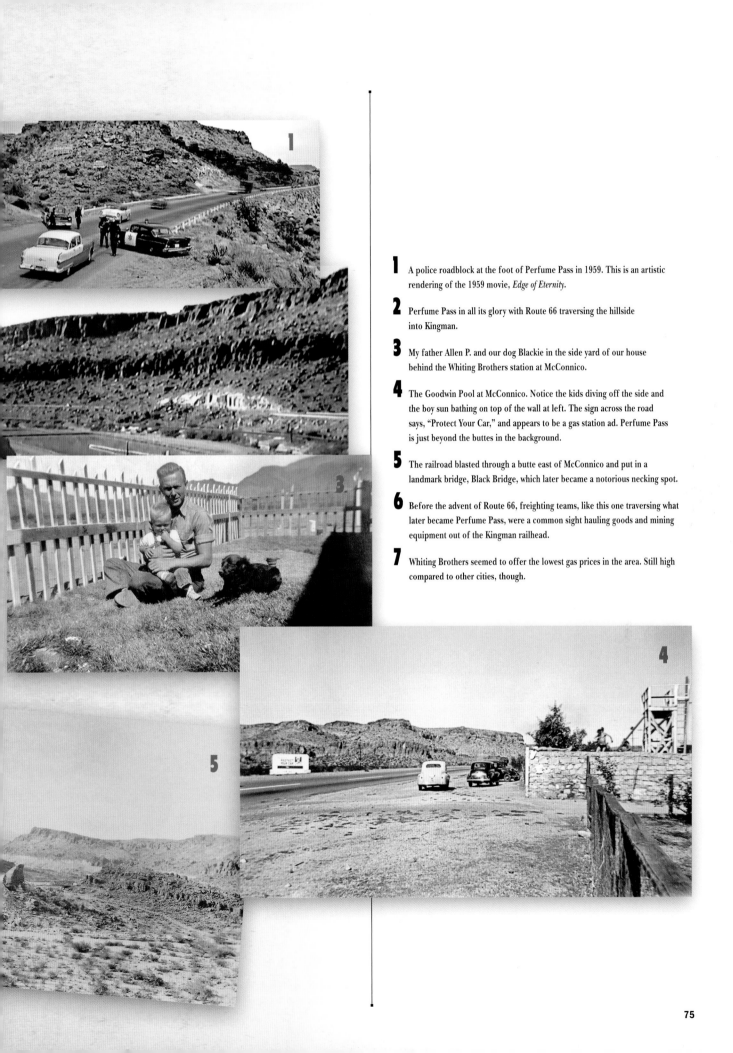

1 A police roadblock at the foot of Perfume Pass in 1959. This is an artistic rendering of the 1959 movie, *Edge of Eternity.*

2 Perfume Pass in all its glory with Route 66 traversing the hillside into Kingman.

3 My father Allen P. and our dog Blackie in the side yard of our house behind the Whiting Brothers station at McConnico.

4 The Goodwin Pool at McConnico. Notice the kids diving off the side and the boy sun bathing on top of the wall at left. The sign across the road says, "Protect Your Car," and appears to be a gas station ad. Perfume Pass is just beyond the buttes in the background.

5 The railroad blasted through a butte east of McConnico and put in a landmark bridge, Black Bridge, which later became a notorious necking spot.

6 Before the advent of Route 66, freighting teams, like this one traversing what later became Perfume Pass, were a common sight hauling goods and mining equipment out of the Kingman railhead.

7 Whiting Brothers seemed to offer the lowest gas prices in the area. Still high compared to other cities, though.

1 Citizen Utilities Electric Power Plant, now the Powerhouse.

2 The Kimo Cafe, better known as just "The Kimo."

3 The Hotel Beale once owned by Andy Devine's parents.

4 Kingman Drug Store on the corner of 4th Street.

5 Casa Linda Cafe, where the locals walked to lunch.

6 Desert Drug on the corner of 3rd Street, where Burf (who lived just 20 feet south of the railroad tracks) always "picked up" his Havatampas; the Frontier Cocktail Lounge and Cafe, and the Brunswick Hotel.

7 Kingman Lumber Company, Kingman's original Home Depot.

8 Oswalt's Restaurant for a swanky meal, Kingman style.

9 You could fill up at McCarthy's Texaco and grab a Dilly Bar at the DQ.

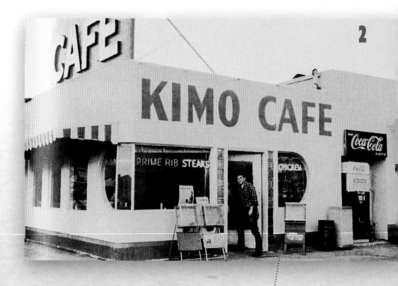

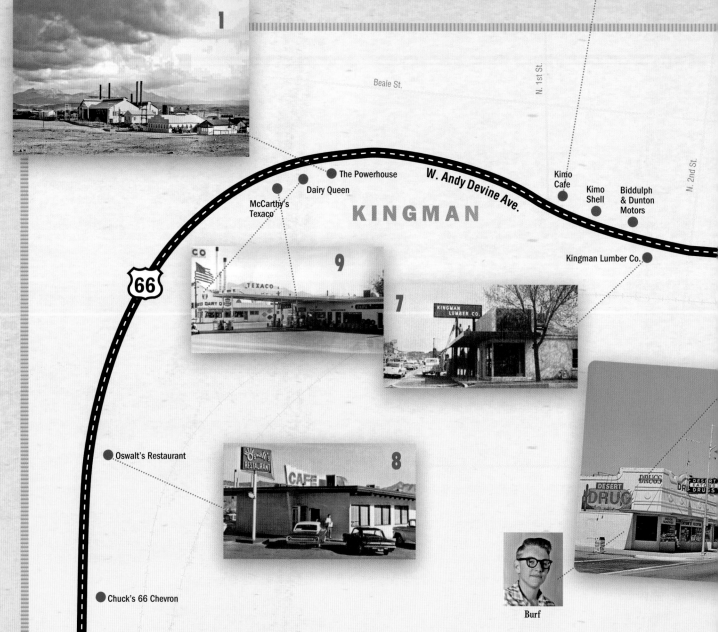

Burf

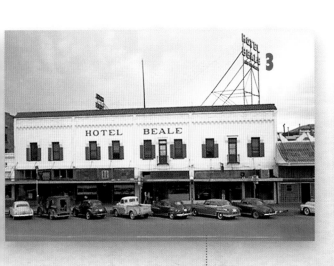

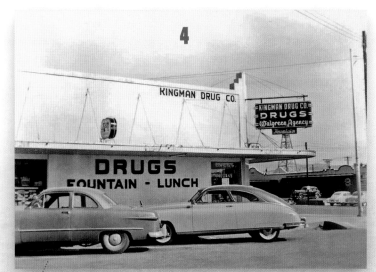

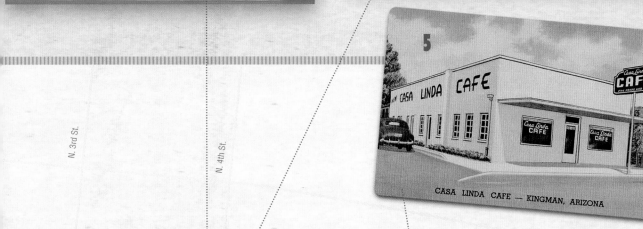

N. 3rd St.

N. 4th St.

Potter's Union Service Station

Desert Drug

Frontier Cafe

Old Trails Garage

Brunswick Hotel

El Mohave Mexican Food

Beale Motel

Kingman Drug

White House Cafe

Kingman Newstand

Britt's Texaco

Graves Chevron

Casa Linda Cafe

Coffman Motors and Shell

Kingman Cab Co.

Atcheson Topeka & Santa Fe Depot

E. Andy Devine Ave.

66

KINGMAN

4th St.

6th St.

DIRECTORY

Chucks 66 Chevron

Oswalt's Restaurant

"Charlie" McCarthy's Texaco Station

Dairy Queen

Citizens Utilities Electric Power Plant (now The Powerhouse)

Kimo Cafe & Kimo Shell
105 Andy Devine

Biddulph & Dunton Motors
119 Andy Devine

Kingman Lumber Co.
120 E. Andy Devine

Cozy Corner Cafe
120 E. Andy Devine

Potter's Union Service Station
229 Andy Devine

Desert Drug
301 Andy Devine

Frontier Cocktail Lounge/Cafe
303-305 Andy Devine

Old Trails Garage
311-15 Andy Devine

Brunswick Hotel
315 Andy Devine

Santa Fe Train Depot
316 Andy Devine

El Mohave Mexican Food
319 Andy Devine

Beale Hotel
325 Andy Devine

Kingman Cab Co.
328 Andy Devine

Kingman Drug Store & Fountain
401 Andy Devine

White House Cafe
401 Andy Devine

Kingman Newstand
405 Andy Devine

Britt's Texaco
425 Andy Devine

Graves Chevron
501 Andy Devine

Casa Linda Cafe
511 Andy Devine

Coffman Motors and Shell
543 Andy Devine

Peggy's Kitchen
601 Andy Devine

1 Hillcrest Motel. On hilltop, where else.

2 Lockwood Cafe, where the good-looking girls ate Chicken-In-The-Rough.

3 Wal-A-Pai Court, not Hualapai or Walapai.

4 Brakeman's Mobil, where Pablo took his Olds for gas.

5 Stony Wold, not Stony World. But could have been.

6 The Jade Chinese Restaurant, lots of Cadillacs parked out front.

7 The El Trovatore Restaurant, Bar, and Motel.

8 Al Bell's Phillips 66, BBB's dad almost made it here.

9 Bell's Motel, where Salty & Punchy grew up. And Karen, too!

10 Al Bell's Flying A, where BBB iced jugs—free.

11 The City Cafe, where you could listen to *Ring of Fire* on the counter-top jukebox.

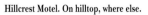

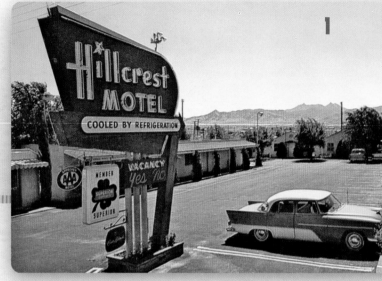

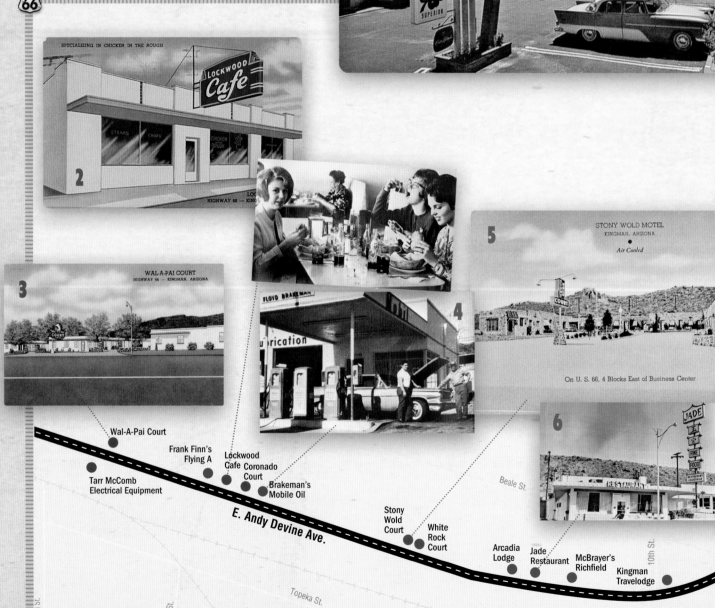

SPECIALIZING IN CHICKEN IN THE ROUGH

LOCKWOOD Cafe

STEAKS CHOPS CHICKEN IN THE ROUGH

HIGHWAY 66 — KINGMAN

WAL-A-PAI COURT
HIGHWAY 66 — KINGMAN, ARIZONA

FLOYD BRAKEMAN

STONY WOLD MOTEL
KINGMAN, ARIZONA

Air Cooled

On U. S. 66, 4 Blocks East of Business Center

JADE
FINE FOOD
RESTAURANT
COCKTAILS

RESTAURANT

Wal-A-Pai Court

Frank Finn's Flying A

Lockwood Cafe

Coronado Court

Brakeman's Mobile Oil

Tarr McComb Electrical Equipment

E. Andy Devine Ave.

Stony Wold Court

White Rock Court

Beale St.

Arcadia Lodge

Jade Restaurant

McBrayer's Richfield

Kingman Travelodge

10th St.

Topeka St.

ROUTE 66

ROUTE 66

10

JUGS ICED FREE

Tydway CAFE

11

CITY CAFE

9

Bells Motel
U.S. 66, East entrance, Kingman, Arizona

Jefferson St.

Al Bell's
Flying A and
Tydway
Cafe

Kingman Motel

Smokehouse Cocktail Lounge

Bell's Motel

Hillcrest Motel

Stubb Shaeffer's Humble

Tommy's Market

Hood's Court and Market

Finch's Texaco

Motel Siesta

City Cafe

Imperial 400 Motel

Hilltop Motel

8

Al Bell's Phillips 66

PHILLIPS 66

Iron Motel

Cafe

El Trovatore
Motel, Bar,
and Restaurant

7

EL TROVATORE
RESTAURANT
SMORGASBORD
EVERY SUNDAY

RESTAURANT

Hall St.

grounds Ave.

500 Ft.

DIRECTORY

Tarr McComb & Ware Inc.
614 Andy Devine

Wal-A-Pai Court
617 Andy Devine

Frank's Flying A
703 Andy Devine

Lockwood Cafe
709 Andy Devine

Mohave Indian Store Novelties
713 Andy Devine

Richfield Oil Corp
716 Andy Devine

Coronado Court
721 Andy Devine

Brakeman's Mobil Service
729 Andy Devine

Stony Wold Court
843 Andy Devine

White Rock Court
843 Andy Devine

Arcadia Lodge
909 Andy Devine

Jade Restaurant
937 Andy Devine

McBrayer's Richfield Service
941 Andy Devine

Kingman Travelodge
1001 Andy Devine

El Trovatore Motel

Al Bell's Phillip 66 (1963–1966)

Hilltop Motel

Imperial 400 Motel
1911 Andy Devine

Antler's Garage
1919 Andy Devine

Finch's Texaco
1921 Andy Devine

Motel Siesta
1926 Andy Devine

Brainard Richfield
1945 Andy Devine

Hood's Court and Market
1950 Andy Devine

Tommy's Market
1960 Andy Devine

Astro Motel
1967 Andy Devine

Stubb Shaeffer's Humble
1976 Andy Devine

Kingman Motel

Bell's Motel

Hillcrest Motel
2018 Andy Devine

Al Bell's Flying A &
Tydway Cafe
2015 Andy Devine

Smokehouse Cocktail Lounge
2030 Andy Devine

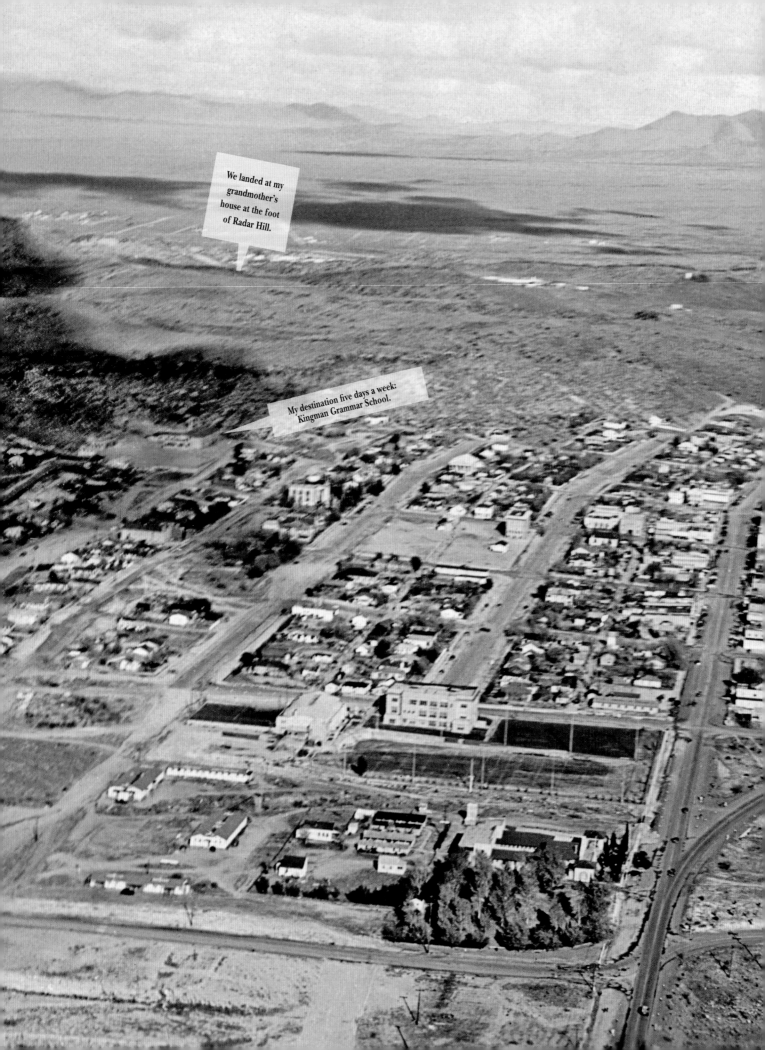

We landed at my grandmother's house at the foot of Radar Hill.

My destination five days a week: Kingman Grammar School.

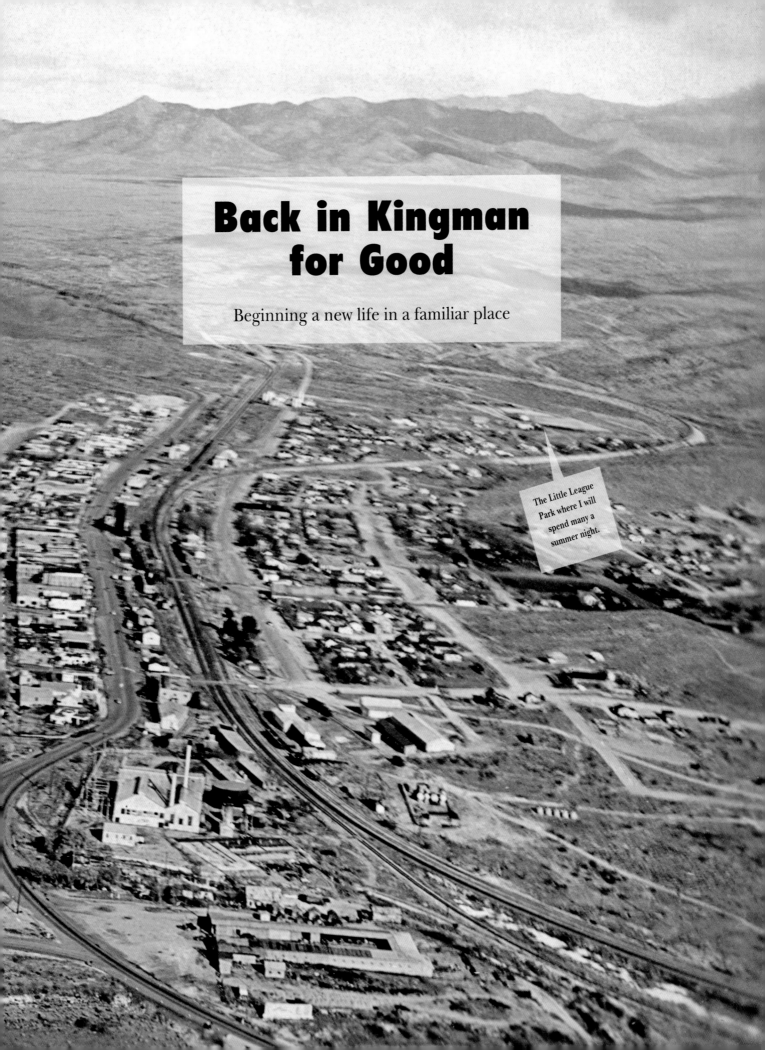

Back in Kingman for Good

Beginning a new life in a familiar place

The Little League Park where I will spend many a summer night.

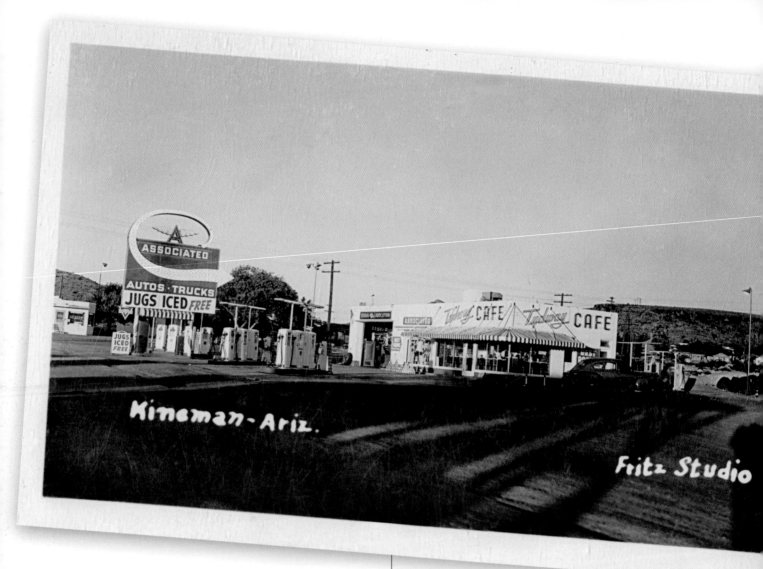

LANDING AT THE FOOT OF RADAR HILL

In January 1956, we moved again from Iowa, this time to my grandmother's house at the foot of Radar Hill on Jefferson Street in Kingman. We lived in her small, one-bedroom house for several months while my father ran the Flying A all by himself. (My mother would take him dinner and supper, two midwestern terms I soon had to discard since in the West they were called lunch and dinner.)

It was a very slow start; my dad said he only took in $2 the first day. In due time, business picked up considerably, and by the summer of 1956 he had to hire four pump jockeys. He was making close to $100 a day, which was pretty sweet for that time and place.

My parents slept on a makeshift bed and I slept on a roll-a-way in the living room. At this point, I got it in my head to read a page of the Bible every night before going to

sleep. I found it tough reading, but my mother loved it and announced to her family that I was going to be a minister when I grew up. Given my motor-mouth tendencies, I don't think anyone thought it was a stretch.

A couple of months into this arrangement, something caused a rift between my grandmother and my father. "Allen Bell, I will break you," was the statement attributed to my grandmother. I never knew how it all came about, or why, but it upset me because I loved them both.

My parents found a house on Ashfork Avenue and were able to qualify for a loan with the GI Bill. It was a stretch, because the asking price was $6,500 for the two-bedroom house. They took the leap and we moved into the first house my parents actually owned.

FLYING A SIGN WORSHIP

When we moved back to Kingman in January of 1956 my father took over a new kind of super station, a Flying A with a big arrow that lit up and came on in an animated motion, calling out to everyone on Route 66 to *Come On In!* I was so taken with the sign, that one night, while up at my grandmother's house on Jefferson Street, my cousin Robert Jerl Stockbridge and I stood out in the cold and just watched the sign do its thing.

And yes, I am wearing my Little League uniform in the above painting. I was so proud of being on a team—The Oddfellows Yankees—I often wore it to family functions. I know, weird, but hey, I was a weird kid. Well, maybe not by Kingman standards, but you know what I mean—a little odd.

ODD FELLOWS YANKEES — One of the strongest teams in the Kingman Little League and winners of a second place tie with the Elks Cardinals in the second half, are the Odd Fellows Yankees, pictured above. Front row, left to right, are Neal Pascoe, Paul Torres, Danny Myers, David Cox, Steve Bradley, and Gary Brock. Second row are Dale Nichols, Gene Brummett, Dennis Paulson and Robert Bell. The team was managed by Jim Pascoe and coached by Dick Brock.
(Gallup Photo)

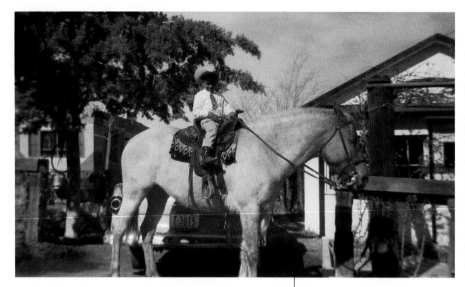

Robert Jerl Stockbridge aboard Cleo in front of my grandmother's house on Jefferson Street. You can see how the small boy would have a rough time controlling big ol' Cleo. That is my father's Ford behind Cleo. My grandmother and Ernie used the travel trailer at left to camp on the Mogollon Rim in the summertime. My grandmother would pay me $20 to water her plants while she was gone. She had grapes growing (at right).

A HORSE NAMED CLEO AND A DOG NAMED PAL

Before we left for Arizona, my dad promised that I would have a dog and a horse when we got to Kingman. The horse turned out to be Cleo, my cousin Tap Lou Duncan's mare that was kept in a small stable on the hill behind my grandmother's house. It was my job to feed Cleo twice a day and make sure she had water.

On weekends, my cousin, Robert Jerl, and I would saddle her up and play Indian attack. While one of us rode out toward Arnold D's house and back up the foothills of Radar Hill, the other would climb on the roof of the tack room and pretend to be a soldier sentinel, warning the rider that Apaches were attacking. Then the kid on the horse would gallop back to the stable so we could trade places and the other scout could ride out.

For the first three or four runs, Cleo would naturally plod out from the corral. When we later turned her toward home, she would lope back to the barn as most horses are prone to do—I believe it's called "barn sour." By the fourth time, with Robert Jerl on her, Cleo tired of the routine.

When he turned her for home, Cleo took a shortcut and jumped a small wash. On the subsequent gallop, Robert Jerl started going airborne. And by the third jump, my cousin flipped in the air and landed face-first in the dirt.

As the sentinel on the roof, I watched this in horror, but continued to make rifle noises with my mouth so the Apaches wouldn't get him.

Robert Jerl was crying as he got up, and his face was red with blood. I ran down to the house to get an adult. It turned out not to be as bad as we feared, but that was the end of our playing Indian attack on horseback.

Around this same time, a man brought a box of puppies into my dad's gas station and put them on the floor in the office. As I looked at the cute little mutts, my father told me to choose one. I picked up a little spotted, black-faced noodle and petted him as he snuggled into my neck. One of the pump jockeys suggested I call the dog "Pal" because that was what he would be. I took the advice and Pal was my dog, following me on my bike everywhere up and down Ashfork Avenue.

One day, when the late-summer traffic on Route 66 was especially heavy, I was riding my bike home from the station toward our house. Where the apron for the gas station ended, there was a small bike path right along the highway that I had to travel before angling off back to the dirt roads west of the highway.

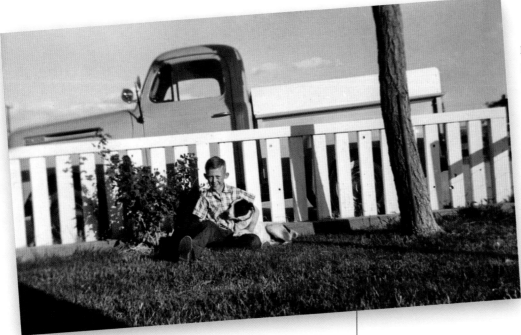

Pal and I huggin' it up in the front yard of our Ashfork Avenue house. The '49 Ford was one of the many rides my father had at the time. My mother said the street in front of our house resembled a car lot at times because of all the vehicles my dad would buy from friends and broke tourists.

As I peddled along, Pal saw a jackrabbit and chased it as it angled out on the roadway. A car hit Pal head on and ran over him. The horrified people stopped and got out, but Pal rolled several times, jumped up, and, trailing blood, ran all the way home.

My father got home before I did and we found Pal in the side yard, coughing up blood. The vet came and cleaned him up, examined his abrasions (incredibly he had no broken bones), and said he didn't think Pal would make it through the night. I worried all night. But in the morning, Pal, looking even worse than before (bloated, bruised, and with one eye swollen shut), was still breathing.

Pal lived to fight another day and we had many adventures together. Unfortunately, while I was at school and my parents were working, Pal started running with a pack of neighborhood dogs and got into it with a porcupine out near Doc Arnold's house. Someone found him on the side of the road and called the number on the tags.

Again, the vet was called, and this time my father had to hold Pal with a rolled up newspaper jammed into his mouth so the vet could pull out all the quills with a pair of pliers. It took about an hour, and Pal was traumatized by the painful experience. So was I.

I remember my dad joked that hopefully Pal had learned a lesson. But the vet shook his head and said that not only do most dogs not learn, but they go back and seek out more porcupines.

This time the vet was right. Not long after, Pal showed up briefly with his face full of quills again. But now, he wouldn't come close.

We never saw him again.

The Flying A office where I got my dog, Pal.

> ## "Nothing is illegal if a hundred businessmen decide to do it."
>
> –Andrew Young

SERVICE WITH A SMILE

With the rise of the full-service gas station in the 1950s, four men met every car that pulled in off the road during the summer season—from Memorial Day to Labor Day. They wore uniforms with their name stitched over their hearts and they walked out with lockstep precision.

The first guy asked if the customer wanted to fill it with "Flite-fuel" or "100+ Octane." (We had names for our gas back then, names that promised, "You put this in your car, Jack, and you're going to fly, baby!") The second man checked the air pressure in all the tires, even asking to check the spare in the trunk because, well, you're about to cross the most dangerous desert known to man. The third guy washed all the windows. And the fourth guy went under the hood and cut the fan belts.

I jest, of course. My dad didn't run that kind of operation, but a few gas stations in Kingman (and all along Route 66) did. Some of these con men were legendary. A certain Chevron station owner in Kingman was so wealthy that he allegedly had maids at his house. Tire sales were his crew's specialty. They would inspect the tires, spot "a problem," and ask if they could pull the tire to

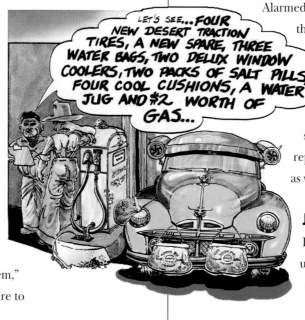

check it. Once the tire was off, they would find the seam on it and press it down with the tire changer to exaggerate it. Then they'd tell the owner the seam was bad and he wasn't going to survive the trip across the Mojave Desert. They reportedly even sold new tires (four AND a spare) to people who were driving brand-new cars.

But the most amazing story I ever heard involved batteries. Two of the best con men were bragging about their "salesmanship" and one said he could sell anybody a battery. The other guy took up the bet, but said he would pick the customer. When a savvy-looking family man pulled in the outside lane, the bet taker said, "You're on." The first guy ran to the car and yelled to the family to get out. Alarmed, they did. The guy went under the hood, cut the battery cables with bolt cutters, removed the battery, and threw it across the driveway, where it exploded. He not only won the bet and sold them a new battery, but he reportedly sold them a set of new tires as well.

Jugs Iced Free

I was the fifth guy. I didn't have a uniform, but I wore my Little League cap and it was my job to ask, "Do

you have any jugs you'd like iced?" I was only nine, but I practiced this line over and over. Of course, I blew it on the first customer: "Do you have any ice you'd like jugged?" That got a big laugh from the customer, a Texan, who tipped me a quarter! I was stunned and very happy. Wow! This was easy and fun, and you got money for it.

The next four customers stiffed me and one even told me to get lost—he smelled a tip hound and was having nothing to do with it. I quickly learned that teachers tip the worst. (I know this because my family is full of bad-tipping teachers, perhaps due to how little money they made. Or maybe they were just cheap.) And Texans generally tipped the best, although they could also be tight.

That summer I saved all my tips (over $10!) and ordered a book I saw for sale on the pages of *True West*, my favorite magazine. The book was Ed Bartholomew's *Biographical Album of Western Gunfighters* and it sold for the crazy price of $11. For a book! My other friends who were cutting weeds and delivering newspapers were going to buy bikes or cap guns with their earnings, but not me. I wanted this huge and historical book that was going to tell me the truth about all these gunfighters I was seeing on TV every night.

SERVICE STATION CON MEN TACTICS ON ROUTE 66

Eastbound cars that just came up the long, tough grade from Needles to Kingman:

· Pop the radiator cap half-way, let all the water and coolant run out on the driveway, and then sell them a radiator flush, saying that the clogged radiator had caused the overheating. If that didn't work, they were always good for a gallon or two of coolant to replace what had run out.

Westbound cars, particularly with drivers with eastern license plates who expressed some fear about crossing the great Mojave Desert for the first time:

· "You did buy the special desert tires for this trip, didn't you?" the con man would ask. Then he'd sell them a new set of tires.

SCAMS FOR EVERYONE

· A shot of oil on the outside of the fuel pump would make it look like it was leaking.

· A shot of oil on a shock absorber would make it look like it had blown.

· BBs in battery cells would deaden a battery and Alka-Seltzer would make it foam.

· A small sharpened screwdriver (called a razoo) would cut slits in the tire treads and make the tire look like it was cracking. And no one in his right mind is going to cross the desert with cracked tires.

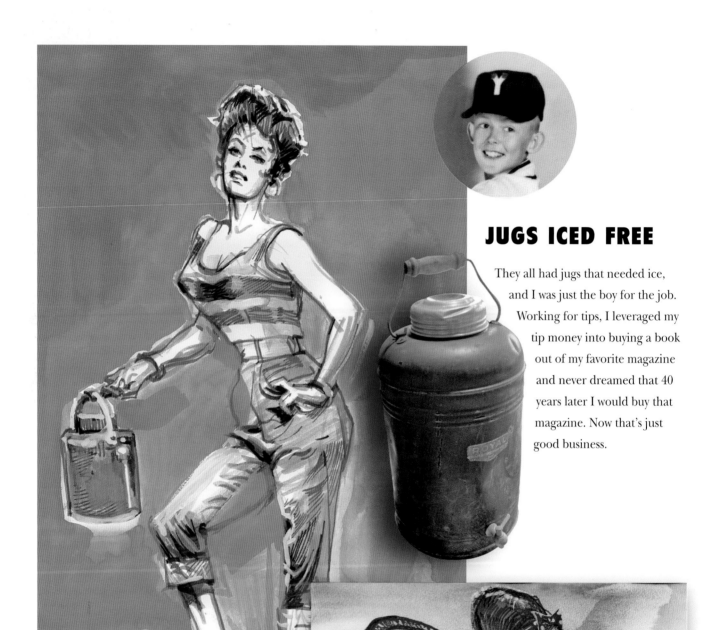

JUGS ICED FREE

They all had jugs that needed ice, and I was just the boy for the job. Working for tips, I leveraged my tip money into buying a book out of my favorite magazine and never dreamed that 40 years later I would buy that magazine. Now that's just good business.

"Gina Lollabrigida wasn't built in a day."

—Jimmy Durante

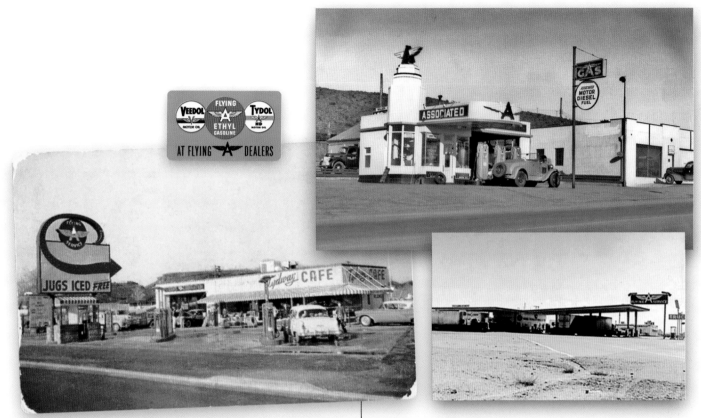

Top left: Flying A dealer hand-out card
Left: Al Bell's Flying A and Tydway Cafe
Top right: Frank Finn's Flying A
Above: McConnico Truck Stop Flying A

THE RISE AND FALL OF FLYING A

Associated Oil started in 1900 as a pipeline company, distributing gasoline along the Pacific Coast and in Hawaii. In 1926, Associated merged with Tide Water to form Tide Water Associated Oil Company and creating the Flying A brand. After the merger, J. Paul Getty became a major shareholder and the company began expanding aggressively, amassing 15 ocean tankers, 9 harbor tankers, 1,579 railroad tank cars, and 1,067 truck tankers.

For some reason, the company built three impressive gas stations in the Kingman area, including Al Bell's Flying A, Frank Finn's Flying A, and a large truck stop at McConnico. Why they invested so heavily in this remote area is unknown, but in 1966, the U.S. government broke up Tide Water on antitrust grounds and Getty was forced to sell its western division to Phillips 66 (my father's next station). The last Associated Gas Station closed in 1970.

HISTORY DETOUR

The First Drive-By Shooting

Four or five times a year, artist Ed Ruscha would drive from L.A. to his parent's home in Oklahoma. In 1962, Ruscha photographed a series of gas stations on Route 66, including the Flying A Truck Stop at McConnico. Utilizing very little text, Ruscha published a numbered edition of 400 books in April of 1963. The book, *Twentysix Gasoline Stations*, sold for $3.50. An art critic said the book "combined the literalness of early California pop art with

a flat-footed photographic aesthetic informed by minimalist notions of repetitive sequence and seriatlity." Today, an original copy of the book sells for $35,000.

> # "And yes, we do have
> # gold in our gas."
>
> —BBB

SIXTY-TWO MILES TO HELL

Throughout my gas station career, we got several questions all the time from customers. The most common and persistent was, "Do you have gold in your gas?"

The average price of gas in Kingman in those days was 40 to 45 cents a gallon. (Whiting Brothers stations were cheaper at about 29.9.) Prices back east averaged about 20 cents a gallon, and many tourists traveling on Route 66 thought our gas prices were outrageous, even criminal.

So, we often got "runners." Most stations had long, rubber tubes stretched across the driveway, and when a car's tires drove over them, a bell would ring in the lube room to alert the pump jockeys of a customer. We'd start out to the pumps only to see the car careening back out on the road, fleeing our price-gouging pumps. Occasionally, the driver would even extend us the middle-finger salute.

Funny thing is, even those who did stop for gas invariably said the same thing as soon as they got out of the car: "Have you got gold in your gas?" They always thought it was so original and funny, but we literally heard this line 10 times a day. I often wanted to respond with, "Hey, that's the first time I've heard that one—TODAY!"

The second question we always got from people westbound on 66 was, "How far is it to California?" The answer was 62 miles. Hearing that, the customer usually would give a disgusted grunt and add, "Good. I can't wait to get out of this God-forsaken desert."

To a man—and they were invariably men—they obviously were imagining bikini-clad surfer girls lounging next to the "Welcome to California" sign as cool Pacific Ocean breezes caressed their collective cheeks.

What we didn't have the heart to tell them was that while the border of California was in fact only 62 miles away, they were about to descend into the blasting furnace of the Mojave Desert. And that the armpit of that furnace was Needles, the first town across the Colorado River. There, it likely would be 122 degrees in the shade with humidity through the roof. Perhaps the only more disagreeable places in the summer were Blythe or Yuma, both further south along the river on the Arizona-California line.

Instead, I responded thusly, with as much sincerity as I could muster: "I hope you get a chance to linger there, sir."

A canvas bag full of water draped across the front bumper was a desert-crossing must. The water would seep out of the bag and the rushing air would keep the water cool and sort-of refreshing.

Saturate Before Using

DESERT
· BRAND ·
REG.U.S.PATENT OFF.

TRADE MARK
REGISTERED

WATER BAG
MADE BY
AMES HARRIS NEVILLE CO
San Francisco U.S.A.

THE GRAVEYARD SHIFT

After Memorial Day many service stations along Route 66 would stay open 24 hours. Summer vacation students or seasonal "night men" would be hired to work the overnight shift. They were usually loners and laconic types. Allen Bell's favorite night man was a guy named Scotty. I never knew his last name. Scotty was meticulous, friendly, but rather shy. He lived alone in an apartment and walked to work at the gas station.

Out on the road, the traffic was lighter than in the daytime, but many cross-country travelers preferred driving at night when it was cooler, especially across the desert. Business was slow but steady until the wee hours, when a good night man would use the downtime to clean the restrooms and the driveway. One summer night man, Dan the Man, describes how he filled the time:

"It was busy until around ten and then my good friend—Box-Lip Darrell—would stop by and we'd raid the pop machine since I had the keys, and drink a couple of orange sodas. And I'd pump a couple of free gallons of gas in his '50 shoebox Ford. We gave a discount to local people, I'm guessing 10 cents per gallon. We had to write down the discount on a piece of paper kept by the cash register. So I'd make up some discounts equal to how much gas I put into Box-Lip Darrell's car, so it all came out even. About 11:30 every night I had to wash down the drives by the pumps. I would squirt some high-octane onto the concrete and using a push broom scrub the drives. It worked great and cleaned all the daily oil leaks off. Then I'd mix in some Tide and water to nullify the gas, then hose everything into the gutter on the highway. The only thing that scared the hell out of me was when someone would pull onto the drive when it was full of raw gas and they'd get out of their car smoking a cig. Lucky for me and them the gas never caught fire.

"I remember one night, I was ready to close up, probably about 11:45, and a car pulled in with his windshield an inch thick with smashed grasshoppers. He didn't want gas, just his windshield cleaned. I started scrubbing it and by the time I was done I had about ten more cars lined up with windshields covered in grasshoppers. I ran over to turn off the lights to show we were closed, but I was there 'til 12:30 scrubbing windshields. And nobody bought any gas—they said the price was too high; they went on down the highway, as if they would find gas in Kingman any cheaper. Ha!"

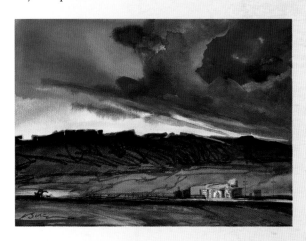

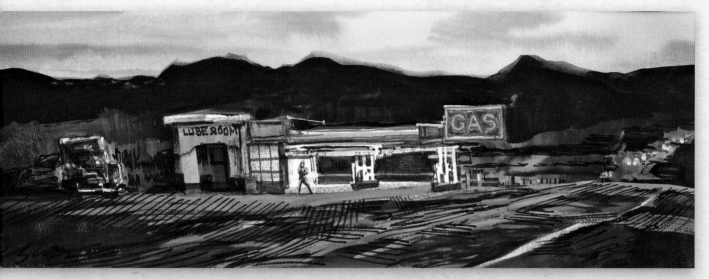

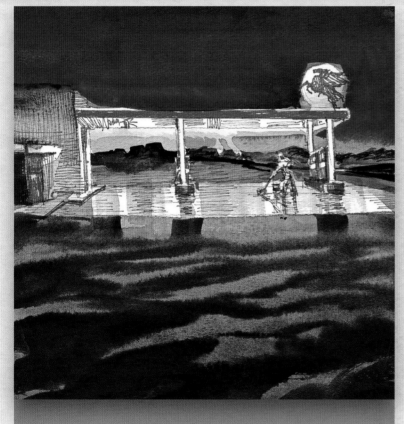

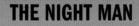

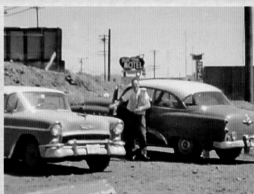

THE NIGHT MAN

"When I opened the far left stall door, there was the night man. His pants were down around his ankles and he was passed out drunk, half on and half off the toilet and leaning on the wall. I tried to wake him up, but he was completely out. I called my boss, Ron, and told him what was going on. He said he'd be right down. He called the cops and they hauled the guy off to jail."

—Bugs, on night man behavior

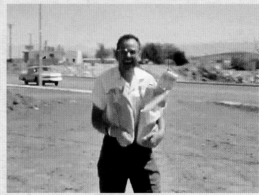

Night man Scottie coming to work with his night time goodies.

WRONG SIDE OF THE TRACKS

Kingman wasn't perfect. Like most of America in the 1950s and 1960s, there were still pockets of racism in every region of the country (some would argue there still are). My mother had very strong ideas about racial issues: White people good. Others, not so good. As a Christian, this made no sense to me.

One of the oft-told Guess family stories is about my grandfather, Bob Guess, riding in a wagon through a pass near Lordsburg, New Mexico, when two Mexicans jumped him and tried to knife him. My mother would claim it was this incident that soured her on all Mexicans. Not my favorite family story, but one of the stories told, nonetheless.

In fourth grade, a black kid named Doyle enrolled in the middle of the school year. His dad was stationed at the radar base and the family rented a house around the corner from my aunt and uncle, the Hamiltons. Doyle invited me over to play. He had cool toys, his mom made us lunch, and I had a great time.

When I got home, my mother had a cow, and she demanded that I not play with him. When I asked why, she said I'd understand when I grew up. Well, Mom, it's been 58 years and I still don't understand.

Doyle's family moved shortly thereafter, and it was rumored that the town fathers pressured the Air Force to make them go away.

Often, when I would go downtown to the junior high on weekends to play basketball, I would be the only white kid there. When my mom would come to pick me up, she'd inform me that I couldn't go back, saying it was too dangerous.

I never stopped going, and I never had a problem. While there occasionally were fights among the Hualapai and Mexican kids who hung out and played there, they always left me alone, probably because they thought I was harmless.

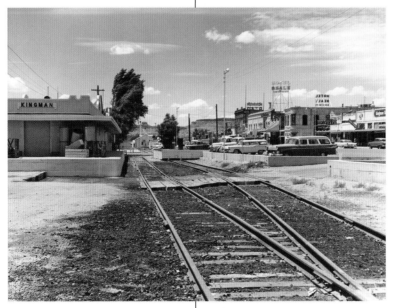

Santa Fe Depot and tracks, Kingman

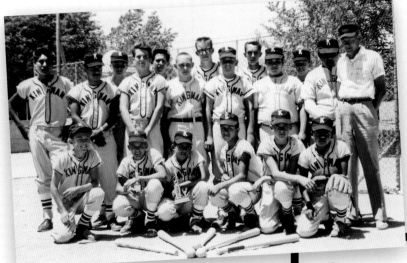

While Kingman lacked African-Americans, the sports teams, at least, had a very rich ethnic mix of Native Americans, Mexicans, cowboys, and at least one midwestern refugee from Iowa. This photo is of my junior high baseball team, 1961. Our coach, Les Byram, (far right) would serve as Mayor of Kingman for several terms.

Grapes of Wrath

HISTORY DETOUR

In John Ford's classic film *The Grapes of Wrath* (1940), the Joad family—Dust Bowl refugees—are shown migrating across Arizona on old Route 66 (which was dirt, by the way, at the New Mexico border). As they come into an inspection station, a not-so-friendly Zonie tells them to "keep moving." Ah, Arizona. Where everyone is welcome except for Mexicans, Indians, Blacks, Okies, and Democrats. Especially Democrats.

THE DOPER ROPER CLEANS UP COUNTY

Mohave County cowboys had a tough time accepting non-conventional types with long hair and—heaven forbid!—bellbottom pants! I know this because, as a member of a rock band, I found myself in the crosshairs more than once. I wasn't alone. I created the character The Doper Roper in 1972 as a reaction to the bellicose attitudes of my Kingman cowboy cousins and their disbelief at my betrayal of the manly traditions of the past. Grantham P. Hooker, or D-R, as we called him for short, was based on several Kingman area cowboys, most notably Buzzy Blair.

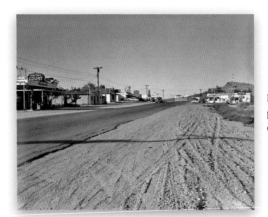

Looking west on Route 66 as it passes through Hilltop east of downtown Kingman.

A TOWN PULLS TOGETHER

My mother's penchant for fussiness when it came to whom I played with wasn't always wrong, and in one incident, at least, I believe she saved my life.

A troubled boy came to Kingman and a local family more or less adopted him and tried to give him a good home. His name was Larry and he had a rough background we never were privy to, but it was understood he had issues. Larry was in my Boy Scout troop and one weekend he called and asked if my mother would drive me down to his house to play. My mother thought about it and said no.

The boy who did go, Michael (pronounced Michele) Flores, was playing at Larry's house when they found a loaded pistol in the house, and while horsing around, the pistol went off, striking Michael in the head. Michael was transported to a hospital in Las Vegas, and before he died, some staggering medical bills were run up in the short time he was there. His family had no money and the hospital soon started threatening to sue. Charlie McCarthy, the mayor of Kingman at the time, and several other townsmen, including Joe Torres, Frank Esquibel, and Dick Waters, put together

a fundraiser and raised several thousand dollars. It still wasn't enough to cover the medical bills. So, Waters and McCarthy set up a meeting in Las Vegas with the hospital and gave those in charge an ultimatum: Either take the money they had raised and sign a release, or read about how a greedy Las Vegas hospital was trying to ruin a grieving family. After consulting outside the meeting room, the hospital agreed to the terms, signed the agreement, and took the check.

A small town had pulled together to help a Hispanic family. This is a story I am proud of and makes me glad to be from Kingman.

Michael Flores drew the best flames.

96

FIVE BABYSITTERS WHO CHANGED MY LIFE

Funny what impact a babysitter can have on a kid, both good and bad. While numerous people have come up to me over the years and told me that they babysat me when I was little, for the life of me I can't place them. On the other hand, there were a handful of babysitters who literally changed my life.

MRS. HOLMES

Mrs. Holmes—I'm not even sure of the spelling of her name—was my babysitter when we lived south of the tracks in Kingman in 1949. I remember posing for the photo of the two of us sitting on her back steps. Although I can't recall anything she said, or believed in, she conveyed a real sense of warmth and love that I can still feel today. She was very supportive of my hyper-active imagination, and I distinctly remember running to the corner of her yard and climbing the fence brace to yell at the passing trains. She was strong and calm, and I am lucky to have known her.

DON'T FORGET WINONA

My Hualapai babysitter in Peach Springs likewise had a profound effect on me, and I don't even remember her name. I just know I have a deep respect and admiration for the Hualapai people and she must have communicated that through her actions and caring ways.

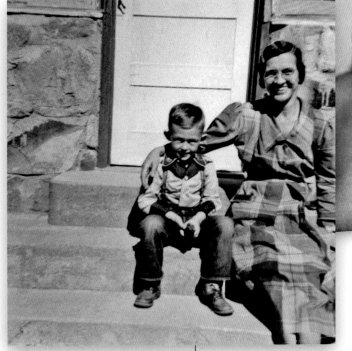

Above: Winona probably looked like this, at least in my mind.

Left: Here I am dressed in my cowboy shirt, sitting on the stoop with Mrs. Holmes.

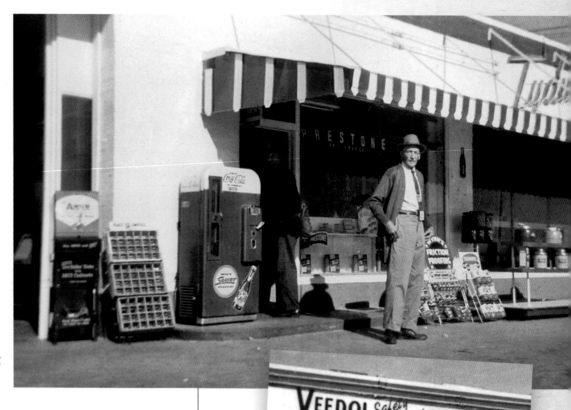

LIPPO ASMUS

A Norweigan farmer from Thompson, Iowa, Lippo babysat me during my mother's second childbirth trauma.

My grandmother Minnie was at Mayo Clinic in Rochester, Minnesota., with her own medical issues and I got farmed out to Lippo, whose wife, Annie (my grandfather's sister), was also out of town. So Lippo and I "bached it" (Midwest slang for bacheloring). Lippo entertained me with a box of old stereoscopes and allowed me to ride his Allis-Chalmers, promising to drive it to my school so I could show my friends. (It was a blatant lie, by the way, but it didn't matter. I loved the guy.)

The biggest influence Lippo had on me is that he burned the toast. On those old-time toasters, you had to manually open them when you guessed the bread was done. Annie probably did the toast chores every morning, but she wasn't there, so Lippo burned it good. And by good, I mean it was great! I loved Lippo's burnt toast, and later insisted my mother burn our toast the same way. She couldn't, of course. And my dad always laughed when telling how I often told her, "This burned toast isn't as good as the burned toast Lippo makes."

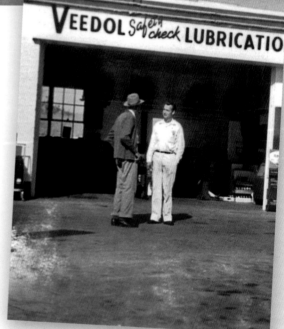

Top: Lippo Asmus and Carl Bell (at door) in front of Al Bell's Flying A station. Lippo and Carl drove out to Arizona together. along with their wives, in 1957. They once farmed together as bachelor farmers and were the inspiration for my cartoon strip "Lippo and Pagoona," at right.

Above: Lippo gabs with pump jockey and master salesman Tom Booth who worked at my Dad's station.

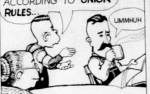
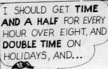
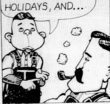
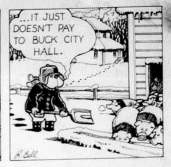
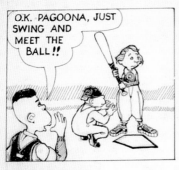
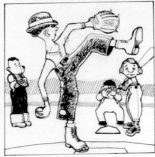
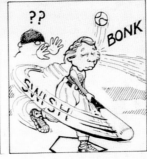
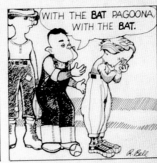

I thought so much of Lippo that in the early 1970s I created a comic strip called *Lippo & Pagoona*, about a farm in Iowa. I spent 500 hours developing it, only to be told by the *Des Moines Register* Syndicate, "Farm strips don't sell." So, the comic was toast.

"You're born, you die, everything in between is open to interpretation."

–Good Ol' Ben Rux

GOOD OL' BEN RUX

Before we moved back to Iowa, my dad had one of the old guys who hung out at the gas station babysit me one day when my mom was working. My regular sitter, Mrs. Holmes, apparently wasn't available, so my dad called on an old miner named Ben Rux to watch me for an afternoon.

Ben lived in a shotgun shack across the tracks and around the corner from Mrs. Holmes. I remember he had zero furniture and that I sat on a small landing in the back of the one-room apartment.

I must have been very young because I remember fussing on the floor. Perhaps in desperation he brought out a tin can full of silver dollars and let me play with it. I, of course, loved the clanging sound and spent some time throwing everything on the floor and then putting the big silver dollars back in the can, one at a time. Then I'd do it all again, over and over, watching with fascination as some coins rolled across the room and clanked to a stop

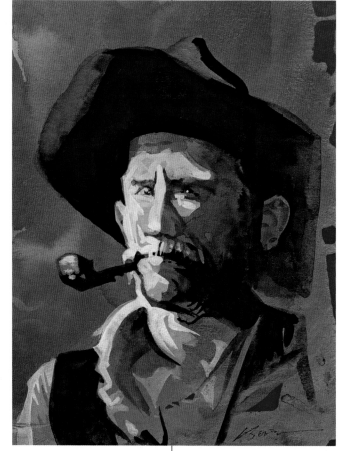

Good Ol' Ben Rux as I remember him.

along the wall. It kept me amused the entire time I was there, and in my mind it was the coolest toy a kid could ever have.

I couldn't tell you what Ben Rux looks like, and I can't remember anything he said. But he impressed me. I attribute sayings to him throughout this book, but I doubt he ever said them. To me, he embodies old Arizona, when mining was king and you gambled with your life even being out here.

Here's to you, good ol' Ben Rux. I hardly knew you, but I will never forget you.

But my fifth babysitter is the one who gave me my burning desire to find out the truth about legends of the Old West.

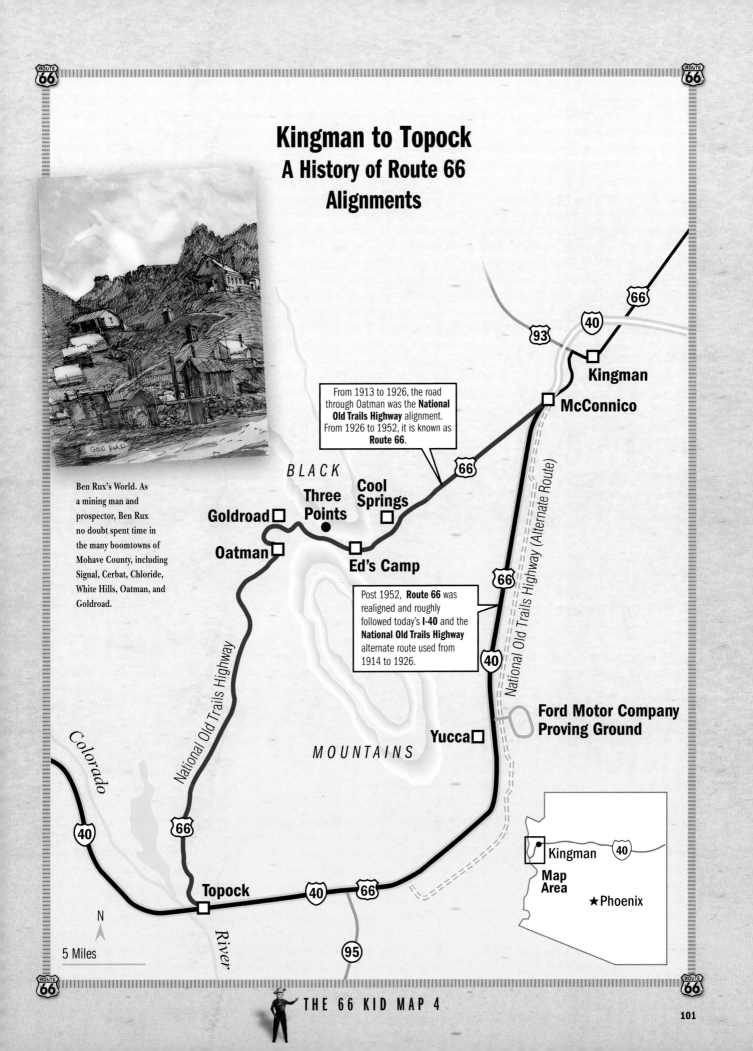

Kingman to Topock
A History of Route 66
Alignments

From 1913 to 1926, the road through Oatman was the **National Old Trails Highway** alignment. From 1926 to 1952, it is known as **Route 66**.

Ben Rux's World. As a mining man and prospector, Ben Rux no doubt spent time in the many boomtowns of Mohave County, including Signal, Cerbat, Chloride, White Hills, Oatman, and Goldroad.

66

93 **40** **66**

Kingman

McConnico

BLACK

Three Points

Cool Springs

Goldroad

Oatman

Ed's Camp

Post 1952, **Route 66** was realigned and roughly followed today's **I-40** and the **National Old Trails Highway** alternate route used from 1914 to 1926.

66

National Old Trails Highway (Alternate Route)

National Old Trails Highway

40

Ford Motor Company Proving Ground

Yucca

MOUNTAINS

Colorado

40

66

Topock

40 **66**

River

N

5 Miles

95

Kingman **40**

Map Area

★Phoenix

Related to Outlaws

Worried about the back trail

> ## "A typical Westerner will punch you in the face if you call his father a crook, but he'll brag a little when he tells you his grandaddy was an outlaw."
>
> —Good Ol' Ben Rux

AND THEN THERE WAS THE BABYSITTER WHO LIT THE FUSE

I loved to go to my grandmother's house. She loved to cook and she would sing and hum while she fried up the best potatoes and eggs you have ever tasted. She also made knock-out cowboy beans. (Even though she taught each of her five daughters how to do the same, each daughter's pinto beans had a slightly different taste—all good—but my grandma's were the best.)

I also liked to spend the night there because she and Ernie had added on a room in the back, which had no heat. I would pretend I was a cowboy in a line shack way out on the range, and that was a definite plus in spending the night there.

One night, before I went to sleep, I heard cars racing up the street behind us. Then I saw lights raking off the ceiling of the little room, followed by the sounds of sirens, car doors slamming, loud voices, and men talking. After a long while, the talking died down and the lights raked back across the ceiling and disappeared.

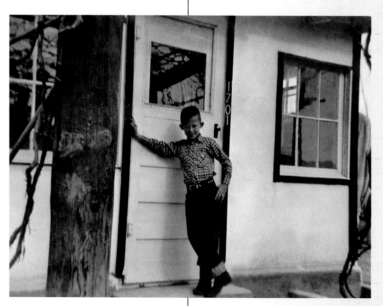

I found out in the morning that hot rodder T. J. Stockbridge, a shirttail cousin, had eluded the police and was hiding out behind my grandmother's barn. That was very outlaw cool to me.

What was even better, however, was how my grandmother would get out all her old photos from a large box and tell me stories about all of our outlaw kin. She told of rustlers and train robbers and all kinds of bad men who resided on the outer edges of the law. Famous outlaws, she said, came in the middle of the night, leaving a winded horse and taking another. Sometimes, the horse they left was better than the one they took.

While all this thrilled me to no end, my mother hated it. And it drove her crazy when I'd tell other people about being related to outlaws. When I said we were related to Big Foot Wallace, John Wesley Hardin, and Black Jack Ketchum, what she heard was Jack the Ripper, The Boston Strangler, and Charlie Manson.

At my grandmother's house on Jefferson Street in Kingman.

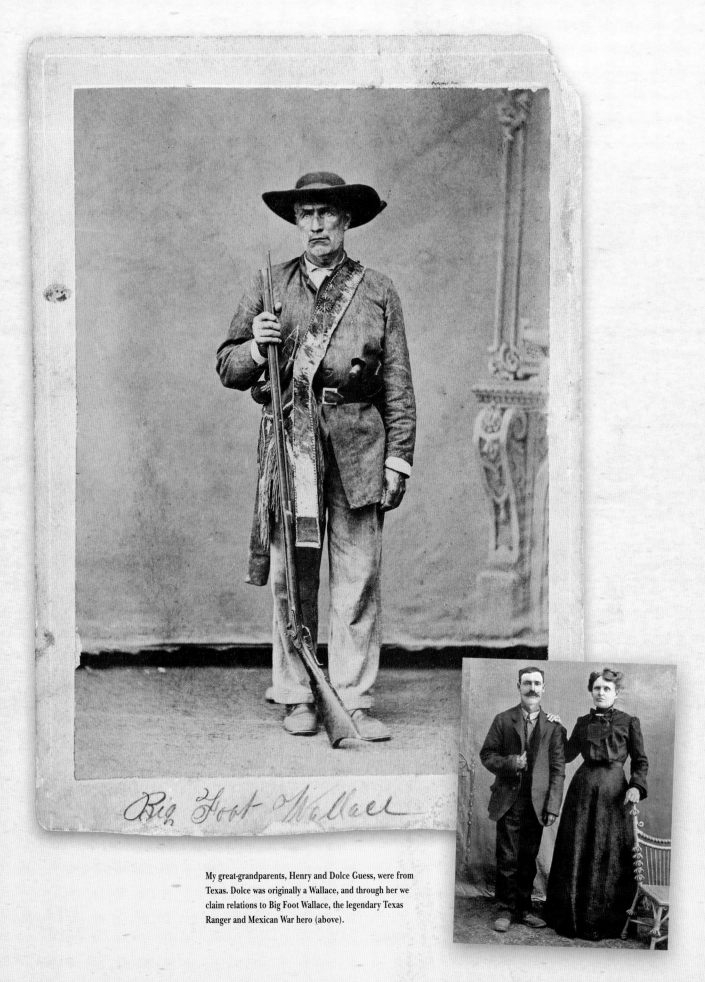

Big Foot Wallace

My great-grandparents, Henry and Dolce Guess, were from Texas. Dolce was originally a Wallace, and through her we claim relations to Big Foot Wallace, the legendary Texas Ranger and Mexican War hero (above).

That's me, front left, standing in front of Ernie and Grandma "Guessie" Swafford, around the time she told me we were related to outlaws.
Next to them are Mary Hamilton, my mother, and Billy Hamilton. In back are my father, Allen P. (without a hat), and Choc Hamilton.
This photo was taken in 1956, not long after our arrival back in Kingman.

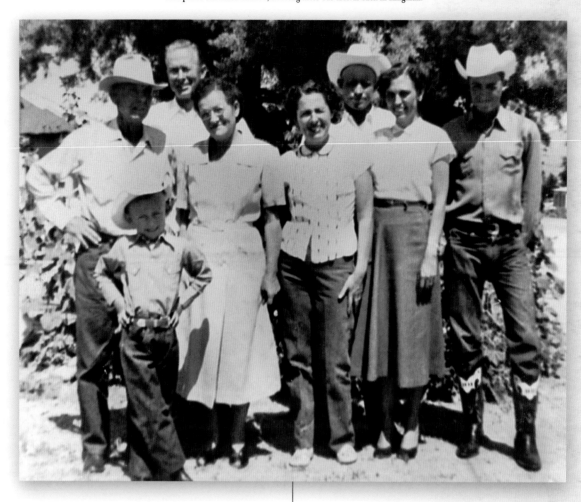

THE KETCHUM CONNECTION

In addition to Big Foot Wallace, my grandmother regaled me with stories of our Ketchum connection. That would be Blackjack Ketchum, the notorious train robber and member of the Wild Bunch who was hanged in Clayton, New Mexico, in 1901.

My grandfather, Bob Guess, came to Mohave County in 1912 to visit his grandmother in Hackberry. While there, he met legendary cowman Tap Duncan, who hired Bob to ride for one season with the Diamond Bar cowboys. Later, after a ranching career in the Bootheel of New Mexico and then on the Gila River near Duncan, Bob Guess was busted by the Depression. He returned to Mohave County in 1936, and his first stop was Duncan's Diamond Bar Ranch.

Guess now had a wife and five daughters. His oldest, Sadie Pearl, married Tap Duncan's grandson, and that is how we are related to the Duncans. In 1879, Tap's brother, Bige, married Nancy Ketchum, the sister of Tom "Black Jack" Ketchum. And that's how we are related to the Ketchums.

Our connection to John Wesley Hardin came from my grandmother's mother, Tiny Pickhart. She married a Hardin, also in Texas, and they had a daughter named Rosie Hardin. Twisted stuff, but heady just the same for a nine-year-old boy.

"If you monkeyed with Tap Duncan, you were monkeying with a rattlesnake."

—Choc Hamilton

Diamond Bar cowboys in 1913.

TAP DUNCAN

"BLACK JACK" KETCHUM

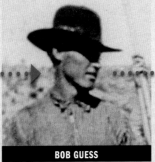

BOB GUESS

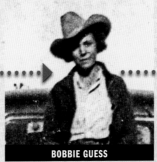

BOBBIE GUESS

BOB BOZE BELL

THE LINE OF FIRE

Tap Duncan "retired" from Texas after his brother was hanged for allegedly killing a family near Eagle Pass, Texas. Moving to Idaho, Tap worked as a wagon boss until he got in a gunfight with bad man Billy Hayes in Bruneau. Although cleared of the killing, Duncan departed for Arizona. Along the way, Tom Ketchum joined him, and Ketchum tried to get Duncan to go on a holdup with him. Duncan declined. One family story has it that Ketchum once rode up to the Diamond Bar Ranch on a bicycle, thus giving some credence to the much-hated "Rain Drops Keep Falling On My Head" sequence in *Butch Cassidy & The Sundance Kid*.

Tap Duncan survived the Wild Bunch and the Wild West, but in 1944 he was run over by a car just off Route 66 in downtown Kingman. He is buried in Mountain View Cemetery on Hilltop.

"Wyatt Earp was the biggest jerk who ever walked the West."

—Grandma Guessie

MY GRANDMOTHER DISSES WYATT EARP

Of all the story times at my grandmother's house, one would have the most influence on me and my later career. My parents had gone to a dance at the American Legion, and while my grandmother regaled me with stories from the Old West, I was nervously watching the clock. My favorite television show came on at seven, and I didn't want to miss it. I finally asked if I could turn on the TV, and she said I could. I rushed to the TV and turned it on, just in time to hear this theme song:

Wyatt Earp, Wyatt Earp,
Brave, courageous and bold.
Long live his fame,
and long live his glory,
And long may his story be told.

Yes, the show was *The Life & Legend of Wyatt Earp*, starring Hugh O'Brian. I loved the show because he cleaned up every cow town in the West, he was a bachelor, he drank milk, and he had a very long pistol with a barrel that went all the way to the ground. He could write his name in the dirt with the barrel of that gun.

Badmen never stood a chance against a guy with a glass of milk and a Colt .45.

Well right in the middle of that song, my grandmother pointed at the TV and said: "Wyatt Earp was the biggest jerk who ever walked the West."

I was stunned. Here I was looking at the TV, which never lied, and my grandmother, and I thought, "Wow, someone is not telling the truth here."

I didn't know it at the time, but the fuse had been lit. It would take another incident, a few months later, to crystalize my passion for finding out the truth about all the Old West outlaws and lawmen.

And it happened on Route 66.

Hugh O'Brian (real name Hugh Charles Krampe) was offered the starring role in "The Life and Legend of Wyatt Earp" in 1955 and the TV show became a big hit, running for six years. Hugh's proudest achievement is the Hugh O'Brian Leadership (HOBY) which he founded in 1958 to help young people become leaders. The longtime bachelor finally tied the knot at age 81, marrying his longtime girlfriend Virginia.

Above and right: Hugh O'Brian as Wyatt Earp

> ## "Most of the kids I grew up with in Kingman were brought into this world by Doc Arnold."
>
> – BBB

DOC ARNOLD SOLVES A MYSTERY

During a routine examination by Doctor Arnold in Kingman, my mother mentioned her medical history and the death of two babies in Iowa. Doc Arnold ran some tests and discovered she had a condition known as Rh factor incompatibility, which means that her blood cells produced antibodies that attacked the unborn baby. Although the condition was identified during the mid-1940s, heroic measures were rarely successful and there was no standard treatment until about 1961.

Unfortunately, the nurses and doctors at Buffalo Center, Iowa, didn't know this, and told her she was healthy and should try again. Prior to modern treatment, the condition often worsens in the third or fourth child. As a result, her third child, Sharon Lee, was stillborn. The chances for survival are slightly higher if the first born child is a boy.

Doc Arnold was an old-school frontier doctor who worked hard, played hard, and drank hard. As Kingman grew in the '60s, new doctors came to town and were mortified by some of Doc Arnold's antics, which included doing operations while obviously intoxicated and telling off the new doctors who didn't like it. My parents swore by him and always supported him, as did his longtime friend, Edie, seen here.

Bobbi Bell all dressed up and ready to go to town. My mother loved the color yellow and she had three of our houses painted her favorite color.

LEGENDS
OF THE ROAD
ROUTE 66

AMERICA'S BIGGEST SIDEKICK

Andrew Vabre Devine was born in Flagstaff in 1905. His father, a railroad employee, lost a leg in an accident and he received a settlement that he used to buy the Beale Hotel in Kingman, where Andy grew up. When Andy was three the *Mohave County Miner* reported he fell from the back porch and broke his arm. Local tradition claims he got his froggy voice when he used a curtain rod as a pretend trombone. He tripped, jamming the rod down his throat and tearing his vocal chords.

A talented athlete, Devine played football at Arizona Teachers College in Flagstaff (now NAU), then he moved on to Santa Clara University in California. He played semi-pro ball under an assumed name (Jeremiah Schwartz) so he could keep his eligibility for college ball.

After a stint as a lifeguard, Devine landed minor roles in the silents, but with the advent of sound it appeared his career was over, until he discovered his high-pitched squawk was perfect for comedy roles.

Through the thirties he played in a series of B westerns until he landed his biggest role in *Stagecoach* in 1939. He then went on to start in numerous movies and TV shows

HOTEL BEALE

Kingman, Arizona
OPPOSITE DEPOT

47 Handsomely Furnished Rooms

All modern improvements
Running Water . . Baths . . Electric Lights
Well lighted sample rooms

HEADQUARTERS for MOTORISTS

THOMAS DEVINE, Proprietor
114

from *Andy's Gang*, a TV show for kids, to *The Wild Bill Hickok Show*, where Andy played Jingles and shouted this phrase in every show: "Wait for me, Wild Bill!" He also starred in *The Man Who Shot Liberty Valance* (1962) and even appeared as a pathological liar who was abducted by aliens on *The Twilight Zone*. In 1966 he appeared as Santa Claus on *Batman*.

His hometown of Kingman honored him by renaming Front Street (Route 66) as Andy Devine Avenue in the 1950s and every September by holding the Andy Devine Days Parade and Rodeo. America's favorite sidekick died of leukemia in 1977. He was 71.

Above: Andy Devine is well-remembered for his role as Jingles, Guy Madison's sidekick in *The Adventures of Wild Bill Hickok*, which Devine and Madison reprised on television.

111

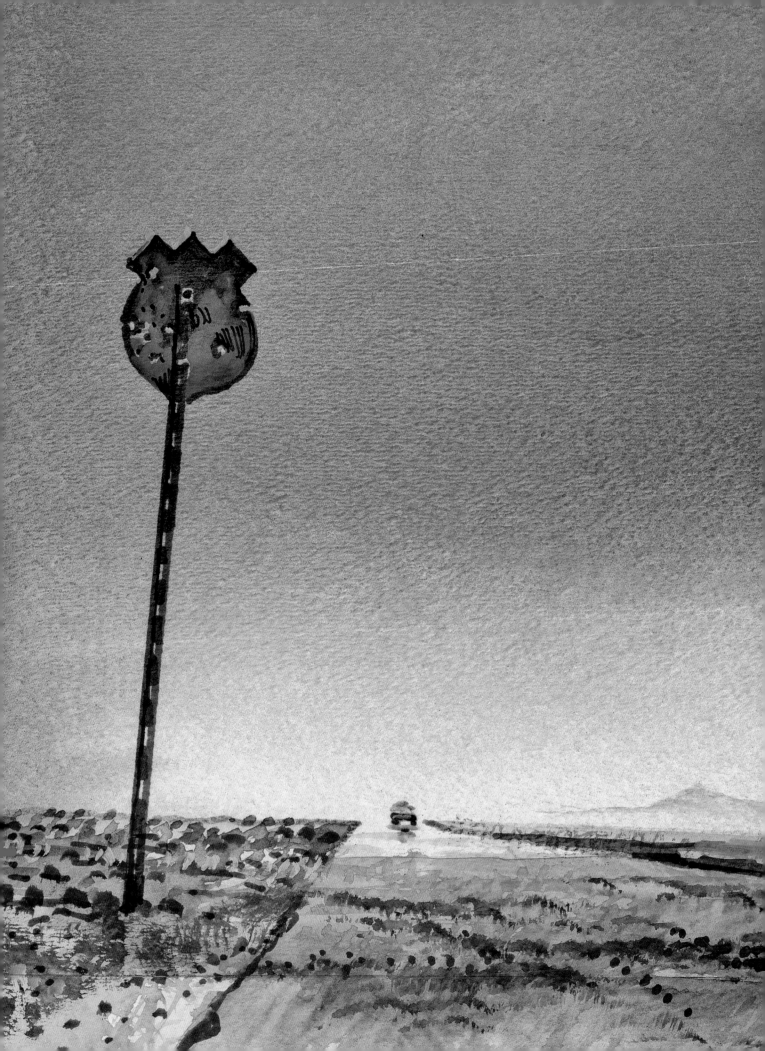

Making Time

In Search of the

World's Largest Buffalo

The night before we left was like Christmas Eve to me. We were going to hit the road and see some sights, eat some great food, and have adventures. My mother packed and my dad loaded the car so we could get an early start. We didn't leave Kingman; we escaped! Nobody was out at four in the morning and we slipped right out of town and onto the open road!

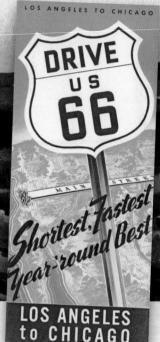

LOS ANGELES TO CHICAGO

DRIVE US 66

Shortest, Fastest Year-'round Best

LOS ANGELES to CHICAGO

THE GREAT AMERICAN ROAD TRIP

For more than two decades, our family hit the road late each summer on the same stretch of road between Kingman and the Bell family farm north of Thompson, Iowa. And every year we followed the same regimen: up at four, on the road by five, drive for an hour or so, and then stop for breakfast (invariably at the Copper Cart in Seligman). My dad always ordered the same thing: bacon and eggs, coffee and orange juice.

Most cars going west had inner tubes on the top, vacation stuff, and the people were smiling and excited. They were on their way to Disneyland and the beach. We were Norwegians on our way to the family farm and we were determined to get there so we could eat five times a day and talk about crops.

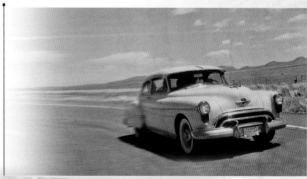

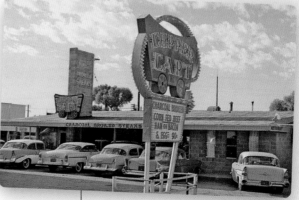

Above: Very few cars passed my father unless he wanted to see something— in this case what the back end of an Oldsmobile looked like.

Left: The Copper Cart was a mainstay for road food, and we usually ate there when we went through Seligman.

114

Perils of the Road

It wasn't always smooth sailing on our road trips to the family farm in Iowa. We often encountered great storms with freight-train clouds that dumped inches of rain in a flash, turning the roadway into a river. Kingman high school coaches told tales of having to stop the bus on return trips and wade out into the water to see if the pavement was intact in order to cross.

Valentine, Arizona, was named after Robert G. Valentine, U.S. Commissioner, Indian Affairs, 1908–1910. At one time, there was a boarding school for Hualapai, Supai, Mojave, Apache, and Coconino students in Valentine.

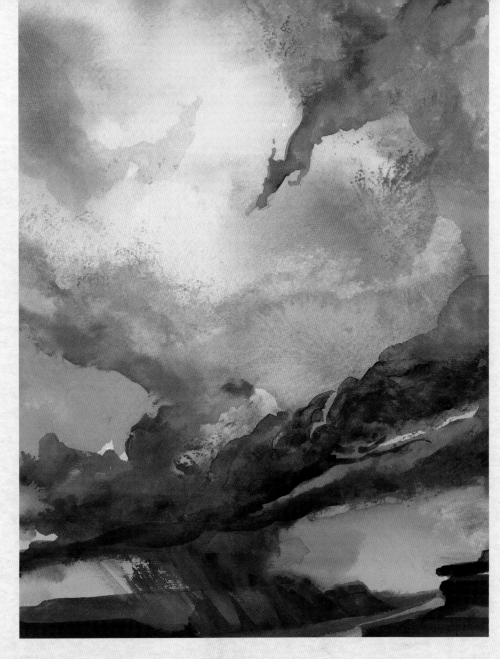

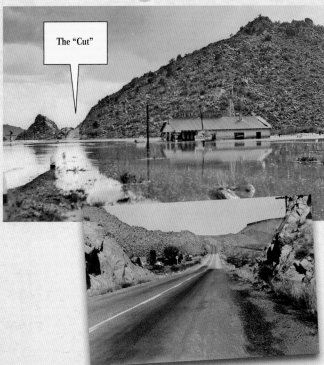

The "Cut"

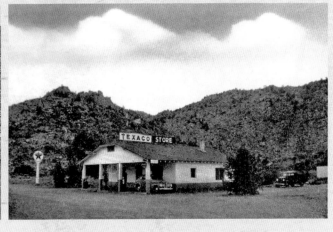

The photo at upper left shows the ravages of flooding along Route 66 in Valentine, Arizona. Although taken in different years, the flooded Shell station is the same building as the Texaco station (once owned by Trudy Peart's family), both sometime in the 1930s. The "cut" shown in the flooded photo is looking southwest. The inset photo is looking northeast through the "cut." The area where the station was is now a zoo.

NORSKYS ROCK OUT

As we drove eastward, we met all the happy, laughing tourists heading to California. We were eastbound, on the road to Iowa where we would eat five times a day and talk about crops with this party hardy crew. The Hauans get wild on a Saturday night, from left: Dina Hauan, Hank Hauan, Thelma Hauan, and Carl Bell. Front row: Grandma Hauan, Minnie Hauan Bell, Shirley Hauan (the baby), and Glenn Marvin Bell.

As the country rolled by, I stood on the transmission hump and gazed over the wraparound windshield at what my friend (and fellow Kingmanite) Jim Hinckley calls "America's longest sideshow." Long signs that traversed an entire mesa tempted us with tantalizing come-ons: "World's Largest Buffalo!"

"Can we stop Dad?" Zarrooooom. We blew by there without even slowing down. "Gotta make time," he'd say gravely.

When we got into New Mexico, I saw the signs: "Live Indians." I was hooked.

"Dad?" Zarrooooom.

At Santa Rosa, my heart leaped: "Billy the Kid's Grave: 54 miles." Zarroooom.

I finally realized Dad wasn't going to stop for anything except gas, food, and maybe open wounds.

After we got to Iowa —and we're eating our fifth meal of the day, at the Hauans', as I recall—I asked if he'd let me choose just one place to stop at on the way home.

"We will, Kid," he said, "if we have time."

I knew what that meant. We were going to blast straight back to Kingman and he wasn't stopping for anything.

So I hatched a devious plan.

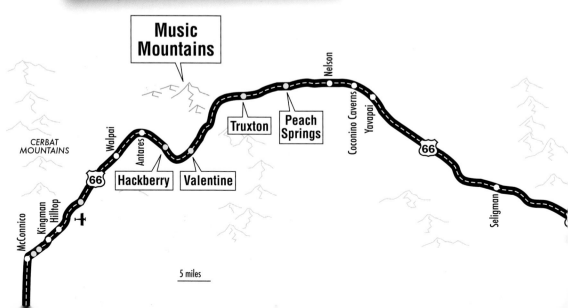

5 miles

The Men from Music Mountain

In 1857 Lieutenant Joseph Christmas Ives commanded an expedition to explore the Colorado River. After wrecking their 54-foot paddlewheel steamboat, *Explorer*, on a a rock in Black Canyon (where Hoover Dam is today), Ives and his men set out overland. While camped in the mountains east of the Colorado, Ives allegedly noticed the "regularity of the strata" on a nearby ridge that gave a "distinct appearance of a huge sheet of music." So he named the range the Music Mountains. In 1936, with the opening of Hoover Dam, Gene Autry filmed a movie called *The Man from Music Mountain.*

I THINK THAT'S A C-FLAT.

THE PLOT: When Boulder Dam opens in 1936, a couple of swindlers offer everyone who buys land in Gold River 50 shares in the Betsy Lee Mine. The formerly deserted town becomes the new home to dozens of victims of a swindle who need electricity to open businesses. When local rancher Gene Autry and his men ride into town, he realizes that John Scanlon and William Brady (ironically, the name of the sheriff killed by Billy the Kid in the Lincoln County War) are out to ream everybody. Hairdresser Helen, to whom Gene is attracted, and her friend Patsy, who is smitten with Gene's friend, Frog Milhouse, need the income from their new shop so badly that Gene resolves to help them and the others. After Gene is falsely accused and a mining guard is killed and the mine caves in, revealing a genuine vein of gold, Gene and Froggy win the day and the love of the girls.

Meanwhile, back at the studio, Republic Pictures resents Gene Autry's salary demands and decides to make a relatively unknown singer—Leonard Sly—into a replacement for Gene, so they change Sly's name to Roy Rogers and refilm the same movie, only with Roy as the star. Gene starts Flying A Pictures (no relation to my dad's gas station) and never looks back.

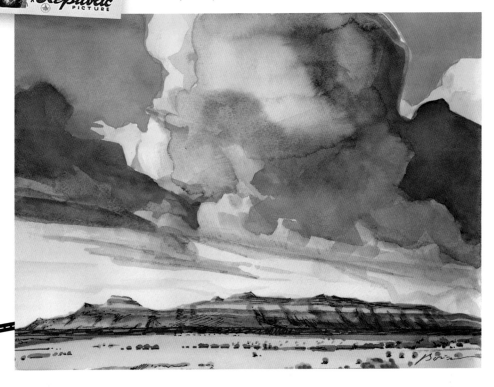

The Music Mountains' distinctive strata appeared to Ives and his men to be a huge sheet of music.

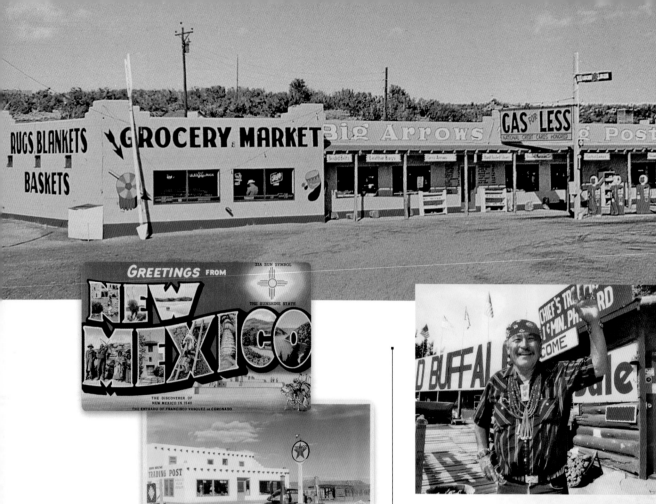

GREETINGS FROM NEW MEXICO

HOPI HOUSE
Main Entrance to Navajo and Hopi Indian Reservations
on U. S. Highway 66, 10 miles west of Winslow, Arizona

On the way to Iowa, I had picked out the place: 43 miles east of Albuquerque, on the south side of the road. The Longhorn Museum, it said, and it sat above a fantastic mini-street of Old West buildings. After breakfast in Santa Rosa at the Club Cafe, I went into action.

Every father has a weak spot, running from the ear down to the shoulder. And you can discover it if you stand behind him while he's driving and start poking him there, saying repeatedly, "You promised, Dad. Come on, you promised!"

Dad, of course, kept trying to shake me off, probably because he was in the process of passing 10 trucks. But I would not be denied. Finally, he swung that big, long '57 Ford (with the continental kit on the back) into the dusty parking lot of the Longhorn Museum. He shut off the engine, turned to look at me in the back seat, and said sternly, "Kid, you've got fifteen minutes."

CASHING IN ON THE WHITE MAN

Chief Yellowhorse, a Navajo, learned early how to entice white-eyed travelers off Route 66 in the early 1930s. His mother taught her sons how to sell blankets to tourists along the highway: he and his brothers would sing a Navajo "Good Luck Song" in their native language. And, of course, she charged for it. The chief later built a trading post and expanded it to include Anasazi ruins and a prairie dog village. Yellowhorse also had several buffaloes and for a time advertised one of them as the largest in the world. He had me, but I never could get my father to stop there. We had to make time.

Another safe bet for good road food was Rod's Steak House in Williams. It is still open for business, making it one of the longest-running restaurants on the highway. Some of the menu prices in those days are hard to believe, but this is a typical menu (opposite).

MEXICAN FOOD

Enchiladas, Two.................85¢
Tamales and Chili, Three.........85¢
Meat Tacos, Two..................85¢
Chicken Tacos, Two...............85¢
Mexican Spaghetti................85¢
Chili............................40¢
Guacamole Salad..................35¢

ALL SERVED WITH MEXICAN HOT SAUCE
CRACKERS AND TOASTADAS

Steaks

Kansas City Choice Corn-Fed Beef

NEW YORK BONELESS SIRLOIN STRIP STEAK............
TOP SIRLOIN STEAK................................
CHOICE T-BONE STEAK..............................
RIB STEAK.......................................
PRIME RIB OF BEEF au Jus, (Medium, Well or Rare),......
GRILLED HAM STEAK with Glazed Pineapple..................$1.50

SERVED WITH YOUR CHOICE OF FRENCH FRIED OR BAKED POTATO,
CHEF'S GREEN OR HEAD LETTUCE SALAD, YOUR CHOICE OF DRESSING
HOT ROLLS AND BUTTER

Sea Foods

INDIVIDUAL RAINBOW TROUT (Broiled),
Lemon Wedge, Tartar Sauce.....................$1.65
INDIVIDUAL CATFISH, Fried in Corn Meal........$1.50
FRESH JUMBO SHRIMP, French Fried..............$1.50
BROILED AFRICAN LOBSTER TAIL, Drawn Butter, Lemon Slice..$2.00
FRENCH FRIED OYSTERS..........................$1.50

SERVED WITH LEMON, TARTAR SAUCE, SALAD
AND FRENCH FRIED POTATOES

OYSTER STEW...................................$1.00

Dinners

SOUP OF THE DAY - TOSSED GREEN SALAD,
CHOICE OF FRENCH, GARLIC CREAM, ROQUEFORT DRESSING,
OR 1000 ISLAND
CHOICE OF POTATOES: FRENCH FRIED - WHIPPED - BAKED
AND GREEN VEGETABLE

BREADED VEAL CUTLET, Cream Sauce..........................$1.50
ROAST TOM TURKEY, Our Dressing, Giblet Gravy,
Cranberry Sauce...$1.75
MANHATTAN STEAK, Smothered Mushrooms......................$1.75
GRILLED CALF LIVER with Onions or Bacon...................$1.75
PAN FRIED CHICKEN, (One Half).............................$1.75
BROILED PORK CHOPS, Apple Sauce...........................$1.50
DINNER SIZE SIRLOIN STEAK.................................$1.85
TENDERLOIN OF TROUT......................................$1.65

COFFEE OR TEA, ICE CREAM OR SHERBET

Onion Rings........25¢ Basket........75¢

Sandwiches

Sliced Turkey Sandwich.............................
Hot Beef with Potatoes.........................75¢
Hot Turkey with Potatoes......................$1.00
Three Decker Club.............................$1.00
Grilled Ham with Cheese.......................$1.00
Baked Ham......................................75¢
Hamburger (Our Own)............................50¢
Cheeseburger...................................40¢
Bacon and Tomato...............................50¢
Grilled Cheese.................................50¢

may we suggest

ARMOUR
Potted SWISS STEAK
with Baked Potato
and Mixed Vegetables
$1.35

FULL MEXICAN DINNER
Guacamole Salad
Meat Taco, Enchilada,
Tamale & Chili, Chili Rellano
Fried Beans Coffee or Tea
Sherbet
$1.90

SUMMER SPECIAL
Assorted Salad Plate..........$1.25
California Fruit Plate........$1.00

Appetizers

SHRIMP COCKTAIL...................$1.00
GREEN OR RIPE STUFFED OLIVES......50¢
CELERY HEARTS AND OLIVES..........50¢
FRUIT COCKTAIL....................50¢
SOUP OF THE DAY, CUP..............20¢
 BOWL....35¢

Salad Bar

TOMATO STUFFED WITH
CHICKEN OR TUNA SALAD............$1.00
HALL'S SALAD BOWL,
CHOICE OF DRESSING..............$1.00
INDIVIDUAL COMBINATION SALAD......50¢
SHRIMP SALAD....................$1.00
PEAR, PINEAPPLE OR PEACH
WITH COTTAGE CHEESE.............75¢

SERVED WITH CRACKERS AND BUTTER
OR HOT GARLIC TOAST WITH CHEESE

Potatoes

BAKED IDAHO POTATO................20¢
HASH BROWN POTATOES...............20¢
FRENCH FRIED POTATOES.............20¢
CREAMED POTATOES..................20¢

Beverages

COFFEE............................10¢
TEA, HOT OR ICED..................10¢
BUTTERMILK........................12¢
SWEET MILK........................12¢
CHOCOLATE MILK....................12¢
SOFT DRINKS.......................10¢

Dessert

STRAWBERRY SHORTCAKE
WITH WHIPPED CREAM...............40¢
ICE CREAM OR SHERBET.............20¢
MERRY-GO-ROUND SUNDAE............30¢
CHERRY PIE......................20¢
APPLE PIE.......................20¢

Children's Menu

SERVED TO CHILDREN UNDER TWELVE ONLY

FRIED CHICKEN, ONE FOURTH, GRAVY.....$1.00
FRIED TENDERLOIN OF TROUT............85¢

> # "He was the all-American boy and a cold-blooded killer. Of course I immediately loved the guy."
>
> –BBB

THE BUY OF A LIFETIME

The fantastic Longhorn Ranch Saloon and Museum loomed before me.

Those were the most precious minutes of my life. I ran in the museum and there were all the things I love: saddles, longhorns on the wall, rifles, and muskets everywhere. I was in a buying mood because my grandfather, Carl Bell, had given me a shiny quarter when we left the farm and headed west the day before and told me to buy something special with it.

I asked the man behind the counter how much for a Flintlock rifle hanging on the wall. He said, "one hundred dollars." I said, "I'll give you a quarter?" Then I saw it: "An authentic photo of Pat Garrett and Billy the Kid."

The price? A quarter.

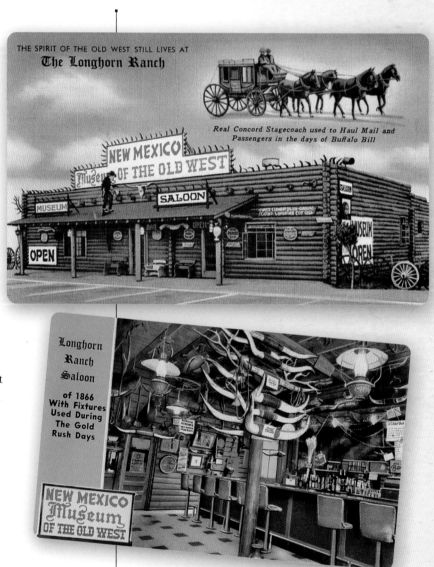

The Longhorn Museum thrived for many years on Route 66 as a must stop for anyone who loved the Wild West. Today only the sign remains.

It was incredible to think I was holding in my hands an actual photo of Pat Garrett and Billy the Kid. It was mine. I owned it. I couldn't have been prouder.

BEALE ROAD SURVEY 1857

Former Navy Lieutenant Edward F. Beale bid successfully on a military contract to survey a road linking Fort Defiance in Texas to the California border near present-day Needles. He relied on camels, purchased by the government for military purposes, testing their suitability as pack animals before delivering them to Fort Tejon and his nearby ranch. Beale's route eventually became the basis for the Atchison, Topeka & Santa Fe Railway and Route 66.

5. Terminating the survey expedition at present-day Beale's Crossing, Beale followed the U.S. surveyors' trail (Mojave Trail), taking the righthand road directly to Fort Tejon.

4. Reaching Fort Defiance, Beale officially began his experiment. The camel caravan rested at El Morro, then headed toward Zuni and across present-day northern Arizona.

3. From Fort Davis, the camel convoy picked up the Rio Grande and followed it to Albuquerque.

2. After a rough trip from California, Beale arrived at Camp Verde. Taking charge of the animals, he set out with his caravan for Fort Davis.

1. Two separate shipments of camels, along with Middle-Eastern tenders, arrived at the Texas coast about a year apart. They eventually were moved inland to Camp Verde, where they awaited the arrival of Beale in July 1857.

100 Miles

BEALE BLAZES THE WAY FOR ROUTE 66

Among my favorite road-trip pastimes is looking out the window and imagining the outlaws, renegades, and trailblazers who beat paths across the trackless desert.

Although Lieutenant Edward F. Beale certainly wasn't the first to blaze a trail across northern Arizona, he was the one who really locked down the path that eventually became Route 66.

And he did it with camels!

In 1855, Congress decided to test such animals in the American Southwest and appropriated $30,000 to the War Department for the purchase and importation of camels and dromedaries. After a buying trip to Morocco, thirty-three camels were transported to America on ships. For safety reasons on the three-month journey, the camels were tied down on their knees. One camel died in passage, but six calves were born and two of those survived, which put the total at thirty-four when they landed May 14, 1856, on the Texas coast.

An expedition was formed, making its way across Texas, into New Mexico, and up to Albuquerque. There, the journey got serious. Led by Beale, the Camel Corps Expedition took off from Albuquerque with a local guide who allegedly knew the way to California. It quickly turned out, however, that he really didn't have a clue beyond present-day Grants, New Mexico.

Beale had been assured the guide would lead them to California and had paid a handsome price for the privilege of being lost several times. "I should have killed him right there," Beale wrote of the guide in his journal.

After a 30-mile detour to get around Canyon Diablo—today we zip across the bridge in about six seconds—Beale cut a primitive trail across New Mexico and Arizona. It essentially is the basis for the Atlantic & Pacific Railroad (later the Atchison, Topeka & Santa Fe), and then for Route 66.

Beale Street and the Beale Hotel in Kingman are named for him.

We got back in the car and my dad blasted back out on Route 66 and floored it. He had to catch all the trucks that got by him while we were in the museum.

Me, I was studying my authentic photo in the back seat. We fought our way through Albuquerque, then cruised around Laguna, Cubero, Grants, and on into Arizona. I was so quiet my mother was concerned. "Are you alright?"

"Yes," I assured her. "I am studying this authentic photo of Billy the Kid and Pat Garrett."

I don't even remember the rest of the trip through Saunders, Crazy Horse, Geronimos, Lupton, Holbrook, Saint Joseph, Two-Guns, Flagstaff, don't forget Winona.

H-1576—CANYON DIABLO, ARIZONA

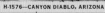

U. S. HIGHWAY 66, HOLBROOK, ARIZONA

Top: Kiowa Cafe, a typical Route 66 tourist stop, sometimes referred to as a place that sells rubber tomahawks.

Above: Canyon Diablo where Beale had to take a 30-mile detour to get around.

CRUISIN' UP AND DOWN THE RADIO DIAL

I loved trying to find local radio stations, especially in the outlying areas. In the Winslow corridor they actually had a radio station with Navajo announcers and they would talk in long, loping syllables and every once in a while you would hear the words "Canyon Ford," or "Levis on sale." That was fun, but it did get old quick. In the bigger towns like Albuquerque you would get flashier shows, but even then there were no "rock stations" or "country stations," or "The BIG" anything. There simply wasn't enough musical product to fill out an entire play list. Top Forty was in its infancy, or, had yet to make it's way into Route 66 country. That doesn't mean you wouldn't hear hits. We must have heard "Little Jimmie Brown" in five states on station after station.

The signal for most stations petered out quickly and static on the airways was the majority of the sound I could get on the dial. My mother would tire of the static and ask me to turn off the radio for a while. I remember Leslie Gore's "It's My Party and I'll Cry If I Want To" getting big play and I was struck with how the song spoke to people my age. That was a marvel in its time. The next song would be something by Jimmie Dean or Farron Young. I don't remember any formats, but I do remember smart-assed announcers. That is something that has never gone out of style.

Elvis was a big deal, but the DJs invariably made fun of him, "Here's Elvis the Pelvis. . ." and more than once I heard early rock described as "jungle music," in a man-I-can't-believe-we're-playing-this-crap-again way.

But my absolute favorite find on the radio dial on road trips was the farm and ranch report. You'd get some hayseed guy talking about corn futures and it just always made me smile. Someone would sing happy birthday to some kid in town and it was just a slice of small-town Americana. That is the radio I miss, when it had distinct, regional personality. it wasn't slick and it wasn't all that funny or even entertaining in the Big City Market way, but it was hilarious in a wonderful way.

Wolfman Jack broadcast out of Mexico, and we could hear him all over the Midwest. Later, The Wolfman relocated to Tijuana and from there he blasted southern Cal. It was during this period that George Lucas heard him in Modesto and included him in his classic "American Grafitti."

Spin a dial and push a button and hope like hell there's something to listen to.

DIAL 1520

KOMA
Oklahoma City

"If you're a loyal KOMA listener, kiss your sweetheart!"

—KOMA JINGLE THAT WORKED EVERY TIME

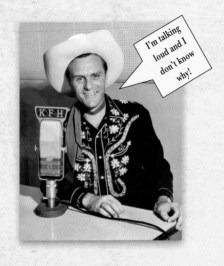

I'm talking loud and I don't know why!

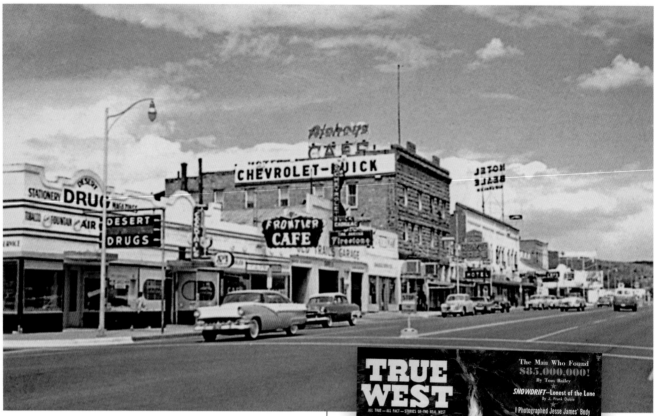

When we got home, I put that photo on the wall by my bedroom door and studied it every day. I made a vow to someday have a rifle, hat, and vest exactly like the one Billy was wearing.

 Two weeks later, I went with my mother to Desert Drug in downtown Kingman. While she was getting a prescription filled, I ran to the front of the store and bought the latest issue of *True West*. I took it out to the car to read, and on page 32 I discovered that the authentic photograph I had paid a quarter for was A FAKE! It had been taken at a parade in Santa Fe in 1937.

I spent the rest of my youth—and a fair share of my adulthood—trying to find the real Billy the Kid. And thus began a lifetime obsession with Old West outlaws and lawmen.

It would take another 25 years to make it to Fort Sumner and the Kid's grave for the first time. What I would discover there, however, was somewhat underwhelming.

Top: Desert Drug in downtown Kingman is where I first encountered the magazine that would later spark my life's work.

Above: *True West* magazine was founded in 1953 by Joe "Hosstail" Small in Austin, Texas. Joe also published *Frontier Times* and alternated the two titles monthly to double their newsstand exposure to 60 days. I thought *Frontier Times* was an inferior product, even though it was put out by the same staff! This is either an excellent example of the power of loyalty and branding or the utter stupidity of a snot-nosed kid from Kingman.

Lost and buried treasure was a big theme in *True West* magazine, and I loved the painting on this cover so much I bought a print that still hangs in my office today. The idealized fantasy of such an encounter, no matter how absurd, still rings true in my mind.

LEGENDS
OF THE ROAD
ROUTE
66

THE KING OF THE KINGMAN QUARTERMILE

A carload of toughs from Boulder City, Nevada, are looking for some heat when they pull into the Kimo Shell and quiz the pump jockey: "Who's got the fastest car in Kingman?"

Without hesitation, the kid with a red rag in his pocket says, "You're looking for Billy Logas. He shouldn't be that hard to find."

The word spreads like wildfire and the next thing you know everybody who is out on a hot, Saturday night is cruising up Hall Street, a string of taillights heading for the well-known drag-race spot. Rattling across the cattle guard, the long line of cars pull off into the ditch on either side of the road, and guys get out to take a gander at the 409 Chevy from Boulder City.

Within minutes, we hear Billy coming, his '64 Dodge 426 Hemi rumbling down the road like an egg beater with a rocket booster on it. Billy gets out and starts prepping his car. Outside mirrors come off, even the windshield wipers (no wind resistance!). He and a couple of other guys strip that puppy down to its skivvies. Finally, everyone but Billy steps away and we see Logas get in and rev up the Plymouth.

On the flashlight signal, both cars fishtail off the line and, like shot out of a slingshot, Billy pulls ahead. They disappear into the darkness, but we know he has won again and we all cheer for our hometown hero.

Very few out-of-towners looking for heat ever bested Billy Logas. In fact, the drag strip became known as the Logas Quartermile. Today it's known as Stockton Hill Road, and is the heart of Kingman's Hilltop business district.

Top right: Billy Logas blows the doors off a Boulder City Chevy.

Above: One of Billy's many MoPars, this one a 1966 Plymouth 426 Hemi parked in front of the garage and wrecking yard owned by Billy's dad, Buster, in Logasville, 5 miles east of Kingman on Route 66. Across the highway was another wrecking yard owned by the family of Billy's friend Boxlip Darrell.

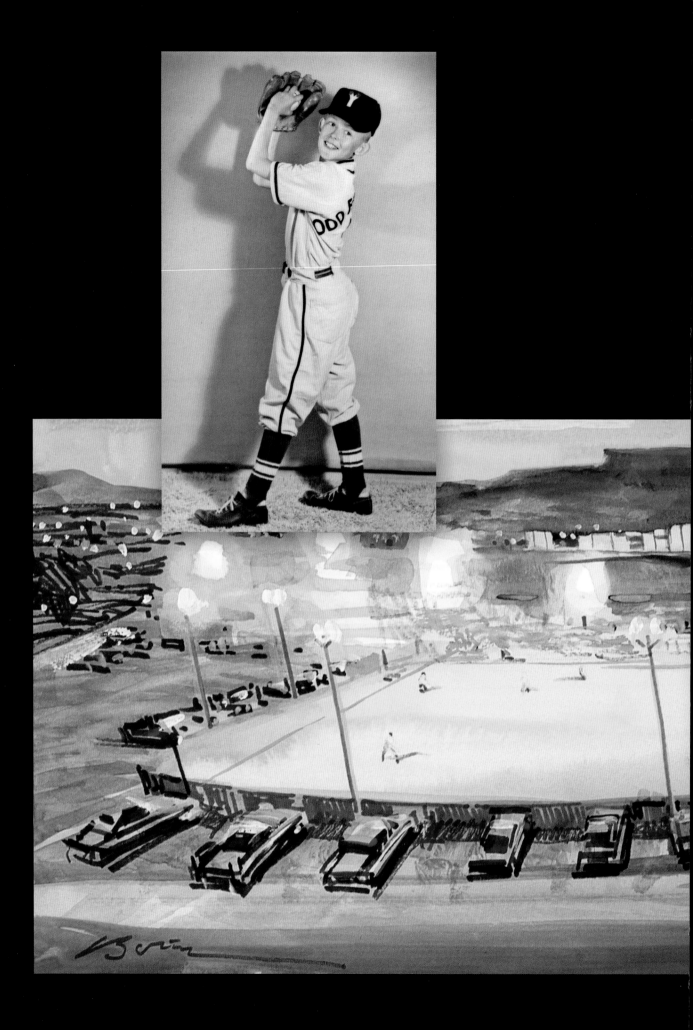

HEYBATTABATTA!

An Oddfellow Yankee in Kingman's Court

> ## "Little League baseball is a very good thing because it keeps the parents off the streets."
>
> —Yogi Berra

LITTLE LEAGUE, BIG FRIENDSHIPS

The news spread through our little school like a Mojave duststorm. It was Little League sign-up time and all the boys I knew were giddy with excitement. I was a third-grader and new to the scene, so I joined the mob and signed up. Mickey Mantle was my hero and he played on the New York Yankees, and I told the man at the desk I wanted to be on the Yankees. He said he couldn't promise anything, but he'd put that down.

I soon found out I had been accepted by the Yankees (if only getting on the real Yankees could be so easy, I thought). I was told to take bus number six after school to Hilltop, and to get off at the Mountain View Cemetery stop, where I would meet my coach and teammates.

I was very nervous about getting on a strange bus, and I worried I'd miss my stop and end up in another county. As we chugged up the cut to Hilltop, I finally asked the bus driver to tell me when my stop was coming up. It turned out to be the very first stop. That was a relief, but as I jumped off the bus with my ball and mitt, my heart sank. There wasn't a soul in sight, just a lonely backstop in the northwest corner of an empty, dusty block, and as I watched my ride lurching north on Hall Street, the wind picked up and swirls of dust obliterated the horizon. I stood there for some time, wondering what to do.

Finally, I looked around and saw a kid at the other end of the block, throwing a ball up in the air and catching it. I made a circuitous trip, aping the same motions, throwing

my ball up as high as I could and catching it, but angling it so I kept going in his direction. Finally I got close enough to say, "Wanna play catch?"

His name was Daniel Harshberger, and we have been playing catch ever since.

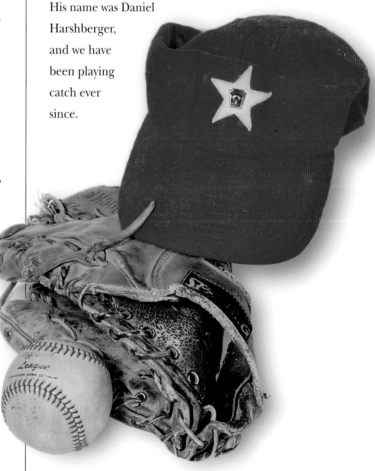

Ray Bonham's Little League glove and all-star cap with his all-star pin. The baseball is the gameball from the 1959 Northern Arizona Little League Championship game.

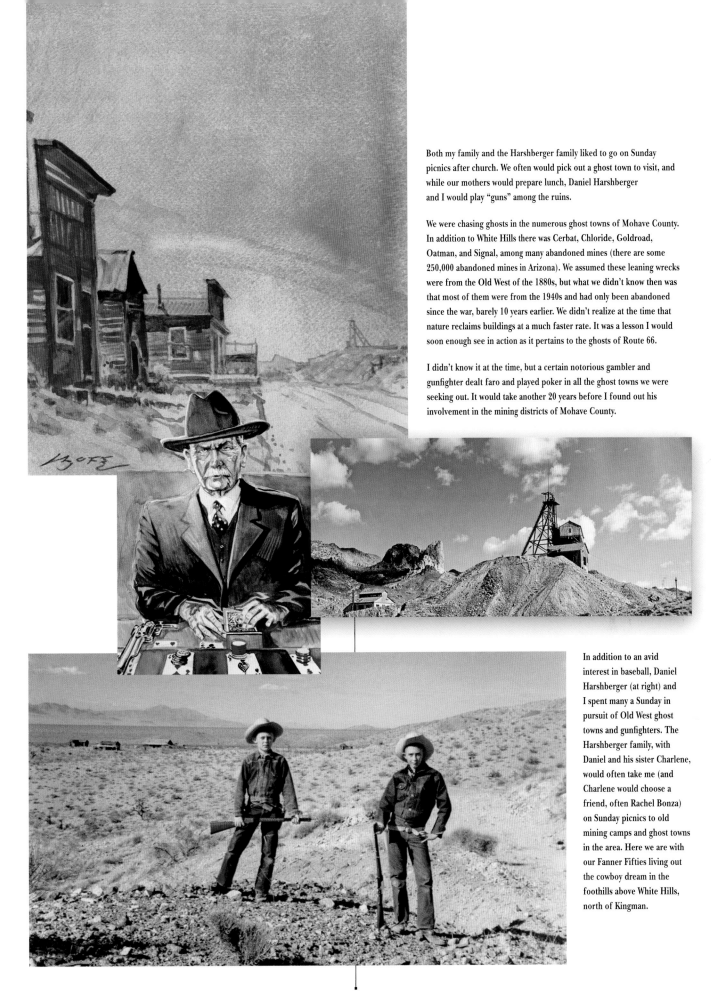

Both my family and the Harshberger family liked to go on Sunday picnics after church. We often would pick out a ghost town to visit, and while our mothers would prepare lunch, Daniel Harshberger and I would play "guns" among the ruins.

We were chasing ghosts in the numerous ghost towns of Mohave County. In addition to White Hills there was Cerbat, Chloride, Goldroad, Oatman, and Signal, among many abandoned mines (there are some 250,000 abandoned mines in Arizona). We assumed these leaning wrecks were from the Old West of the 1880s, but what we didn't know then was that most of them were from the 1940s and had only been abandoned since the war, barely 10 years earlier. We didn't realize at the time that nature reclaims buildings at a much faster rate. It was a lesson I would soon enough see in action as it pertains to the ghosts of Route 66.

I didn't know it at the time, but a certain notorious gambler and gunfighter dealt faro and played poker in all the ghost towns we were seeking out. It would take another 20 years before I found out his involvement in the mining districts of Mohave County.

In addition to an avid interest in baseball, Daniel Harshberger (at right) and I spent many a Sunday in pursuit of Old West ghost towns and gunfighters. The Harshberger family, with Daniel and his sister Charlene, would often take me (and Charlene would choose a friend, often Rachel Bonza) on Sunday picnics to old mining camps and ghost towns in the area. Here we are with our Fanner Fifties living out the cowboy dream in the foothills above White Hills, north of Kingman.

The Oddfellows sponsored the Yankees Little League team and we had to go to their lodge to pick up our uniforms. Bill Blake and I went together and we were led into a cluttered room on the second floor where we were given fresh, wool uniforms to try on for size. I ended up with number 33, a number I have since preferred in all its permeations. (Hey, I wrote this book when I was 66).

THE ODDFELLOWS

There were five Little League teams in Kingman: the Cardinals, sponsored by the Elks Lodge; the Giants, sponsored by the Fire Department; the Indians, sponsored by Saint Mary's Church; the Red Sox, sponsored by the Rotary; and my team, the Yankees, sponsored by the Oddfellows.

Looking back, I am struck by how much time the coaches and all the volunteers devoted to us. First of all, they built the Little League field with donated materials and volunteer labor. We practiced after school and on Saturday mornings, and we played night games Monday through Friday. We learned valuable skills and sportsmanship, and, most importantly, we were kept off the streets and out of trouble.

HEYBATTABATTA!

We were taught and encouraged to chatter, as in yelling nonsensical phrases. They started with "Hey, Batter Batter" and went downhill into our own insults such as "You Can't Hit," "Pitcher's Got a Big Butt," and other gibberish— all intended to put the opposing player off his game. It seemed to be sort of a cross between a Rebel Yell and an Apache War Cry. We only did this in Little League, and I'm not sure it ever worked.

The Little League field was built across the tracks where an old Hualapai camp had been. (The railroad, allegedly concerned about eminent domain, dispossessed the tribal members living there and moved them across the tracks and farther east.) It was a dirt field, but it had lights, dugouts, a significant set of bleachers, and a billboarded fence in the outfield.

TRAIN KEEPS A COMIN'

One of the unique aspects of our Little League park was that the railroad tracks passed behind the right-field fence at a high angle. When a big freight train rumbled past, you couldn't hear a thing. You don't realize how much you rely on sound to play baseball until you are stuck in right field (my default position because I had a weak arm) and you can't hear anything. You see the batter swing, but you don't hear a crack. Suddenly, all the infielders turn to look at you, but you didn't hear or see the contact, or where the ball went. Out of the blue, a ball lands off to your right and goes to the fence. Fortunately, the loud train noises blocked out the sound of my sobbing.

THE JADE TRADE

The Holy Grail of our Little League world was the fence where Charlie Lum's Jade Restaurant sign was prominently placed—if you hit a homerun over that sign, you got a free meal.

Among the first to hit one was a phenom from Valentine who not only hit a ball over the sign, but over the lights! Wendell Havatone was a Hualapai and his coach said he was 8 years old.

All the coaches for the other teams thought this was ridiculous. The problem was that Wendell had no birth certificate. He was born on the "res" and his age was up for grabs. It was finally decided that Wendell could share his cousin Delano Havatone's birth certificate, which made him 10. No one knows how old Wendell was at the time, but we all joked he was the only kid who brought a shaving kit to the Little League championship in Flagstaff.

LITTLE LEAGUE FINAL STANDINGS

	W	L	Pct.
Giants	8	2	.800
Cardinals	6	4	.600
Yankees	6	4	.600
Indians	4	6	.400
Red Sox	1	9	.100

In the final games of the season played last Friday evening, the Yankees cinched a tie with the Cardinals for second place standing in the second half by defeating the Red Sox 18-7 and the Giants stretched the margin on their first place lead by downing the Indians 12-1.

In the opener the Yankees lost no time in showing their superiority over the Red Sox by pounding Havatone for five hits and ten runs in the first inning. Bradley and Myers occupied the mound for the winners, allowing only two hits and seven runs while striking out nine in five innings. Cox and Bradley divided hitting as each hit safely two out of three times.

Havatone, Havatone and Ridenour pitched for the losers and were tapped for nine safeties and 7 runs.

In the season finale, the highlight was a home run hit by Jim "Salty" Richardson which set a new league record in that department, topping by one the nine home run record chalked up by Jim Sumner last year.

Richardson grounded out to the pitcher his first time up and then received two intentional walks before he was pitched the home run ball on his last trip to the plate for the season.

Jerry Craig, who pitched his first full game of the season turned in a two-hitter and struck out fourteen opposing batters. The game ended dramatically when Glancy took a line drive and doubled the runner off first for an unassisted double play.

Suuthojame took top honors for the game in the hitting department with one safety and two walks in three trips to the plate for the Indians. Summer connected for the only other Indian safety. Meins, Butler and Klein occupied the mound for the losers.

The Fire Department Giants took a choke hold on Little League championship for the year 1957 July 17 by downing the Yankees by a score of 17-7 after the Yankees had held an advantage for the first three innings.

The game [...] crucial contest in th[...] [...]nt win would give them [...]ted top spot while a Yar [...] would throw the two te[...] tie and the champional [...]not be settied until [...]lay night's [...]kees won or [...]tied for sec [...]honors, play[...]offs would [...]n necessary as the Gi[...]e Cardinals were tied [...] half. [...] for the Cox, Y[...] [...] scored his

ST. MARY'S INDIANS — Members of the St. Mary's Indians Little League baseball team are pictured above. They are, left to right front row, Bobby Benjamin, Roland Serrano, Dana Klein, Brian Meins, Mike Baxter and Jimmy McDougal. Second row, Leroy Bender, Kenneth Lorton, Alex Suuthojame, Tammy Clinkenbeard, Estil Sumner, Steve Whaley, Jimmie Bullmore and Chris Suuthojame. Standing in back are Coach Bill Baxter and Manager Frank Esquibel. (Gallup Photo)

ELKS CARDINALS — The team which tied for first place honors in the first half — and finished sec[...] [...]nd to the Giants in the second half of the Kingman Little League, is pictured above. Members of the Elks Cardinals are, first row, left to right, Larry Ross, Jay M. Gates, Bert Hands, Bill Hudson and Jackie Kesler. Second row Robert Flores, Ray Bonham, Chuck Peckovitch, Richard Christman, David Glossbrenner, Steven McLendon and Charlie Waters. Third row, Coach Floyd Cisney, Kim Bond and Manager J. Y. McLendon. (Gallup Photo)

ODD FELLOWS YANKEES — One of the strongest teams in the Kingman Little League and winners of a second place tie with the Elks Cardinals in the second half, are the Odd Fellows Yankees, pictured above. Front row, left to right, are Neal Pascoe, Paul Torres, David Cox, Steve Bradley, and Gary Brock. Second row are Dale Nichols, Gene Brummett, Dane Pascoe, Mike Smith, Mike Mag[...]noli, Steve Brock, Andy McCumber, Dennis Paulson and Robert Bell. The team was managed by Jim Pascoe and coached by Dick Brock. (Gallup Photo)

FIRE DEPARTMENT GIANTS — Little League Champions for 1957 are the Fire Department Giants pictured above. They tied for the first half with the Elks Cardinals and won the second half and the title. They are, from left to right, first row, Charlie Glancy, Alex Nish, Jim "Salty" Richardson, and Jerry Craig. Second row left to right, first row, Eddie Ray Dollarhide, Hubby Grounds, Tommy Dollarhide, Richard Nish, Pat "Punchy" Richardson, Bobby Bishop, Gerald Tipton and Stephen Tipton, bat boy. At back are Jim Rich[...]ardson, team manager and coach Jim Glancy. (Gallup Photo)

ROTARY RED SOX — Members of Rotary Red Sox, a scrappy team that gave all the other teams plenty of trouble at one time or another, are pictured above. Front row, left to right, are C. Powskey, Joe Pow[...]skey, Allen Tapija, Mike Finnigan, Dennis Laulo, Mike Tarr and batboy Brian Graves. Second row, Bill Ridenour, Bob Rodriquez, Wendell Havatone, Gary Young, Daniel Harshberger, Delano Havatone, and Richard Ridenour. Back row is assistant manager Ed Laulo and Manager Bernard Dehl. Not pictured is coach Freeman Thomas. (Gallup Photo)

Top: A view of the Kingman Little League field from right centerfield, a position I knew intimately over a four-year period.

Above and left: The five Little League teams in 1956 posing for the *Mohave County Miner* camera. Note the high railroad tracks in the Cardinals photo (above right). I have been lifelong friends with most of the kids in these photos. Little League really bonded us. More than a half century later, I still hear from some of these "kids" about a game where they "got us good."

CHARLIE LUM

The man behind the Jade sign at the Little League park was a Mohave County legend—Charlie Lum. He paid to have a sign in the outfield and honored the claim that anyone who hit a homer over it got a free meal. I never did.

Charlie Lum's grandfather, "China" Jack, was born in California, and he and his father worked on the railroad for a time before coming to the Kingman area in 1884, where Jack cooked for various cattle outfits. Jack returned to China and this is where Charlie was born in 1912. Jack returned to Mohave County with his family and opened the White House Restaurant where Charlie worked as a young man.

Some believe when Charlie was 14, he witnessed the killing of his boss, Tom King, by members of the San Francisco "tong," who drove to Kingman and whacked King. The case made national headlines, but it's debatable whether Charlie testified at the trial of the perpetrators. Four out of the five were executed.

In the 1930s Charlie returned to China to marry, but was unable to bring his wife back. His first wife died in 1939 and he married her sister and moved back to Kingman, where he opened the Jade Restaurant in 1952 at the foot of the hill on Route 66. Charlie worked 15 to 20 hours a day and was a mainstay at the popular restaurant. Many dinners to celebrate wins on the diamond were celebrated in the back room of the Jade.

A savvy businessman, Charlie owned a laundromat, a nightclub, apartments, and a chicken franchise. With the handwriting on the wall with the bypass, Charlie retired and moved to Hawaii in 1978. He returned several times and told his friends he missed the people of Kingman. He died in 1996.

Top: Charlie Lum

Above: The Jade Restaurant as it appeared in 1959.

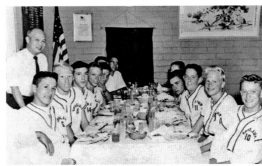

In addition to Kiwanis and Rotary, many Kingman sports teams were treated at the Jade. This is a Pony League team dinner and the boys are still in their uniforms.

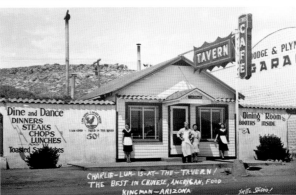

According to local lore, Charlie Lum and his father worked as cooks for various cow outfits in Mohave County before opening the White Cafe and the Tavern Cafe on Front Street (Route 66 and now Andy Devine Avenue).

The 1959 Kingman All-Stars pose in front of the Jade sign in the outfield. That's Wendell Havatone in the circle. For some reason I didn't make it to this photograph even though this is my team.

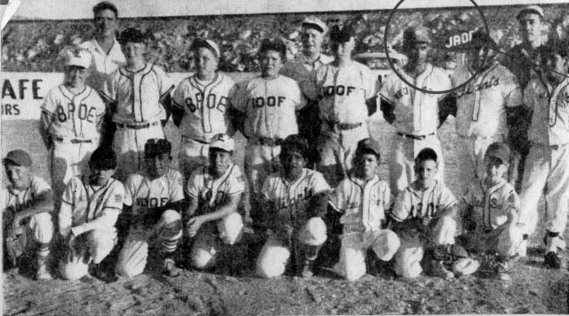

LITTLE LEAGUE ALL-STARS—Members of the Kingman Little League All-Star team, with their manage and coaches, are pictured above following their selection from the five team league last week. The team is working out preparing for the Northern District Tournament at Flagstaff on July 28-29-30-31. They play Holbrook at two p.m. July 28th and if they win they meet Page the second day. Front row, left to right, are Heber Nelson (Giants), Mickey Campa (Indians), Philbert Watahomigie (Yankees), Chuck Petkovich (Cardinals), Richard Nish (Giants), Allen Tapija (Red Sox), and bat-boys Donald Cisney and Mike Casson. Second row, left to right, Ray Bonham (Cardinals), Rusty Petry (Indians), Steve McLendon (Cardinals), Paul Torres (Yankees), James Davis (Yankees), Wendell Havatone (Red Sox), Alex Nish (Giants) and Leroy Bender (Indians). In the back row are, left to right, Manager Billy Baxter, coach Floyd Cisney and Coach Frank Esquibel. (Gallup Photo)

> **"Baseball is ninety perecent mental and the other half is physical."**
>
> —Yogi Berra

THE HUALAPAI STUD MUFFIN

My hunch is that Wendell was probably 15 or 16. He definitely was more mature than the rest of us, and he was built, as they used to say, like a brick outhouse.

In one game, I witnessed Wendell's "maturity" first hand. We were playing his team, the Red Sox, and at a crucial point, Wendell rounded third and headed for home as the potential winning run. Our catcher, Gene Brummett, stepped up to block the plate and receive the throw. Wendell lowered his shoulder and came into home on the fly, hitting Gene so hard that he did a back flip or two and ended up with his feet sprawled up the backstop. The umpire ruled Wendell "safe," and the Sox won the game.

In the pandemonium that followed, Gene's mom, who was in the stands, started screaming bloody murder. She wanted Wendell arrested for assault. And though there were coaches who worked in law enforcement on the scene, they declined. They tried to calm her down, but she was inconsolable. She tried to make a citizen's arrest, but Wendell slipped out of her grasp and the incident eventually died down. From then on, however, Wendell had an aura of outlaw about him.

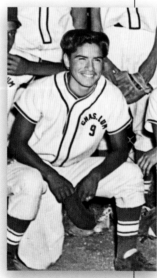

Above: Wendell Havatone, looking buff in his uniform. It's easy to see why he was catnip to the ladies.

THE 1959 NORTHERN ARIZONA LITTLE LEAGUE CHAMPIONSHIP IN FLAGSTAFF

When I was 11, and a Kingman All-Star team alternate, I didn't play one single inning. I hated riding the bench, so I was determined to give my last year of eligibility everything I had, not only to make the team but to play as well as I could.

I made the team, and I had a very good All-Star coach, Frank Esquibel, who taught me the finer points of drag bunting and how to get an extra step toward first base.

On July 27, 1959, we traveled to the big city—Flagstaff—by car caravan on Route 66. I rode with teammates Ray Bonham and Chuck Petkovitch, and our driver was "Jonesy." He was our hitting coach and worked the bug detail at the inspection station on Highway 93.

We landed at the biggest and best hotel in Flagstaff, The Weatherford, and it was my first time staying at a hotel. When we got to our room on the second floor, Jonesy told us we could use anything he had, but we weren't allowed to use his toothbrush. Although I made a mental note about this, I think he was joshing. (Jonesy also carrried little pebbles that he would give to certain players to put in their back pockets to help them play better. Alan Tapija had a great tournament and he had Jonesy's little pebble in his left back pocket for every game.)

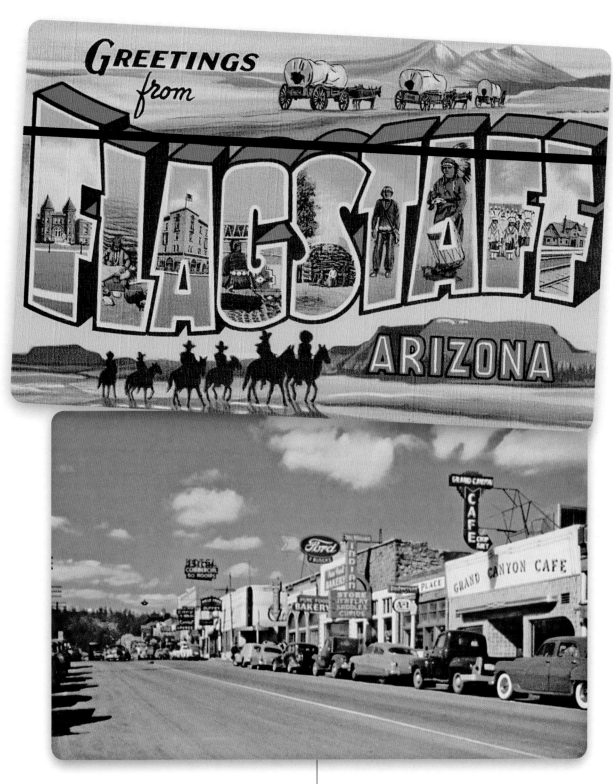

Downtown Flagstaff on Route 66. One of the hotels we stayed in was
on this block. As we stood outside waiting for a ride to the ballpark, a
carload of college girls drove by and honked. Wendell hooted and said,
"Check out those babes!" We all looked at him like he was crazy.
We were, after all, only 12.

We hadn't been in the hotel very long before Chuck Petkovich and another kid from our group threw a water balloon out the second-story window, right outside our room. It drenched a man and woman dressed up for a business meeting, and they were not happy. The hotel staff responded quickly and kicked everyone from Kingman out on the street. We ended up at a flea-bag hotel on Route 66, just east of San Francisco Street.

Things went better on the playing field. In our first game, we beat Holbrook, 7–3, on a Tuesday afternoon. Skip Davis started as our pitcher, but was relieved by Wendell Havatone in the second inning. The *Mohave County Miner*, Kingman's newspaper, later reported that coaches said Skip's arm "tightened up in the mile-high dampness and he was removed to prevent injury." The *Miner* also reported that the "game started at 2 p.m. but was called after two and one-half innings of play at 2:50 p.m. because of rain. Play resumed at 4:40 p.m." The paper said that "Wendell Havatone had two hits, with Robert Bell, Ray Bonham, Paul Torres and Heber Nelson each getting one apiece."

We advanced to play Page. Ray Bonham was our pitcher and went the distance, striking out 10 and giving up one walk.

"Kingman jumped off to a two run lead in the first inning when Allen Tapija bunted and was safe. Robert Bell bunted and was safe on a fielder's choice, and Leroy Bender walked," the *Miner* said.

"Tapija and Bell scored on passed balls before the side was retired. In the big fourth inning, Skip Davis walked and Stephen McLendon was safe on an infield error. Then Tapija walked to load the bases. Robert Bell singled sharply to right scoring Davis—Havatone then singled to score Tapija and Bell."

I have never been so successful on any playing surface in my lifetime, and no newspaper ever again mentioned me so prominently or as being so successful on the field of dreams. The *Miner* reported that I was the team's leading hitter, going 7 for 11 for an average of .636. Wendell was 6 for 10. True, I achieved this mostly by bunting and being fast, but I'll still take it. This was truly the top of the roller coaster for my sports career.

We beat Winslow in the championship game—Wendell hit a home run in the third inning—and the game was broadcast live on KAAA to the folks back home. We weren't told about the radio broadcast to keep our nerves down, which was probably a good idea.

Arizona District No. 1

LITTLE LEAGUE BASEBALL

TOURNAMENT

July 28 - 29 - 30 - 31, 1959

Grand Canyon Little League Park

Flagstaff, Arizona

Tournament Officers District No. 1

Clyde C. McGlothin — Representative Arizona District No. 1

Bernardo Gutierrez — Tournament Director

Phillip Lucero — Secretary-Treasurer

Gilbert Garcia, Paul Garcia — Official Scorers

Lalo Serrano, Everett Weldon — Announcers

Gilbert Corona — Chief Umpire
Chuck Osborn, Jack Frost, Speedy Castillo, Alfred Jauraqui, Umpires

MEXICAN FOOD VIRGIN

We were in Flagstaff for almost a week and every night we played a hide-and-seek game that took us all over the area, running and hiding and being crazy (if the coaches only knew!). We ate our lunches and dinners at a cafe on San Francisco Street. One night, Ray Bonham's sister, Jean, took Ray and me to eat at El Charro where I had my first Mexican food. I was so naive I tried to take the "wrapping" off my burrito. I thought it was some sort of thick paper. Given how much I love Mexican food today, my kids are aghast at my cuisine ignorance.

CHAMP'S TROPHY ADMIRED—Several members of the Kingman Little League All-Stars were on hand Monday to admire the trophy which they won at the Northern District playoffs in Flagstaff last weekend. Pictured above are, kneeling left to right, Wendell Havatone who pitched and batted the championship game victory; and Leroy Bender. Standing, second row, left to right, are Robert Bell, the teams leading batter; Allen Tapija who excelled in defensive play; pitcher Ray Bonham who hurled the victory over Page; and Philbert Watahomogie who was the winning pitcher in the Grand Canyon game. At the rear are team manager Bill Baxter and coach Frank Esquibel.

When we got back to Kingman, the team's leading players were asked to show up the next day for a photo op in a vacant lot across from Valley National Bank. The select crew, myself included, were there for our starring moment, but there was a slight problem. Leroy Bender showed up with Allen Tapija, and, though he played on our team, Leroy hadn't been asked to be in the photo. Rather than someone telling him he couldn't be in the photo, Leroy stepped into it and is there for all time—simply because he showed up.

That is so Kingman, and it taught me another lesson: So you weren't invited to the big dance? Just show up and you'll be surprised how often you get asked to dance.

GOING ALL THE WAY TO WILLIAMSPORT

Every Little Leaguer dreams of going to the Little League World Series in Williamsport, Pennsylvania. After we won the Northern Arizona Championship, I started to think that maybe we could go all the way. My relatives and friends told us how great we were, and I started to imagine myself winning the world title and bringing the trophy and the glory home to Kingman.

In an August 6, 1959, editorial, our hometown newspaper wrote:

"All Kingman residents share a great amount of pride in our Little League All-Star team. This group of youngsters experienced a great amount of success in tournment play this year and deserve the congratulations of every citizen.

"To manager Baxter, coaches Frank Esquibel and Floyd Cisney and the players, we say, 'well done.'

"The experience of playing and winning the northern Arizona tournament—will be one of the finest memories in the lives of each of these boys."

Truer words were never written.

Unfortunately, our first game at the state tournament in Phoenix was against the Tucson All-Stars, who had to play twice as many games as we did just to get out of the Old Pueblo.

Wally Stone, owner and broadcaster for KAAA, said that our new uniforms were very sharp and "that the Kingman squad was the best-looking team at the state tournament in their new outfits."

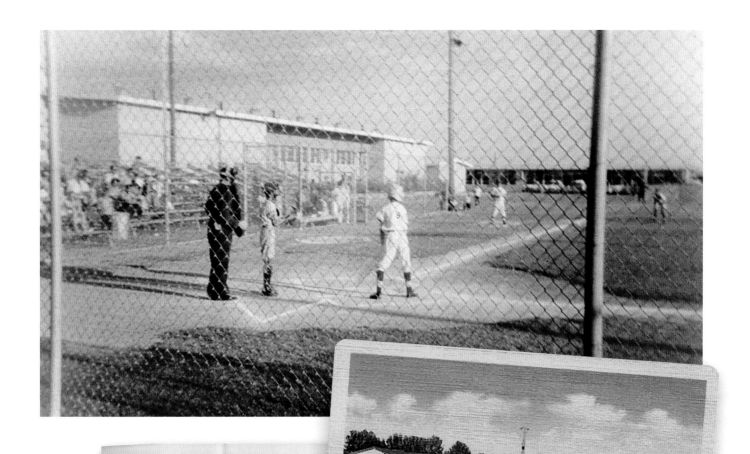

1959
ARIZONA STATE
Little League Baseball Tournament
August 3-4-5

ROSE LANE LITTLE LEAGUE PARK
12th Street at East Rose Lane

Palomine
HOTEL MOTOR COURT — PHOENIX, ARIZONA

HARRY BIVENS, Manager
1520 W. Van Buren

Top: My mother took this photo of me at bat against Tucson on August 2, 1959. Soon after this photo was taken, I struck out, then struck out two more times. Note how thin and weak the crowd is at the state championship! Crazy.

Above: We stayed at the Palomine Inn on West Van Buren and Coach Baxter gathered us in one room and told us we could have fun, but to not jump on the beds. He wasn't gone for 15 minutes before we broke every bed in the place.

Left: Official state championship program.

Right: Me, all ready to go to work.

Below right: Reg Manning sends me a cartoon.

Below: Eating junk food with Shirley Hauan after she kicked my butt.

REG MANNING
BY
REG MANNING

HOWDY BOB BELL — REG. MANNING 1-1892

The uniforms didn't help.

Not only were we shut out by the Tucson All Stars, 5–0, but I struck out three times and was yanked from the game. Tucson pitcher Ruben Duarte was huge, maybe six feet, two inches tall, and I couldn't even get a bunt down. I wasn't alone. Duarte pitched a no-hitter and Tucson shortstop England Laws drove in four runs with two home runs.

Not only that, but as a couple of us were walking around downtown Phoenix, a shoe-shine guy saw our red caps with a lone star and asked us if we were Communists.

Things got worse the next summer on our annual Route 66 trip to the family farm in Iowa. I wore my All-Star cap with all my glory pins attached and strutted around Thompson. Then my cousin Shirley Hauan asked if I wanted to play a little one-on-one baseball in the yard. She humiliated me 10–0, and I wept like the little wimp I was.

The BaBrogie Law was alive and well.

MY WORK UNIFORM

When I worked at my father's gas station after school and on weekends, this was my uniform: my Yankee baseball cap with my year pins attached, shirt, Levis, and cowboy boots. I even brought my glove and a ball because you never knew who you could be playing catch with.

COURTHOUSE MOM

My mother always worked. When we got back to Kingman, she got a job at the justice of the peace office in the basement of the courthouse. She worked for Judge Wishon, who encouraged me to draw and even sent my sketches to Reg Manning at the *Arizona Republic*. I got a nice note from Reg saying, in essence, "Good luck kid. You'll need it."

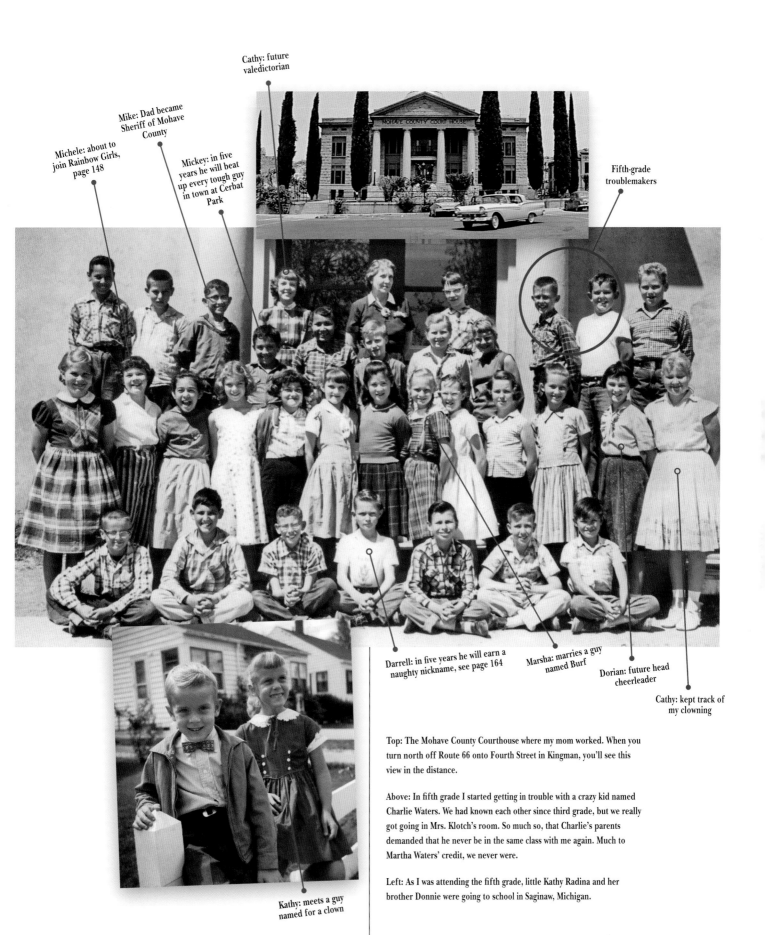

Cathy: future valedictorian

Mike: Dad became Sheriff of Mohave County

Michele: about to join Rainbow Girls, page 148

Mickey: in five years he will beat up every tough guy in town at Cerbat Park

Fifth-grade troublemakers

Darrell: in five years he will earn a naughty nickname, see page 164

Marsha: marries a guy named Burf

Dorian: future head cheerleader

Cathy: kept track of my clowning

Kathy: meets a guy named for a clown

Top: The Mohave County Courthouse where my mom worked. When you turn north off Route 66 onto Fourth Street in Kingman, you'll see this view in the distance.

Above: In fifth grade I started getting in trouble with a crazy kid named Charlie Waters. We had known each other since third grade, but we really got going in Mrs. Klotch's room. So much so, that Charlie's parents demanded that he never be in the same class with me again. Much to Martha Waters' credit, we never were.

Left: As I was attending the fifth grade, little Kathy Radina and her brother Donnie were going to school in Saginaw, Michigan.

Land of a
Thousand Dances

We knew how to Pony, like a Bony Maronie.

A RIDE TO REMEMBER

On July 4th weekend in 1957, I was a guest out at Blake's ranch in the foothills of the Hualapais. It was 14 miles from Kingman on dirt roads to the ranch compound, which was a little funkier than I expected (from watching "Spin & Marty," the serial that ran on the *Mickey Mouse Club*).

On Saturday morning, Bill Blake, Tom Penrod, (his father worked at the ranch), and I saddled three horses, and with a sack lunch made by Bill's mom, Nellie, we rode off for a cowboy adventure. We must have ridden three or four miles north until we came upon a remote stock tank and found a makeshift raft and a pole. After our sack lunch, we took turns playing Huckleberry Finn on the raft while the other two threw rocks and tried to sink the rafter. We then remounted and loped and galloped home while pretending we were being chased by In-dins the whole way.

Today, Interstate 40 goes right by the stock tank, and every time I drive by there—it's just to the west of Blake Ranch Turnoff, on the south side—I have to laugh. We seemed so far from civilization.

A HOEDOWN ON THE BIG SANDY

While I was out at the ranch, Bill's parents took me along to a dance down on The Big Sandy. The dance was held at the schoolhouse in Wikieup, some 35 miles by dirt road from the ranch.

BIG SANDY COWGIRL
All the young boys, myself included, were in love with Roxie Stephens.

Cowboys came from miles around, and the women brought cakes. The band was just a fiddle and a guitar, but there also may have been a piano. Some of the men brought booze, which they kept out of sight, either in their boot tops or in their pickups. I don't remember anybody drinking openly or walking around with a beer can like you see today.

The belle of the ball for us kids was a young cowgirl named Roxie Stephens, and all the boys my age had a crush on her. There were other cuties, of course—Jeri Penrod to name just one.

The dancing was robust but rather tame by today's standards, and there was the obligatory fight in the parking lot. (I didn't witness it. We heard about it after the fact when some poor ol' boy came in with a fat lip.)

This was an old-school cowboy dance. When I later was a drummer in college (see sequence at right), I played quite a few country venues, but that kind of honky-tonkin' was on an entirely different plane. I feel very lucky for having experienced the old-time cowboy hoedown on The Big Sandy.

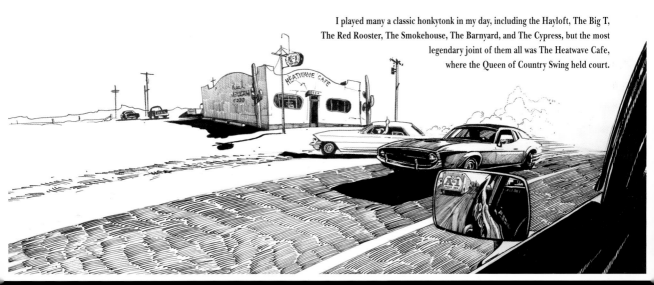

I played many a classic honkytonk in my day, including the Hayloft, The Big T, The Red Rooster, The Smokehouse, The Barnyard, and The Cypress, but the most legendary joint of them all was The Heatwave Cafe, where the Queen of Country Swing held court.

BOOT SCOOTIN' BOOTY

I witnessed plenty of lust and betrayal and flat-out fighting from my perch on the bandstand. I also witnessed interesting dancing styles, if you call interesting dance styles major horndog behavior. But every night I played, there was always one honkytonk woman who came late and closed the place. In my mind, at least, this was the legendary Queen of Country Swing: **Honkytonk Sue**.

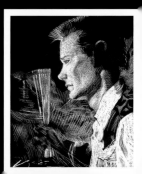

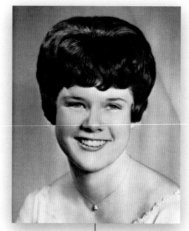
The Rainbow Girl,
Michelle Gilpin

IN OVER MY HEAD

I started dating in sixth grade because of the Rainbow Girls, a teenage group in Kingman sponsored by the Masonic Lodge. (The Masons also had a male teenage group known as DeMolay.)

Each year, the Rainbow Girls had a Rainbow Ball, where the members invited boys to a big, formal dance. Michelle Gilpin called me on the phone to ask me to the dance. It was held that year in the junior high cafeteria, and later dances were at the Elks Lodge.

I remember my mother and father teaching me to "dance" in the living room, playing old records and giving me the old one-two. I can't say I was very good, but I did catch on. And in my defense, I started early.

My parents had to drive me to these forced marches, and when they pulled into the driveway to pick up my "date," the girl's father would come out with an 8mm movie camera with a bank of lights and film me pinning a corsage on her chest. This was a horrible drill and I hated it.

Then it was a drive down to the dance, where other parents were dropping off their kids. The high school kids, of course, had their own cars, which made it even more humiliating: "Oh, there's Robert Bell and his date in the back seat and here comes his mother driving a brand-new 1957 Ford Crown Victoria with a continental kit on the back."

One of the Rainbow Ball holdovers from the horse-and-buggy days was the dance card. We would show up in our starchy suits, and the boys would be given cards, actually little booklets, and the idea was to go around and trade dances with other couples.

Now this was excruciating on a couple of counts. One was that many of the Rainbow Girls were older than us, like in high school. So here was this sixth-grader (me) walking up to, say, H. D. Wilbanks or Joe Hart and asking if he'd like to trade dances on page three. Each booklet had a small pencil attached on a string and we would write down the names we would be trading each dance. The pressure was on because my date wanted to dance with the older guys. Of course she did.

So there I was, dancing with Mary Jane Rutherford, who was in high school. With heels on, she towered over me and my head came about to her sternum—if you know what I mean. I found myself staring straight at her very large array, a crinoline rack of sumptuous portions. It was not sexy, just extremely embarrassing, though I wish I could go back and actually enjoy that view today.

The band in those ancient days usually consisted of a piano player and a fiddle, and the songs were ancient ditties, long on the hokey and short on any beat. This would soon change, however, and I am proud to say I had something to do with it.

In over my head.

148

BEEHIVES IN THE WIND

Historians can't agree where the beehive hairdo originated, but new evidence points towards Kingman, Arizona. In the early 1960s, young female prom-goers were known to shellac their hair, with massive amounts of hairspray in order to survive the windy walk from the car to the gym. And with prom themes such as "Twenty Thousand Cooties Under The Sea" and "The Wind Beneath My Heels," it was a survival-of-the-fittest choice. When all was said and done, these women could split watermelons with their hair (and often did for the amusement of their dates). But don't judge these women too harshly. Those were tough times and called for tough measures. Those early day beehive hairdos could withstand wind gusts of up to 60 miles per hour without mussing a single hair. The only downside was, with the giant wingspans on some of those early 'dos, smaller girls were actually taken airborne. One such prom date was later found near Topock. She was banged up pretty good, but her hair was perfect.

THE BIRTH OF THE EXITS

We were coming out of civics class in the new building at Mohave County Union High School when Charlie Waters stopped, then pointed at the EXIT sign at the top of the stairs.

"Why don't we call ourselves The Exits?" he asked. "Because that's where everybody is going to go when they hear us play."

Charlie and I had formed a band with Wendell Havatone in early 1963 and we needed a name. And so, The Exits we became.

We played our first gig at the Elks Lodge for $5 apiece and we knew five songs: "Your Cheating Heart" (in both a fast and a slow version), "Rumble," "My Ol' Dog Shep," "Money," and "What'd I Say." The kids didn't seem to mind the heavy rotation, and by night's end, Charlie's fingers were bleeding.

For our next gig, we rented the American Legion hall for $15 and charged 50 cents to get in. My parents chaperoned and my dad handled the door. We made $22 a man, and, more importantly, we were in business.

Unfortunately, we got sideways with Miss Deines, the girls' gym teacher and maven of the pom-pon girls. They were used to holding dances in the girls' gym, with one of the pom-pon girls bringing a record player from home and the girls reaping all the door. Now, however, the kids wanted live music.

We charged $50 for a gig, and Miss Deines thought we were being greedy. So Charlie and I ended up in the principal's office to defend our value. Poor Mr. Williams was there to arbitrate, but Charlie defended our position admirably, saying at one point, "Nothing is

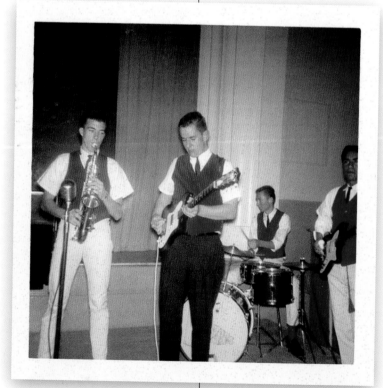

The Exits play for a dance at the girls' gym at Mohave County Union High School in the spring of 1963. The song is probably Surfbeat by Dick Dale, our signature opening. From left: Wayne Rutschman, Charlie Waters, BBB, and Wendell Havatone.

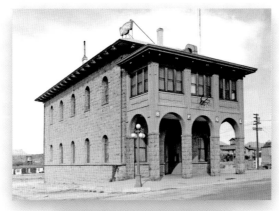

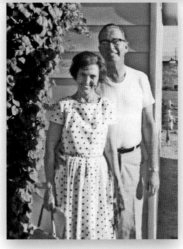

Top: The Elks Lodge on North Fourth Street in Kingman, scene of our very first gig and also, 44 years later, almost the scene of my last gig.

Above: Bobbi and Allen P. were big supporters of The Exits and often chaperoned our dances.

stopping you from doing the dance the old way, but if you want us, it's $50." (Not bad, for a couple of snot-nosed capitalists.)

Soon, though, we found out the limits of our popularity. Not long after the Deines Affair, Rusty Petry had a birthday party at his house and we found ourselves with two people at our dance at the American Legion. We folded our tent and drove our equipment up to Rusty's house on Hilltop, where we played for free by the swimming pool. After all, we weren't really doing it for the money. We were doing it to be more popular with girls.

We finally worked out a compromise with Miss Deines: we would split the door with the pom-pon girls. On Friday, November 22, 1963, I drove up to my house during our lunch hour to pick up my drums for the gig. When I pulled into my dad's Phillips 66, he came out and said, "Have you heard? The president's been shot?" I remember thinking he must have been shot in the arm or something. I couldn't imagine a president shot in the head.

I met one of my bandmates at our house on Ricca Drive, and as we loaded my drums, we turned on the television to hear Walter Cronkite deliver the news that President Kennedy was dead.

School and the dance were canceled as the country went into heavy mourning. (In Kingman, there was a virulent anti-Kennedy strain, and one kid actually laughed at the news, saying, "Why is the dance canceled? It's just a president.")

When my mother and I came home from church the following Sunday, my dad greeted us with the news that "Now they killed Oswald."

It was a bizarre period with one nightmare after another. I think it's safe to say that the giddy enthusiasm of the 1950s and the Route 66 bebop culture died right there. We had no way of knowing that it was just the beginning of even darker times.

But there would also be some respites.

In December, we watched a TV news report about an English rock band with pudding-bowl haircuts. The group had to go to gigs in an armored car, and all the girls screamed at them and threw jelly beans. "Those crazy Brits," I remember thinking. "That would never sell here."

After watching the Beatles on *Ed Sullivan* in February 1964 (really, when you think about it, they played at our wake), I went downtown to Mohave Radio Electric and bought both 45s: "She Loves You" and "I Want to Hold Your Hand." A month later, I read in the paper that the Beatles would be mounting their first American tour in August and one of the stops would be Las Vegas.

The Beatles played two shows at the Las Vegas Convention Center on August 20, 1964. We saw the first one at 4 p.m., then came back for the night show and camped out at the back loading dock area where we knew the group would be leaving from. The police cleared a route and Wayne's car was right on the edge. The police had two decoy vehicles, including an armored car, but the band came out and got in a black limo and came right by us about three feet away. We got a glimpse into the back seat, where John was upset about something and railing at the guys, and then they were gone.

A TICKET TO RIDE

I wrote and requested tickets. They sent a letter back a few weeks later that said Las Vegas kids would be served first and if any tickets were left over I could get one. I wrote it off as a lost cause. But then I got another letter saying they added another show at the Convention Center and asking how many tickets I wanted.

Since the tickets were so expensive—$7.50 each!—I could only afford three, and I quickly ordered them. Then, two of the guys who committed to joining me (Charlie Waters and Rick Ridenour) couldn't go because they were going to Boy's State. So Wayne Rutschman, who had joined The Exits as a sax player, and I drove to Vegas. We got a room at the Sahara Hotel, where the Beatles were staying, and decided we would sneak up to their room and meet them. (We almost succeeded.)

The show itself was surreal. The standard teen rock show in those days, as pioneered by Dick Clark and Alan Freed, was to have a caravan of performers, each performing for 30 minutes. The thinking was that no one performer or group was big enough to command the door. So the Vegas show had a long list of opening acts: The Supremes, The Righteous Brothers, Bill Black's Combo (I kid you not!), and a few others. All got tepid applause and, as the excitement built for the Beatles, some were hooted off the stage.

One girl sitting in front of me leaned over to her friend and asked, "Are you going to scream like those girls on Ed Sullivan?" Her friend scrunched up her nose and scoffed at how stupid that was. A few moments later, a stagehand brought out a spare Hofner bass and placed it on a guitar stand on the left-hand side of the stage. The entire arena went berserk, with the girls in front of us literally flipping out. They started jumping and screaming in mass hysteria. And this was just for Paul's spare bass!

A radio DJ came out, tried to make an announcement and to introduce the band, but we couldn't hear a word he said. It was White Noise City. Finally, he pointed to the curtain at the back and out they came. Flashbulbs went off everywhere and one reporter claimed it looked like "sheet lightning." I would agree.

The screaming was so loud we couldn't even tell what songs they were playing. At one point, Ringo sang "Boys" and we thought it might be "Money." It was that loud. And then, a half hour later, they were gone and every kid in the room had experienced the future, at least, of rock shows. As a side note, the Beatles used the house PA!

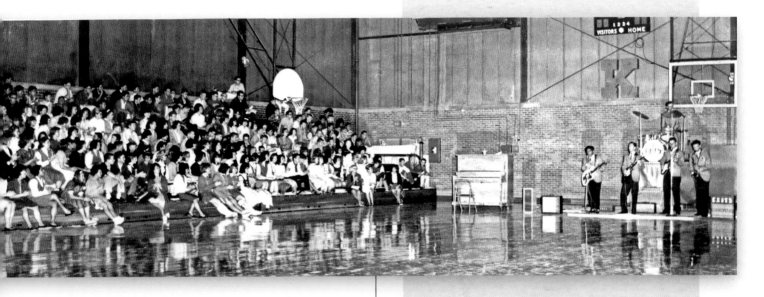

December 23, 1964, as we play for the Christmas program. On the back of this photo I noted that there were 750 kids in attendance and I also wrote out our songlist: We opened with "Surfbeat," then came "Oldies But Goodies," "Do You Want to Know A Secret?," "Do You Love Me?," "Johnnie B. Goode," "Mr. Motto," "Pretty Woman," "X.K.E." (an Exits original?), "Beetle Bailey," "White Christmas," "Merry Christmas Baby," "Silent Night" (seriously!), and then another Exits original "We're Gonna Win." Our encore was "Let's Go Trippin'," featuring the shredder himself Terry Mitchell!

As we walked out, I made a mental note: Forget history, THIS is what I want to do.

Wayne and I went downtown, where I bought four Beatle jackets ($11 each) in a store on Fremont Street. We drove home to Kingman with a plan to change our little world.

Three months later, The Exits had their Ed Sullivan moment under the basket in the new gym. On the last day of school before Christmas vacation, we did a full-blown concert for the student body with our new uniforms and our new sound. Billy the Kid seemed a long ways gone in my life. And he would be for 25 years.

THE EXITS TOP THE STONES IN 1964

According to Keith Richards, the Rolling Stones never made a dime in 1964 because of crooked promoters and all the band's travel expenses. If true, The Exits outperformed the Stones in the same time period, monetarily at least. We made several hundred dollars that year and we lived at home, so all that money was pure gravy! And, by the way, although The Exits prefer and perform the Stones' version of "Route 66," we are all quite miffed that Mick Jagger sings "Don't forget Winona, Bixlow, Bartstow, San Bernardino . . ." Bixlow?

Come on, Mick! Get a clue, man.

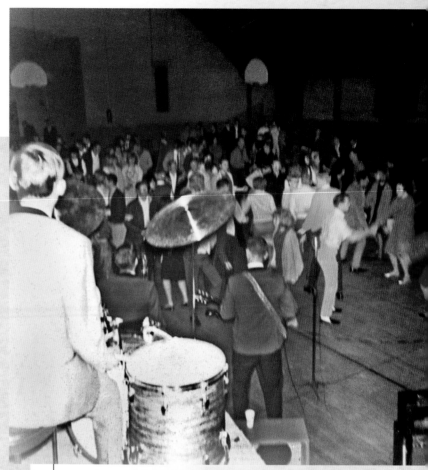

WE KNEW HOW TO PONY

Before The Exits and live music, we usually had our dances in the high school study hall. The first couple of hours were spent with very few people dancing, at least to the fast songs. The guys hung out on one side of the room and the girls huddled around the record player. One or two guys—Tinker Alvarado and Joe Hart come to mind—would have the nerve to jitterbug, but the rest of us would just stand around and watch.

Eventually, one of the girls would put "Blue Velvet" or "To Know Him Is to Love Him" on the record player. The guys would finally dance to a slow song, mashing the girls like crazy as the song or other slow ones played over and over until it was time to go at 10 p.m. If the mashing got too intense, Miss Deines would come into the hall with a ruler, measure the distance between the dancers, and tell them to "back off."

This all changed with the twist. Finally, there was a dance style that didn't involve actually touching a girl and it revolutionized our dances. With the twist came a ton of slightly different dance moves, like the locomotion, the pony, the jerk, the frug, the watusi, and the ska, to name but a few.

My parents went to Vegas in 1962 and I got to choose a friend to go with me. Rick Ridenour and I actually went out on the town to see a show even though we were only 15. We chose Chubby Checker at The Sands, who opened for Paul Lynde or Alan King (or was it Nipsy Russell?). We got a table right by the stage and I remember the cheapest thing on the menu was a $15 hamburger.

At the end of Checker's show, he asked kids to come up and twist with him. Rick was too shy, but I went up there with about five other kids and we all did the twist.

DRUM RISER FROM HELL

As a drummer, I hated being in the back. All those tall guitar geeks standing in front of me, blocking my view of the girls. And, more importantly, blocking the girls' view of me. After we saw Ringo's cool riser on *The Ed Sullivan Show*, my good friend, Rick Ridenour, asked if he could make me a drum riser in shop class. He asked how high he should make it, and I said, "Same as Ringo's, maybe four feet high." I paid for the materials ($40 in wood), and Rick built a massive, three-piece behemoth that required its own truck to hall to gigs. Here I am, above and at far right, looming over the proceedings at the girls' gym on New Year's Eve, 1964. We partnered with DeMolay and played for half the door. The band made $280.

154

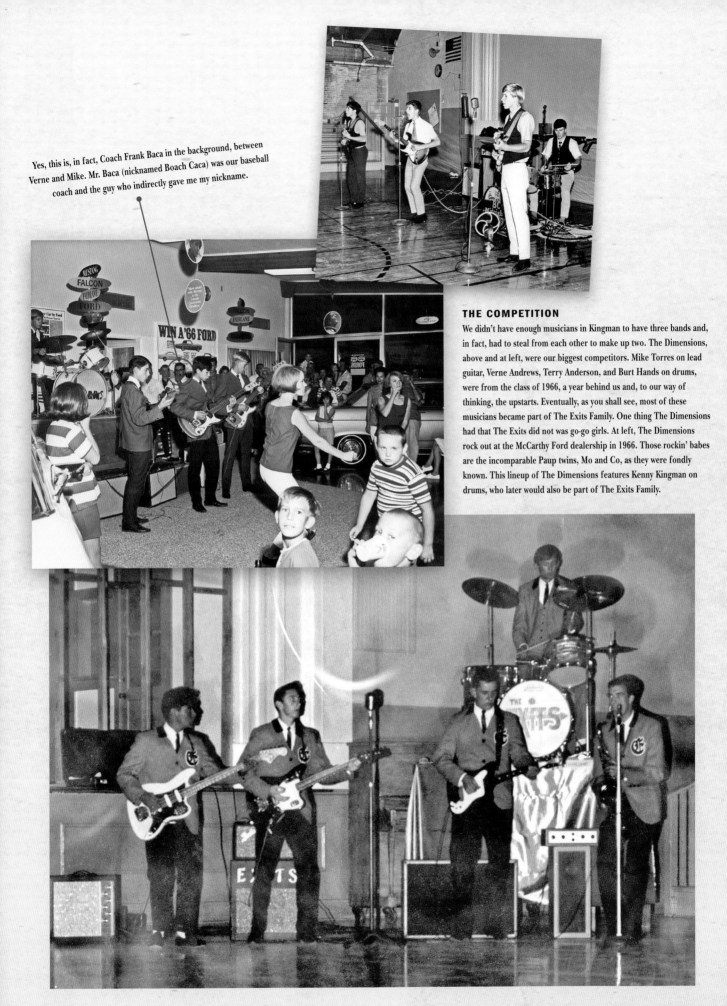

Yes, this is, in fact, Coach Frank Baca in the background, between Verne and Mike. Mr. Baca (nicknamed Boach Caca) was our baseball coach and the guy who indirectly gave me my nickname.

THE COMPETITION

We didn't have enough musicians in Kingman to have three bands and, in fact, had to steal from each other to make up two. The Dimensions, above and at left, were our biggest competitors. Mike Torres on lead guitar, Verne Andrews, Terry Anderson, and Burt Hands on drums, were from the class of 1966, a year behind us and, to our way of thinking, the upstarts. Eventually, as you shall see, most of these musicians became part of The Exits Family. One thing The Dimensions had that The Exits did not was go-go girls. At left, The Dimensions rock out at the McCarthy Ford dealership in 1966. Those rockin' babes are the incomparable Paup twins, Mo and Co, as they were fondly known. This lineup of The Dimensions features Kenny Kingman on drums, who later would also be part of The Exits Family.

TRADING GAS FOR BELONGINGS

In the 1930s, Dust Bowl "Okies" traded clothing and personal possessions for gas in order to make it to the Promised Land—Bakersfield (as Marshall Trimble so humorously puts it).

Believe it or not, this was still happening in the early 1960s. My father would come home from the station at least once or twice a week with bartered goods: a fancy pair of binoculars (still have them) or Bowie knives—lots of knives for some reason. Someone had traded the items to my dad for gas to get to California. A drum set, tool kits, and all sorts of hats.

But the one hocked item that I got the most mileage from was an 8mm movie camera. My dad brought it home in 1962, and it launched my moviemaking career. Perhaps you've heard of a few of my films. Virtually all of them played big at family functions and at frat houses at the University of Arizona. Without further ado, here are the plots and a scene or two from some of my biggest hits.

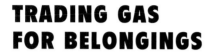

THE BLOND INDIAN

The Plot: As a teen, he (Rick Beach) ran away from home and was adopted by an In-din who was living long after his tribe was massacred and his wife was sold into slavery. You'll blanch at the insensitivity of Mohave County teenagers (Joel Edmondson and BBB), and you'll cringe at costumes featuring white T-shirts and white socks. The remote setting on North Stockton Hill Road is on a knoll that today is behind Ace Hardware.

The camera my father brought home in 1962 along with the entire stash of all my 8mm films.

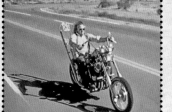

BEN GAS

The Plot: A biker (Steve "Burf" Burford) eats a bad bowl of chili and spends the rest of this painfully long film going to the bathroom. As one early critic of the film put it: "Someone on your crew has an ass fetish." In English with no sound, subtitles, or sense.

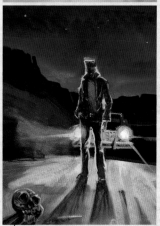

THE CARKID

The Plot: A cool cat steals the ultimate dream car, the XS-5000 from the Ford Proving Grounds, and goes on a wild and crazy joy ride across three counties and two states. He is pursued by a cagey sheriff, Garrett Patsy, who was once the Kid's friend. The Kid drives like the maniac he is, enjoying all the futuristic amenities of the dream car, such as frying eggs on the portable skillet, playing records on the LP console, and popping Fizzies in the lukewarm water stored in the glove compartment. Things really heat up when the Kid picks up a big-boned waitress with halter top issues. Get the picture? Yes, we see.

THE V-2 ROCKET FARM

The Plot: Ambushed by a German patrol, an elite squad is reduced to one man, who looks like he found his uncle's army fatigues in the basement of his grandfather's farmhouse. This ham goes deep behind enemy lines just after D-Day, searching desperately for the V-2 Rocket Farm —a Normandy farm that is disguised to look like a northern Iowa farm— that is raining death on London. Mike Richards of Osage, Iowa, plays the sarcastic French accomplice in the attack. Many German soldiers are slaughtered, one of whom was shaving when he was shot down and, to thin effect, ignominiously smeared with ketchup.

THE MO-PED MAMAS

The Plot: They all dressed in black except for Rachel who claimed it made her thighs look fat. They weren't fast, but they were easy. No guy could resist them (but, since they were all on mo-peds, he could outrun them) and no mother would allow them out of the house dressed like that except in a movie made by some goon ball neighborhood kid who promised their mothers he would cut them out of the picture if they didn't like how it came out.

MY SEMI-FINE ART CAREER

I wanted to be big and I was small. I wanted to be handsome and I had acne. I wanted to be tough and I was a wimp. And people have the nerve to ask me, "Why did you become an artist?"

My biggest problem with becoming an artist was not drawing ability. No, my biggest problem was being from Kingman and not having access to good guidance. How isolated was I? Well, in high school I was drawing surfers on black velvet and my art teacher didn't tell me this was pathetic. I remember looking out the window of my "art" class at MCUHS and watching the wind destroy the paint on someone's used Ford Falcon and thinking, "If I ever find out the secret to becoming an artist, I will come back here and tell anyone who wants to know." That was my vow. I haven't been back to Kingman to tell anyone anything, but then I haven't found out the secret either. In my defense, it's only been 50 years.

My art heroes were—and still are—Charlie Russell, Frederic Remington, and Norman Rockwell. I remember reading a story about Rockwell and some kid asked him what was more satisfying, the road to the top of his profession or arriving at the top, and he responded, "The road is the only thing."

Of course, my cartoonist heroes are a different breed of cat, and, really, these guys are from my tribe: Reg Manning, Kearney Egerton, Winsor McCay, Pat

Oliphant, Heinrich Kley, Walt Kelly, Chester Gould, S. Clay Wilson, Robert Crumb, Burne Hogarth, George Herriman, and Jimmie Swinnerton. I stand in awe of their ability to make me laugh and their artistic skills make me weep. It doesn't get any better than that.

If I ever get a chance to talk to the kids in Kingman, here is what I would tell them. Most situations in life boil down to this: make big plans, big plans fall through, NOW what are you going to do?

ANOTHER DAY, ANOTHER $10,000 PAINTING

When I was young, I had unrealistic ideas about what it means to be an artist. Today, I am much more realistic. For one thing I would never have a bed like this.

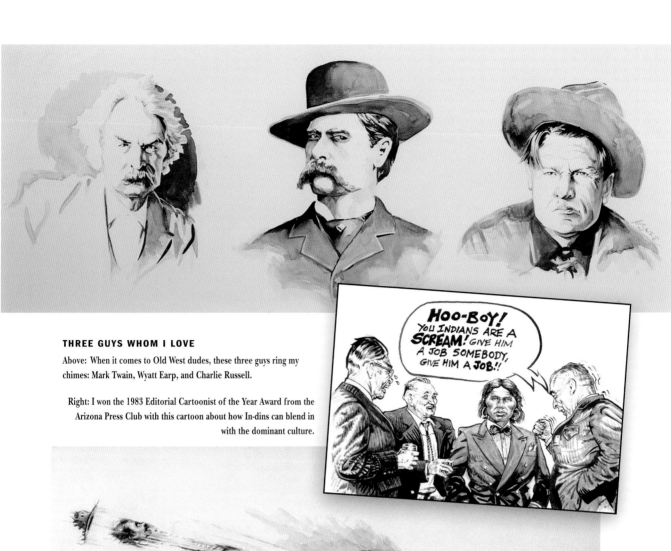

THREE GUYS WHOM I LOVE

Above: When it comes to Old West dudes, these three guys ring my chimes: Mark Twain, Wyatt Earp, and Charlie Russell.

Right: I won the 1983 Editorial Cartoonist of the Year Award from the Arizona Press Club with this cartoon about how In-dins can blend in with the dominant culture.

Above: Coming from the cartoonist side of things, here's a parody of modern-day cowboy art, by a fictitious, amalgamated artist named Russ L. Remington. Get it? The idea being, how many different ways can you tell the same tired stories? For one thing, you can amp up the violence and for another: how about surfers on black velvet?

Right: Frederic Remington spent time in Arizona in the 1880s drawing Apaches and buffalo soldiers. I have long admired his skill and panache.

159

Last Light

The mighty road

starts to

fade.

"Don't look back.
We're not going that way."

—Good Ol' Ben Rux

THE LONE KITCHEN LIGHT

As the years went by, my father discovered a more scenic route to Iowa through Durango and Pagosa Springs, rather than the crowded and increasingly dangerous Route 66 (a few summers prior we had ended up in the ditch by avoiding a jackknifing truck and only through the expert defensive driving maneuvers of my dad). We liked the Colorado cutoff route because we would leave Kingman in the summer heat and by nightfall we would be spending our first night of the trip in the cool pines.

The highlights of the day were the amazing scenery and the Navajos in wagons. But even more thrilling was the ascent over Wolf Creek Pass. Sometimes we got to Pagosa Springs too late and spent the night there, but if we were making good time we ascended the switchbacks in late afternoon light, marveling at the waterfalls and wildlife (we saw elk and deer of all kinds), and landed at Del Norte (my father did not like to drive at night). On one particular trip, we stayed at a motel in Del Norte,

got up early for day two, and hit the road by five. As we motored out across the high country in the predawn light, I spied a lonely ranch house off to our right, down a dirt road, with a lone light on. It appeared to be the kitchen. I wondered what the people in that house were talking about on this early morning. I pictured a cowboy drinking coffee and talking to his wife before starting the day. It was lonely looking, but also somewhat hopeful. That simple scene has stuck with me for all these years.

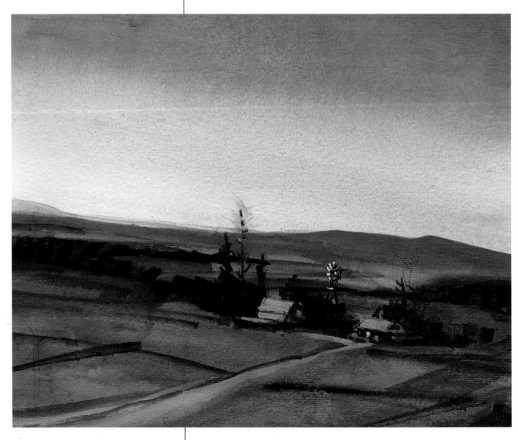

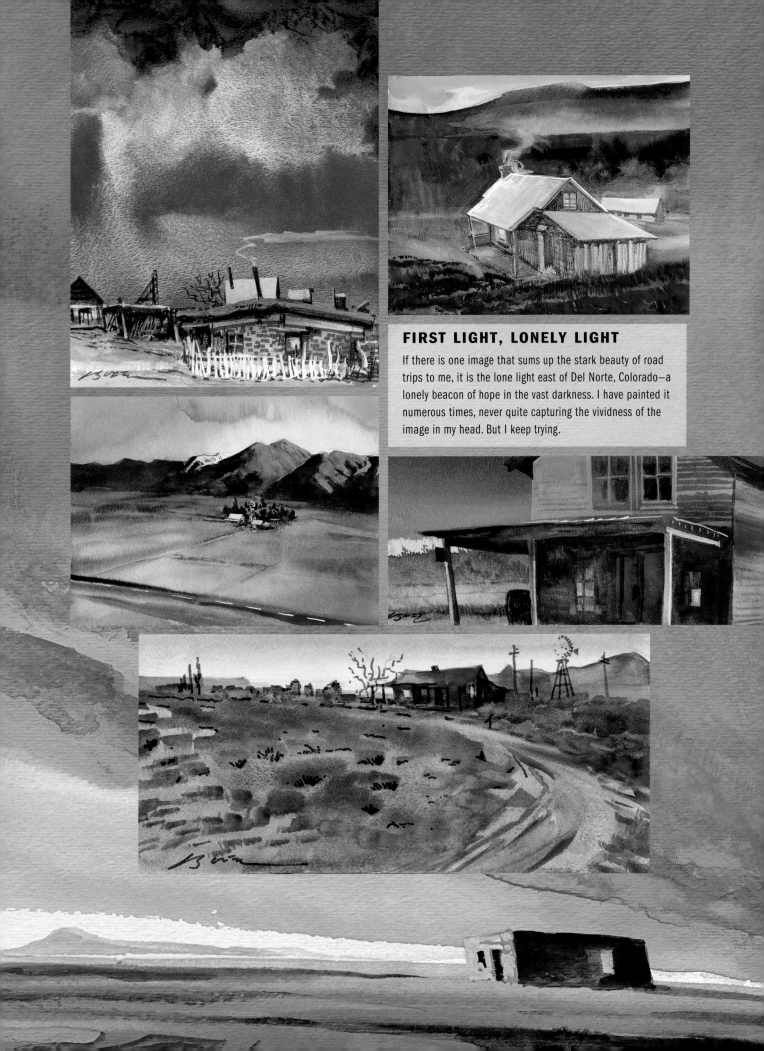

FIRST LIGHT, LONELY LIGHT

If there is one image that sums up the stark beauty of road trips to me, it is the lone light east of Del Norte, Colorado—a lonely beacon of hope in the vast darkness. I have painted it numerous times, never quite capturing the vividness of the image in my head. But I keep trying.

TWO-LANE FLATTOP

The fast, the crewcut, and the curious hit the roads in our area of Route 66 with panache and style. Who could resist these guapo gearheads? Certainly not the 66 Chix who flocked to them.

For some reason most of the guys who sported flattops in our area also sported nicknames, and we had more than a few.

"Chuey"

If you wanted the best flattop in Mohave County, Chuey Chavez was your man. He was the king of the clippers and master of pomade.

"Boxlip Darrell"

Although he grew up to be quite respectable, Boxlip had a very crude mouth in high school and got his nickname from his constant swearing ("box" being a crude euphemism for a woman's private parts) and his brazen theory that if you walked into English class and blurted out crude swear words fast and loud, our teacher, Mrs. Logsdon, would think to herself, "He can't be saying what I think he just said." Much to his classmates' amusement, it worked every day for a year and he never got challenged.

A lot of guys preferred what was known as "The New Yorker Flattop," which had wings on the side like fenders on a '59 Chrysler and combed to a duck's ass in the back—thus the name "New Yorker." "Harsh," "Burf," and I chose to strut with it.

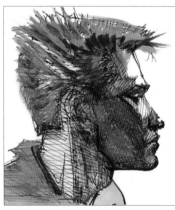

"A.T."
"Bugs"

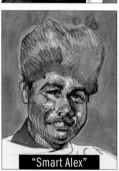
"Smart Alex"

"Salty"

"Hanki"

"Hubby"

"Chapo"

"Spud"

"Buns"

"Booger"

THE HUALAPAIS ROCK A FLATTOP

You haven't lived until you've seen a Hualapai rock a flattop. It's somewhere between a porcupine and the top of an aircraft carrier. Totally cool and totally In-din. Of course you couldn't be an In-din living on Route 66 and not have a flattop AND a nickname. Moon, Squibe, Nay, and Yashoosh were just a few of the handles the boys gave each other.

"Punchy"

"Pistol"

"Chicken"

"Del"

"Goose"

"Tinker"

"Roaches"

"Buzzy"

"Clink"

"Stayne"

"Brack"

"Horny"

FROM "LOW PANTS" JANCE TO SUN CITY HIGH WATER

Growing up in Kingman, we had a kid in the early 1960s nicknamed "Low Pants" Jance. He was a bad boy. Low pants have long connoted rebellion, but with age the opposite happens. Today, guys who wore their pants low probably live in Sun City, and their pants no doubt have crept northward. As comic Jeff Altman puts it: "My dad's pants kept creeping up on him. By 65 he was just a pair of pants and a head. He had to unzip his pants to drive."

THE MOST AMAZING AND SCANDALOUS NICKNAME OF THEM ALL

Every election in the late 1950s, one "Harry Nipple" received a write-in vote (probably his own) for political office and the *Mohave Miner* was obligated to print his name and acknowledge the one vote. This was absolutely thrilling for a 14-year-old kid to see in a family newspaper and I would call all my friends to make sure they saw it. The word was that Harry's first name was Caesar, which would make him Caesar Harry Nipple. I kid you not. And lest you think this was made up, come to find out Mr. Nipple was a real person (and a real character), born in 1876. He no doubt knew Ben Rux, and ran a whorehouse at McConnico until his death in 1962. He was 85.

165

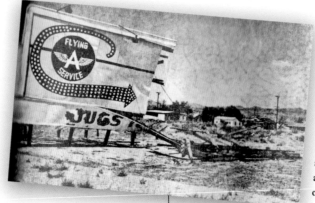

OMINOUS WINDS

Kingman is notorious for wind. In the summer it feels like a blast furnace and in the winter it can feel more like a meat locker in a wind tunnel. In the late 1950s an especially strong wind storm destroyed my father's Flying A sign (above) on east Route 66 near the Felspar plant.

There was an ill wind blowing elsewhere as well. In early 1962, the parent company of Flying A, Tidewater Oil Company, told my father it was going to raise his lease and he said no. When push came to shove, my dad walked.

Around this same time, we saw surveyors putting in stakes to the north of our house on Ashfork Avenue, and when we asked what it was for, they wouldn't tell us. A rumor soon circulated it was for a proposed bypass. We didn't know it at the time, but the rumor turned out to be true.

At the end of the Flying A run, my father started negotiations with Phillips 66, who had aggressive plans for the Kingman area and, in fact, were soon to take over most of the Flying A stations. A site for a new station was chosen just west of the Hilltop Motel and soon backhoes and skip loaders were carving out a cut for what would become Mohave Petroleum Company and the site of my dad's next gas station, Al Bell's Phillips 66. In the beginning, my dad had two partners, Stubb Schaeffer and Maurice Burnham, and they also took over the former Flying A Truck Stop at

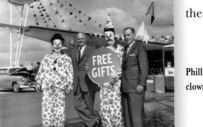

McConnico, which proved to be a financial drain and eventually took down the entire enterprise.

A NICKNAME IS BORN

Phillips 66 was fond of hiring clowns for its grand openings, and when the time came to open my dad's new station it so happened there was a severe shortage of professional clowns in the Kingman area. My dad asked me if I would step in and be the clown, and since I had been the class clown at school for close to a decade, it was a no-brainer. At the last minute, a real clown showed up and worked the grand opening, but the rumor that I was the Bozo working the pumps hit the school like a Kingman wind storm and I was soon getting grief from the usual loud-mouthed jerks (led by one Arnold D. Thomas).

Fast forward to a scrimmage baseball game with Needles at the high school, when I hit a line drive to shallow right and when the fielder flubbed the ball, I easily breezed into second base, running backward from first to second, to taunt our archrivals in the process. Coach Frank Baca, also our Spanish teacher, yelled from the bench, "Piaso!" which is Spanish for clown, and the next thing you know, I had a new handle for the rest of my life.

Phillips 66 was fond of hiring clowns for grand openings.

A "RUNNER" GETS A FREE SNOWCONE!

Sometimes when my father was away, we got a little wild at the Phillips 66 station. I have already mentioned our disgust for "runners," gas customers who pulled in, saw our gas prices, and fled. One busy summer day after we had a flurry of runners, Ralph Stayner finally snapped as yet another runner bolted.

We saw Ralph suddenly turn and run back to the lube room. He opened up the ice machine, grabbed a handful of crushed ice, and, on the run, made a snowball out of it. The runner was still at the curb waiting for an opening on the busy highway. As the car finally got an opening and took off, Ralph hurled the ball of ice and it arced very high across the driveway and landed square on the roof of the car. It sounded like a bomb went off. The car screeched to a stop. The horrified driver got out to see what the hell had happened, saw the ice, looked back in our direction, and saw two of us running for the hills. But Ralph stood his ground with his hands on his hips. We watched from the top of the cut behind the station as the tourist pulled his car back into our driveway, got out, and got right in Ralph's face. We couldn't hear what he was saying because we were too far away, but he was shaking his fist at him in a threatening manner, and we kept expecting someone to throw a punch but there were no fisticuffs. The tourist did demand to use our phone to call the police, which he did. By then we had returned to the office and it was a tense 15 minutes as we waited.

Finally, a deputy showed up, who we all went to school with (ah, small towns!) and he listened to the man rant about a lawsuit and pressing charges. The deputy finally told the belligerent tourist he was on private property and he had no grounds for an arrest. The guy fumed and drove off, flipping us all the bird as he went. Damn me if you want, but this is one of those *Deliverance* stories where I'm proud to be on the inbred side of the equation.

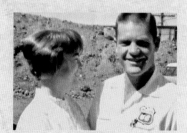

Ralph Stayner was a babe magnet. This visitor
to the station is Lynda Kingman (yes, her
name was the same as her hometown.)

On a very hot July day in the late '50s, I was traveling with Dick and Charlie Waters when we stopped at Sailor's Camp on Highway 93. Mr. Waters bought us a soda and we sat outside to drink them. I bought a Nesbitt orange and I have to say it was the best drink I've ever had in my life.

JUST PASSING THROUGH

Literally millions of people came through Kingman on Route 66. Here are a few you might recognize.

1 EDGE OF ETERNITY (1959)

We were sitting in the Tydway Cafe during a slow time at my dad's Flying A when a black '57 Ford pulled into the outside lane and three guys got out. One wore a beret (Don Siegal, the director) and he started framing shots with his fingers, mimicking a view finder. It turned out they were from Hollywood and wanted to use my father's station in a movie.

Several months later, my dad and I got up at four to open the station early for the shoot. A whole caravan of big gray trucks pulled in, and grips unloaded lights and reflectors with cables running everywhere. The large crew took over the entire driveway and the office.

Veteran character actor Dabbs Greer played the Flying A service station attendant, as Cornel Wilde, the star, pulled up in his sheriff's cruiser right at sunrise and got out to ask questions. The scene, which runs less than a minute in the final movie, took several hours to film.

During a break, Cornel stood next to me in the lube room and said, "You're up early." I agreed, but was too shy to say anything else.

The resulting movie, *Edge of Eternity*, premiered at the State Theater early the next year (1959), and it seemed as if the entire town was there oohing and aahing at the many scenes filmed around the town and the county. Today, the film is a wonderful time-capsule snapshot of Kingman in that era.

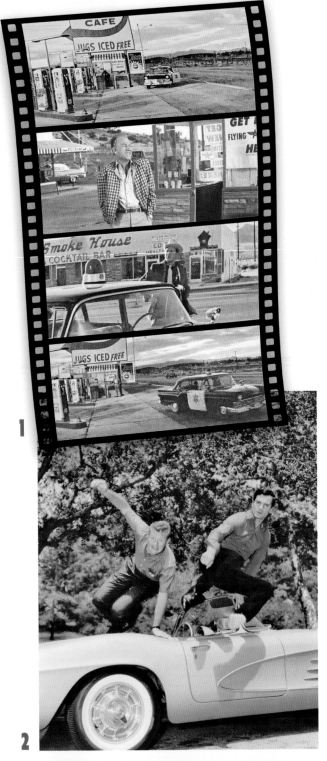

2 ROUTE 66 (1966-1969)

This lame show was one of the worst cases of false advertising in the history of television. It was rarely, if ever, filmed on Route 66, and Arizona episodes were filmed in Tucson, Scottsdale, and Lake Havasu—none of which are on Route 66.

The producers also wouldn't pay for the Bobby Troup version of "Route 66," so they hired Henry Mancini to do a "tinkling of the ivories" dittie that creates a tea-time feeling and is anything but road-worthy.

Jack Kerouac sued for copyright infringement (two guys *On the Road* getting their kicks) but lost. In spite of all this, the show was a hit, especially in Europe. And as much as I hate to admit it, the show is part of the reason the road is an international icon.

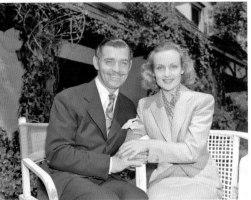

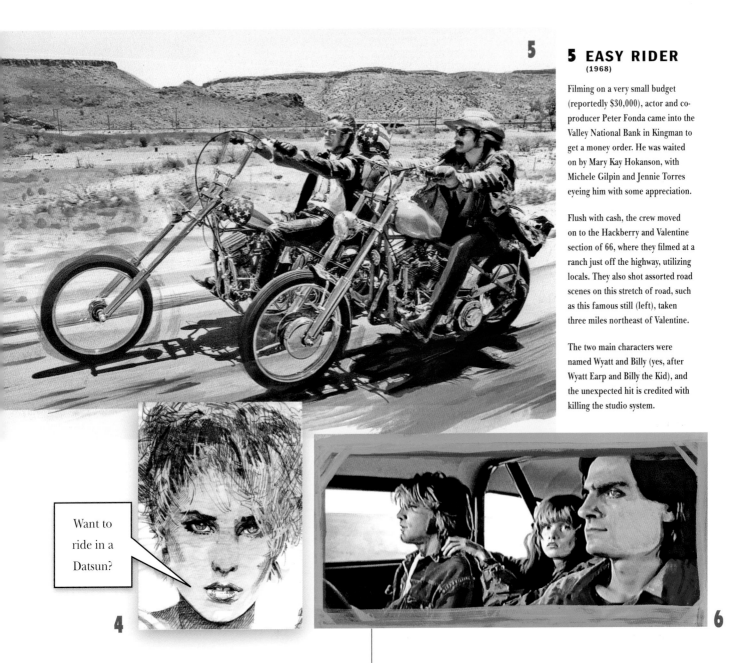

5 EASY RIDER
(1968)

Filming on a very small budget (reportedly $30,000), actor and co-producer Peter Fonda came into the Valley National Bank in Kingman to get a money order. He was waited on by Mary Kay Hokanson, with Michele Gilpin and Jennie Torres eyeing him with some appreciation.

Flush with cash, the crew moved on to the Hackberry and Valentine section of 66, where they filmed at a ranch just off the highway, utilizing locals. They also shot assorted road scenes on this stretch of road, such as this famous still (left), taken three miles northeast of Valentine.

The two main characters were named Wyatt and Billy (yes, after Wyatt Earp and Billy the Kid), and the unexpected hit is credited with killing the studio system.

Want to ride in a Datsun?

3 GABLE AND LOMBARD

In 1939, the sexiest man alive at that time, Clark Gable, drove to Kingman on Route 66 with his girlfriend, actress Carole Lombard. They were married at St. John's Methodist Church (the same church my parents were married in five years later).

4 "TAKE IT EASY"

The song is a classic. But in real life, songwriter Jackson Browne was actually standing at a Der Wienerschnitzel on Route 66 in Flagstaff, Arizona, and the girl who slowed down was in a Datsun, not a flat-bed Ford.

6 TWO-LANE BLACKTOP (1971)

Two street rod racers—James Taylor was the driver and Dennis Wilson was the mechanic—cross Route 66 backward, from west to the east, racing for pink slips. You can hear a snippet of our local radio station (KAAA) on the radio as the two approach Kingman, coming up through Perfume Pass.

With the notable exception of Warren Oates, the acting is wooden and the story ends on a ridiculous note: the film burns in the projector, the effect causing angry car honking whenever the movie played at drive-ins.

But the real stars of the movie (besides Oates) are the '55 Chevy and the road scenes. Filmed on actual locations all along Route 66, the scenes are breathtaking, and in spite of its many flaws, it's one of my all-time favorite road pictures.

THE 66 CHIX

After our Little League experience, we eventually caught up with Wendell, and the view in Kingman suddenly got a whole lot better. I don't know if it was the hormones or the water, but I have long thought the Kingman girls were the best-looking females on Route 66.

My newfound appreciation for the opposite sex was not limited to the locals, of course, and I fell in love with many of the wonderful women traveling up and down the road.

1 Jan: first kiss, first love.

2 Sweet Martha taught me how to eat with a fork.

3 Karen's mother was also a raving beauty and the apple from that tree fell right on my heart.

4 Her name was Dehlia, and we met at a dance in Peach Springs. She sure made me want to go native.

5 I first saw BB at the State Theater on a Saturday afternoon. She was playing a guitar in a weird movie, but her pouty lips leapt off the screen. I made a vow then and there to someday find her and make out with her.

6 Mary Kay was older and wiser and hipper than me, and I have a hunch she still is.

7 Jane busted out of nowhere in *The Outlaw* and I was a huge fan of her huge talents for a long time.

8 Julie London had great road cred: she married Bobby Troup!

9 While I was rocking out at the girls' gym at Mohave County Union High School, Kathy Sue was a freshman at Washington High in Phoenix, and it would be 12 years before we met at her boyfriend's wake.

10 Jennie was a sexy little pistol. A close encounter on the way back from Needles proved she was way over my head.

11 Some girls were royalty and just out of my league, but like most boys I made up for it by dreaming big.

12 Some girls were late bloomers and none of us saw it coming, but we later lamented our lack of foresight.

13 Fay tried to teach me English, but failing that, she allowed me to entertain her classes every day.

14 Debbie was so dang cute in *How the West Was Won*, and she supposedly stayed at the Kingman Travelodge at the bottom of the hill during filming in Oatman. I would finally meet her at Hugh O'Brian's house in Benedict Canyon 48 years later, and she was still as cute as a bug's ear!

15 I had a date with Annette every school-day afternoon on *The Mickey Mouse Club*. The way she filled out that sweater is still a thing of mystery and beauty.

16 Terry had a thing for drummers and cartoonists, and for once I fit that job description to a sweet T.

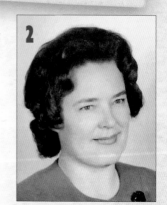

LIKE BEING IN A MOVIE

"Growing up in Northern Ireland, Route 66 always had a special place in my mind. I grew up enchanted with the movies set on that road such as *The Grapes of Wrath*, *Thelma & Louise*, and of course *Easy Rider*. I made a vow to someday travel to America and see it for myself. Route 66 is the fantasy road, leading to Hollywood and the most beautiful women in the world. Eventually in 2005 I moved to Arizona and was able to drive the road for myself. To this day, whenever I see a road sign for Los Angeles, I feel like I'm in a movie."

—BRYAN BLACK

4

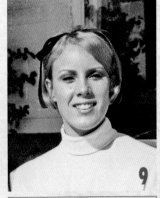

9

14

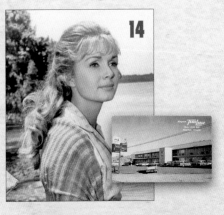

5

PROM DATE!

10

11

...AND I FEEL THE SAME WAY ABOUT YOU— **TAKE ME.** YOU CLODHOPPING YAHOO!

ANNETTE | 15

6

8

7

12

13

16

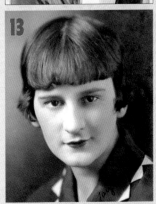

NIGHTSPOT, HOTSPOT

Built in 1948 the structure was a laundry for three years before it opened as the City Cafe in 1951. During its long run, the City Cafe not only attracted tourists with it's 100-foot flagpole sign, but the venerable nightspot became popular with local teens as well, and it became the spot to hit after a football game or a dance at the girls' gym.

After I graduated from Mohave County Union High School in 1964, I worked the graveyard shift as a waitress at the City Cafe. It was the happening place for local late-nighters and tourists since it was one of few restaurants in Kingman open 24 hours. It was hard work, and the cook, a guy named Shorty, yelled at the waitresses if we didn't pick up the orders ASAP. I remember coming home at 6 a.m., smelling of grease but happy with my good tips. I had one couple from California, however, who came to the cafe in a chauffer-driven Rolls-Royce. They were obviously rich, but did NOT leave me a tip. I knew then that I never wanted to wait tables again!!

—Mary Kay Hokanson

My sister Renee and I worked as waitresses at the City Cafe after I graduated from high school. This guy came in every day and played "Ring of Fire" by Johnny Cash on the jukebox, then he'd sit at the counter, leaning forward with his arms crossed. He'd push his muscles out with his thumbs behind his biceps and stare at me for the entire song. He came in every day and did this. I hated that song for years.

—Jan Prefontaine

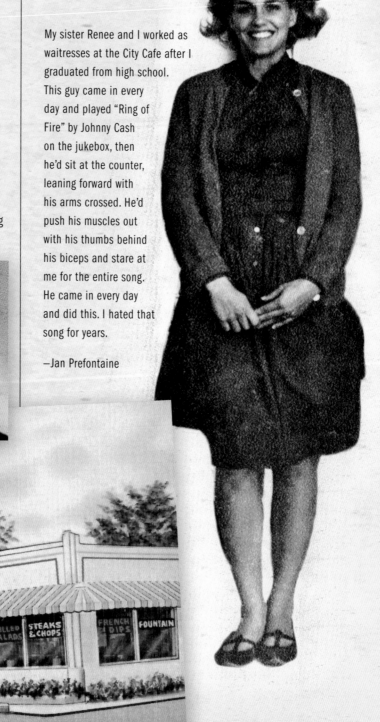

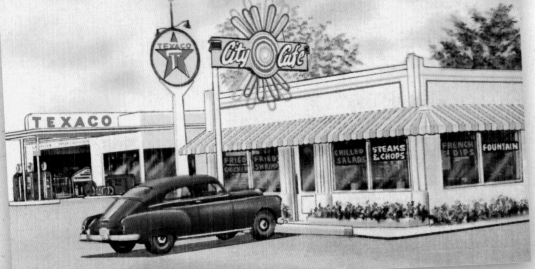

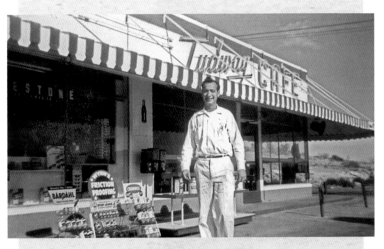

THE B.S. UNION

It's just a theory, but there must be a union somewhere (Chicago?) that sends out a B.S.'er to round out every work crew in the United States. The guy's job is to arrive on a work site, squat down, spit, and say, "That's nothing, one time I . . ." At Al Bell's Flying A, that B.S.'er was this guy, Tom Booth. Man, he could spread it thick.

MR. MOTORMOUTH

In my sixth-grade class, Mrs. Bonelli instituted a fine for talking when we were supposed to be studying quietly. She assigned one of her pets, Cathy Cannon, to mark down every time someone talked when they shouldn't. I, of course, could not go very long without talking out loud because I had to entertain the class—my mission in life!

When Cathy would catch me talking, she'd make a big deal about opening her notebook and, with an exaggerated flourish, putting a mark under my name. I would tell her this was not fair and she would make another mark. Then I would make a face at her and she would make another mark.

I had amassed $5.80 cents in fines by the end of the semester. (Jimmy Covarrubius was closest to me at $2 and change). When the bill came home, my parents were very upset, until they found out all the money raised would go to cancer research. The *Mohave County Miner* sent a photographer to take a picture of the class, featuring me as the top donor.

I didn't realize it at the time, but the motormouth skills I was honing in Mrs. Bonelli's class would later pay me big dividends.

Paul H. Lomasney

THANKS TO BILLY THE KID, I GOT MY BUTT BEAT

In eighth grade we had a history teacher who had a metal plate in his head from injuries received from the landing on Omaha Beach during D-Day. Mr. Paul Lomasney was a former Army Ranger (and by his telling, Paul Anka played him in the movie *The Longest Day*), and if ever a lecture was getting boring, all you had to say was, "Is there a draft in here?" And Mr. Lomasney would say, "That reminds me, I was drafted once." And off he'd go on a tale of Battle-of-the-Bulge fighting. Our fearless leader hailed from Las Vegas, New Mexico, and although he had a begrudging respect for the German fighting man, he had no love for Billy the Kid. When I raised my hand one day to ask why, he snorted, "Billy the Kid shot everybody in the back," to which I said, "He didn't shoot them in the back—they just didn't turn around fast enough." I got a big laugh from the class and an invitation to come up to the front of the room and bend over and grab my ankles. Two swats later, I sat down gingerly (it really, really stung), but I wore my punishment proudly.

"Did it hurt?" everyone wanted to know at recess. Yes, I admitted, as I leaned against a spindly tree on the playground, but it was worth it. Those were the first of several swats I received during my school career in Kingman, and I have to say I am a better person for them. For my money, if you can't stand up for a butt-beating, you really don't deserve the forum to say anything.

> ## "What happens when too many people show up for the same dream?"
> — RICHARD RODRIGUEZ

WE FINALLY GET HIP TO THE TIMELY TIP

We lived on the highway of dreams, but we stopped about 350 miles short of the destination everyone else was heading for. Talk about ironic. And there we sat for a decade or so, waiting on the people every day who were on their way to the California dream.

We finally made it to the coast in 1963, and only then because my father's brother and his wife had a baby boy and my grandparents wanted to see him. Carl and Minnie Bell drove out from Iowa to our house, then we all got in my dad's Oldsmobile and drove to California on Route 66.

The trip was memorable. I had been to Needles many times on sports trips but never beyond it. It was easy to see the attraction. To come out of the barren deserts of Barstow and Victorville, top Cajon Pass, and then drop into the dewey green of the coastal valleys was, and is to this day, a feast for the eyes. An oasis of lush opportunity.

We landed in Long Beach where Glenn and Claudia Bell had an apartment. There were so many Iowans in the Long Beach area that it was known as "Iowa by the Sea." They had an annual "Iowa Picnic" and 10,000 people would show up.

My uncle Glenn was a great host and he took us to Disneyland, Knott's Berry Farm, and Forrest Lawn Cemetery. Everything there seemed so fresh and green and new. We had fantastic burgers and milkshakes at Bob's Big Boy and wonderful breakfasts at Denny's. Even the bowling alleys seemed amazingly futuristic.

For a time we considered moving there as well, but ultimately we stayed in Kingman. And I'm glad of it.

THE SURF WAR

A little-known fact is that "Surfin' USA," the Beach Boys' first national hit, broke in Phoenix, Arizona. For some strange reason, surfing and surf music was a huge deal in Kingman, and the early Exits' playlist was dominated by that music.

The first counterculture altercations in our area were between the cowboys and the surfers. A big turf war broke out in the high school in 1966, culminating with a showdown on south 66 between the surfers from Lake Havasu and the cowboys of Kingman. You could easily get in a fight by not wearing socks.

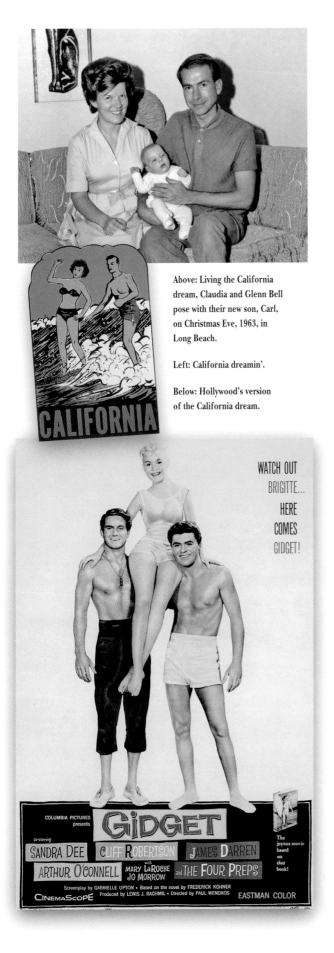

Above: Living the California dream, Claudia and Glenn Bell pose with their new son, Carl, on Christmas Eve, 1963, in Long Beach.

Left: California dreamin'.

Below: Hollywood's version of the California dream.

Philbert "Nay"

DIAMOND CODE TALKERS

One of the joys of being on the road with a baseball team made up of In-din talkers was when Philbert Watahomogie, a Havasupai, was on the mound, and Alex "Nay" Nish, a Hualapai, was catching. The beauty of this arrangement is that they didn't need to use the usual hand signals between the legs for curves or fastballs since the Supai and Hualapai are cousins and their languages are very similar.

So, Philbert simply leaned forward, off the mound, stared at the batter, and said, in In-din, "I don't think this guy can hit a curve." And Nay would reply, in In-din, "No, I think he grabbed the corner last time. Let's try a fastball and then a change-up. He seems to be a little nervous."

By this point, the batter would be crossing himself, stepping out of the batter's box, and looking at the umpire as if to say, "Is this legal? Can they talk like that?"

What a treat it was to witness this, and I don't think I would have had that experience if we had gone all the way to California to live the American Dream.

Which leads me to this road lesson: for everything you lose, you will gain something, and for everything you gain, you will lose something.

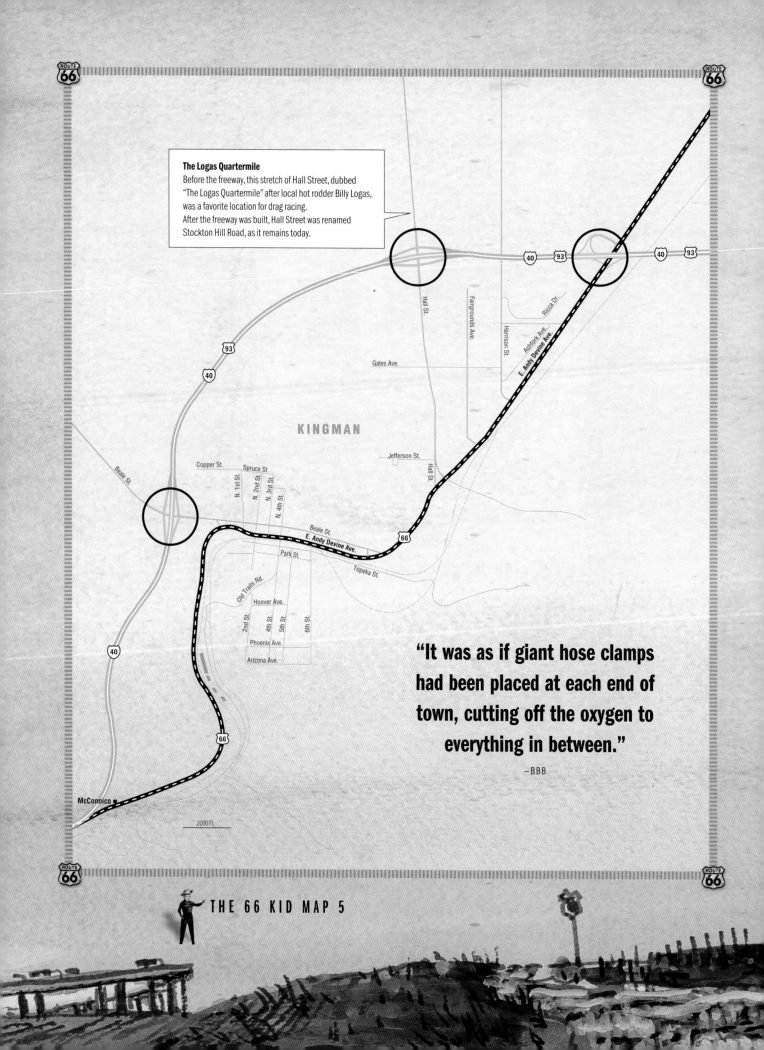

The Logas Quartermile
Before the freeway, this stretch of Hall Street, dubbed "The Logas Quartermile" after local hot rodder Billy Logas, was a favorite location for drag racing.
After the freeway was built, Hall Street was renamed Stockton Hill Road, as it remains today.

40 93

93

40

KINGMAN

Beale St.

Copper St.

Spruce St.

N. 1st St.
N. 2nd St.
N. 3rd St.
N. 4th St.

Gates Ave.

Jefferson St.

Hall St.

Fairgrounds Ave.

Harrison St.

Ashfork Ave.

Ricca Dr.

E. Andy Devine Ave.

40 93

Hall St.

Beale St.
E. Andy Devine Ave.
66

Park St.

Topeka St.

Old Trails Rd.

Hoover Ave.

2nd St.
4th St.
5th St.
6th St.

Phoenix Ave.

Arizona Ave.

40

66

McConnico

2000 Ft.

"It was as if giant hose clamps had been placed at each end of town, cutting off the oxygen to everything in between."

—BBB

The End of the Road

We chased ghosts

until the ghosts

chased us.

"I drank my share, Kid."

— ALLEN P. BELL, WHEN I ASKED HIM IF HE EVER WANTED ANOTHER DRINK

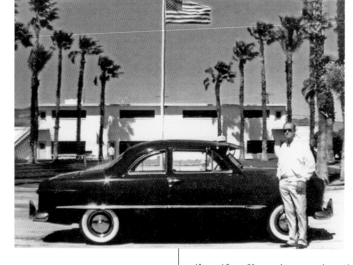

BYPASSED!

The end was quick. By 1974, the mighty road we grew up on was on the ropes. It was as if giant hose clamps had been placed at each end of town, cutting off the oxygen to everything in between.

The hospital had moved to Hilltop, on almost the exact spot where the starting line of the Billy Logas Quartermile drag strip was located, so far out of town. Downtown Kingman gradually became a shell of its former self. By the end of the 1970s, Central Commerical closed, JC Penny shut down, the Beale Hotel, the drugstores, the movie theater, Alex's Toggery, even the dime store bit the dust. But it wasn't just the stores and the buildings that suffered.

My parents divorced in 1968. My father's drinking didn't help, and a total lack of communication did the rest. Both remarried—my father in 1971, my mother in 1972. My father, who long made his living in gas stations, found employment at Ford Proving Grounds in Yucca and worked there for the next 21 years, retiring in 1991.

Ford paid for my father to go into alcohol rehab, and even though many predicted he would relapse, he stayed sober for the rest of his life. When I asked him if he ever wanted a drink, he said, "I drank my share, Kid."

Above: After a 30-year stint as a service station career, my father went to work at Ford Proving Grounds in Yucca, Arizona, on Route 66. He is seen here, posing with his pride and joy, the Bell family 1949 Ford bought new at Senseth Motors in Forrest City, Iowa. The speedometer, he liked to brag, had 30,000 actual miles on it.

Bottom left: My father remarried in 1971 to Shirley Bridges. She was a great sport and got my father to loosen up a bit (he's actually wearing Levis in this pic!). They bought a travel trailer and did many road trips. I painted a mural on their wall in So Hi Estates on the edge of Golden Valley, outside Kingman.

Bottom right: My mother married a pilot, Lou Cady Jr. in 1972 and they also traveled extensively, moving around the country with homes and stints in Fort Smith, Arkansas; Oak Ridge, Tennessee; Annacortes, Washington (where Lou bought a fishing boat); and finally Cody, Wyoming, where they lived three different times.

Top: The mighty beasts that roamed Route 66 are now mostly rusty ruins and housed in junk yards like this one outside Grants, New Mexico.

Above: My father's Mobiloil gas station at Peach Springs was a shell of its former self in 1991 when this photo was taken. It has since been knocked down and even the foundation is hard to find.

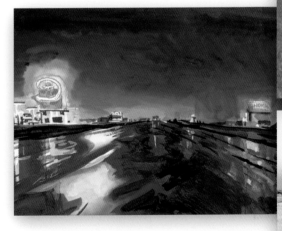

Above: By the late nineties the buggy, neon nights of my youth were mostly a memory.

ON THE ROAD TO FATHERHOOD

On July 28, 1979, at Pioneer, Arizona, I married the girl who I had met at her boyfriend's wake. Kathy Sue Radina gave me two children, Deena Carolina and Thomas Charles (yes, named for Charlie Waters), and together we hit the road for many an adventure. Today my kids carry on the tradition started by my father: get up early, find great road food, and make time.

In 1984, I finally steered our Ford van in the direction of Billy the Kid's grave. Here we are (below) at a Fina gas station just north of Socorro, New Mexico. Two eager towheads, Tommy, 2, and Deena, 4, were already seasoned road travelers. It had taken me 27 years, but I finally got to stop the car at the lonely grave of the Kid outside Fort Sumner, New Mexico. My kids were not that impressed.

179

A CRAZY CAREER

After high school I attended the University of Arizona in Tucson from 1965 to 1969, majoring in art. For several summers, I came home to Kingman and worked as a surveyor on the new Interstate 40 bypass.

Those were wild times and I won't go into detail but a brief stint in jail at Nogales will give you a taste.

After moving to Phoenix in 1970 and working as a draftsman for $110 a week, I partnered with Dan Harshberger to produce *The Razz Revue*, a quarterly humor magazine. It lasted four years and 16 issues and made zero money. But we learned a valuable lesson: publishing is fun to do, but very, very hard to make a living at. I also labored hard at playing in rock bands such as Smokey, The Weeklies, and The Zonies for the better part of three decades.

After *The Razz* tanked, I went to work for *New Times Weekly* in Phoenix as its art director. In addition to my $110 weekly salary, I got an extra $25 a week for a comic strip called "Honkytonk Sue," which I wrote and produced for the paper.

In June 1980, I sold movie rights for "Honkytonk Sue" to Columbia Pictures for $30,000. While also self-publishing four comic books of Sue material and flirting with syndication, it never quite made the grade.

I copublished a book of my editorial cartoons, *Low Blows*, with *New Times* in 1984, which sold out, and followed it with another book, *Even Lower Blows*, which did not.

On a 1986 promotional tour of Phoenix-area radio stations, I did a guest stint as the newsman at a new classic rock station in Scottsdale—KSLX, 100.7. When I got off the air, the program director offered me a job to do to the news what Ferdinand Marcos did to the Philippines. "The Jones, Boze & Jeanne Show" was suddenly born, and I had a radio career that would last for the better part of a decade.

In October 1992, after no legitimate publishers would take the bait, I self-published my first Old West opus, *The Illustrated Life & Times of Billy the Kid*. My father loaned me the $5,000 seed money.

In July 1999, two crazy friends joined me in buying *True West* magazine, and we moved the offices from Oklahoma to Cave Creek, Arizona, where we remain today.

With Arizona's centennial statehood celebration approaching in 2012, my new *True West* partner and publisher, Ken Amorosano, and I pitched Channel 8, the PBS affiliate in Phoenix, about doing an irreverent show called *Outrageous Arizona*. It premiered in August 2012, co-hosted by myself, Marshall Trimble, and Jana Bommersbach, and it won a regional Emmy.

It's been a crazy run, but I've had my fun. Anything from here on out is pure gravy.

The *True West* staff, taken October 29, 2012, at the *True West* World Headquarters in Cave Creek, Arizona. From left to right: Meghan Saar, Robert Ray, BBB, Ken Amorosano, Greg Carroll, Rebecca Edwards, Carole Glenn, Chad Hays, Leah Bohlander, Dan Harshberger, Ron Frieling, Sue Lambert, Marshall Trimble, Jana Bommersbach, and Sheri Riley.

In the '80s I shared studio space with Ed Mell and learned more just by working close to him than I did in five years of college.

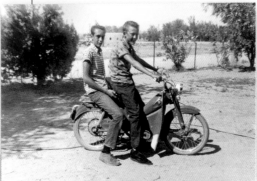

I SURVIVED MORNING DRIVE

Hard to believe I had a decade long radio career. *The Jones, Boze & Jeanne Show* premiered on KSLX in Scottsdale in 1986. We did many wild shows, including the "Indians Take over Scottsdale" show that aired on April Fools Day and melted the Scottsdale 911 emergency lines. Other notable shows included "Black Like Bob" and "The Bozina Show, Or, Bob Tries to Pass as a Woman." And those are just the more respectable shows I can actually tell you about.

THERE GOES THAT DAMN BELL KID!

Top: Just like my grandfather, I had a thing for motorbikes. My father bought me a moped when I was 14, and here I am with Dan Harshberger riding around in his yard in Kingman. I graduated to a Honda 50, then on to a Triumph Tiger 500 cc in college.

Above: Here I am on my U of A roommate Hank Widenmann's BSA Victor 441 with Sweet Annie on the back.

FAILING TO SUCCEED

I sure made a lot of vows growing up. And I sure failed a lot. Here are a few results from the vows I made as a young kid:

I never got to meet Norman Rockwell. I never became a spelling champ. I never played *The Ed Sullivan Show*. I never owned a Jaguar XKE. I never had a hit record. I never dated Annette Funicello and I never made out with Brigitte Bardot.

Then it got worse. I hated the 1970s, which were dark times to me. Altamont, disco, Watergate, and cocaine ("Hey, it's not addictive!") were but a few of the cultural gutter posts that totally bummed me out.

By 1977, I had hit bottom. My wife left me, my truck was repossessed, *The Razz Revue* was busted, one of my best friends had committed suicide, I was still plagued by acne, and I was still stigmatized by being from Kingman. (Yes, I know, at least two of these were self-inflicted calamities.)

In some ways, I think I failed my way clear. Here are a few vows that came true:

· I found a woman who shared my sense of humor and tricked her into having my children.

· With my father's estate, I bought *True West*, the magazine I first bought at Desert Drug on Route 66 in downtown Kingman.

· I learned the truth about Billy the Kid and Wyatt Earp, and published books about them so readers could determine the truth for themselves.

· After buying a fake photo of the Kid when I was a youngster, I actually got to hold the only known photo of Billy. Not long after, it sold for $2.3 million.

· I finally got a Range Rider fringe pullover, 55 years after I vowed to get one. Mike Guli custom-made me a perfect one.

· I took my daughter Deena and her then-fiancé Mike Bortscheller to Hugh O'Brian's 84th birthday party at his beautiful home overlooking Benedict Canyon in L.A. "If only my grandmother could see me now," I thought to myself. Somewhere, I know she was smiling.

· Attending a National Cartoonist Convention in 1992, I actually got to go to the White House and stand in the Rose Garden, five feet from President Bush. I have to say, however, that I was more impressed by Hugh's house.

· My father and I got to do the Route 66 Fun Run several years in a row, driving the '49 Ford that had been in the family since it was bought brand-new at Senseth Motors in Forrest City, Iowa.

· I shared one of those Fun Run rides with my son Thomas Charles, and he got to see what his grandpa was all about.

· During the Arizona centennial celebration, I was commissioned to come up with a painting and I chose to honor my two grandmothers with a portrayal of how tough those women had to be. Thanks to Lora Lee Nye and Ed and Cathy Reilly at Bronzesmith in Prescott Valley, the painting was turned into a sculpture, utilizing the talents of Deb Gessner, and unveiled on July 29, 2013.

· After my "wipeout" in 2008, I lived to meet my first grandson, Weston Allen Bortscheller, in 2013. He is one of the main reasons I wrote this book, so he could see where the Allen in his name came from.

In 2010 I was invited to Hugh O'Brian's 84th birthday party at his beautiful home in Benedict Canyon near Hollywood. I brought along my daughter Deena and her, then, fiancé, Mike Bortscheller. A special guest was Debbie Reynolds, who wowed the crowd with her stunning good looks. If only Grandma Guessie could see me now. Somehow, I think she did.

"I have failed at many things in my life, but I never failed at dreaming big."

—BBB

Thanks to Brian Lebel of Old West Auctions, I got to hold the only known photo of Billy the Kid at the *True West* World Headquarters. It sold three months later for $2.3 million.

NOT-SO-GENTLE TAMER

Vice Mayor Lora Lee Nye said, "The guys may have won the West, but the ladies tamed it." An impressive statue that stands at the heart of the Prescott Valley Civic Center was inspired by my two grandmothers, Minnie Bell and Louise "Guessie" Guess.

I created "Honkytonk Sue" on a makeshift desk in the spare bedroom of our house at 707 West MacKenzie in Phoenix. Two years later I was in this town taking meetings with big-time producers Andrew Solt and Malcolm Leo. My good friend Mark Boardman summed up the experience and the photo with two words: "Wrong finger."

Mike Guli of River Crossing made me an exact replica of the Range Rider's pullover fringe shirt. I only had to wait 55 years, but it's mine, baby!

> ## "When you stop chasing the wrong things,
> ## you give the right things a chance to catch you."
>
> —Good ol' Ben Rux

THE REAWAKENING

My greatest passion was reawakened by my mother on Christmas Day, 1989. The woman who was mortified when I would brag about being related to outlaws gifted me a used book on the biggest outlaw of them all: *The Saga of Billy the Kid*, by Walter Noble Burns. I read the first line—"John Chisum knew cows"—and the rest, as they say, is history.

I had spent the previous 25 years chasing rock 'n' roll dreams, but as I sat among the spent wrappings in our living room, with both my kids jumping all over the place, I read the entire book in one setting. At two the next morning, long after everyone else had gone to sleep, I set the book down and I finally realized my true calling.

As soon as I could, I planned a research trip to New Mexico, and on a weeklong road trip I met with Bob McCubbin in El Paso; Johnny Meggs in San Patricio, New Mexico; and John Sinclair in Bernalillo, New Mexico. After interviewing them about Billy, I threw myself into researching the boy outlaw and read as many of the books on him as I could. (There are more than 1,000 books about Billy the Kid.)

I successfully pitched *Arizona Highways* magazine about doing a cover story on the Kid featuring my artwork, and sent the issue to all the big publishers, proposing a graphic-novel version of Billy's life.

All turned me down. "Just what the world needs, another book on Billy the Kid," commented the University of Arizona Press, the publishing arm of my alma mater.

So I went to my dad and he loaned me the money to self-publish—$5,000 down on a $20,000 printing bill—and I did my first cover on the Kid. It wouldn't be my last.

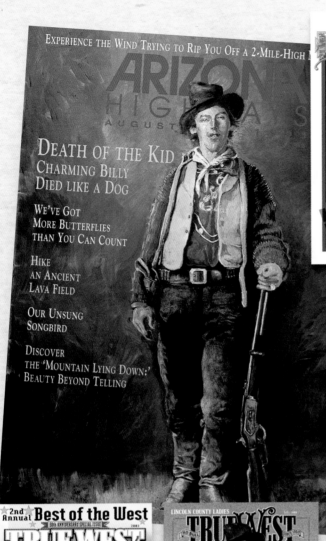

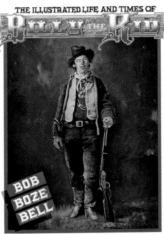

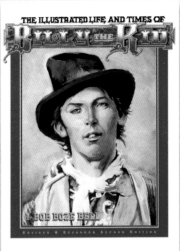

Cover boy: Here are just a few of the covers I have created on Billy the Kid in the past 20-some years.

Opposite page: A Billy on the Brain coffee mug.

"Just what the world needs, another book on Billy the Kid."

—EDITOR AT UNIVERSITY OF ARIZONA PRESS

BELL ON WHEELS

The Al Bell Fun Run Crew: BBB, Allen P., Milton Sysy,
and Ray Hader. Check out the matching jackets.

THE FUN RUN

For the last decade of his life, my father and I reconnected every May for the annual Route 66 Fun Run. The car rally runs from Seligman to Kingman, then on to Topock on Sunday morning. Classic cars from all over the world show up for this event. This was a great opportunity to relive our glory days on old Route 66. After I arrived from Cave Creek, my dad would fire up the old Bell family 1949 Ford and off we'd go, along with a chase car (a '74 Lincoln Town Car) for insurance, manned by Ray Hader, one of the Bell on Wheels road crew.

The drill was familiar: up before dawn and out the door. Drive to Seligman on I-40 and have breakfast at the Copper Cart Cafe, then down to the sign-in area next to the Snow Cap Drive-in. My father would spend the next couple of hours checking out most of the 500 or so cherry cars that lined up for the run.

At 10, we'd make the familiar run from Seligman across Long Valley to Truxton, then push on to Peach Springs, Valentine, Hackberry, and on to Kingman. Although each little berg had events and come-ons—bands, go-go girls, prize-winning bar-b-que—we rarely stopped. Why? By now, you know why—we had to make time!

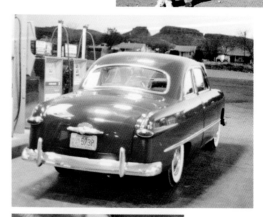

Our family stopped for breakfast at the Copper Cart in Seligman for the better part of five decades. Here's my father and his grandson, Thomas Charles, in 1991. The last time we ate there was in 1998. It has since passed into other hands.

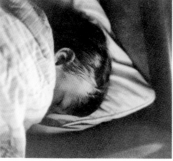

Up at four, on the road by five, here we are getting gas at a Chevron in Kingman on April 27, 1991. My son Tommy is catching a few Zs in the back seat, just like I did when I was his age.

WIPEOUT

The passing of Wendell Havatone in 2006 was a big shock to all of us. He was so strong and so resilient—in many ways, the lion of our gang. Not long after the funeral, I got a call from Charlie Waters, who said he wanted to get The Exits back for one final gig to honor Wendell.

And so on March 22, 2008, we gathered at the exact spot where it all began, the Elks Lodge in Kingman some 45 years earlier. We assembled not just former Exits, but some of our competitors and extended friends for a night of celebrating old songs and old friends.

At the afternoon rehearsal, during a three-drummer round-robin on "Wipeout," I went off my drum set and started playing the wall, the floor, and my butt before capping it off with floor-hugging gyrations, known in college as "the gator."

It's the last thing I remember before waking up in the emergency room at Kingman Regional Hospital. I had not one, but two heart attacks and ended up with four stents. Turns out my life was saved by two of my bandmates, Terry Mitchell and Wayne Rutschman (Cody, his son also helped), who gave me CPR. What are the odds that former bandmates (rock musicians!) would even know this?!

Thanks to the heroic efforts of Dr. Michael Ward and the emergency room nursing staff at Kingman Regional, I got a second chance.

When I got back to the Valley, my cardiologist took a look at my charts and said that if he didn't know the outcome of the incident, he would give the patient a 1 percent chance of survival.

This was a sobering experience and led almost directly to the book you are holding in your hands. I was given a second chance, and I truly want to get it all down while I still can.

WENDELL AND THE HAVATONES

After his career in The Exits, Wendell went to Haskell University in Lawrence, Kansas, and had his own band there. When he returned to Mohave County, he formed a country-western band, The Havatones, and they played for many years in northwest Arizona. In later years, Wendell became a pastor in Alaska, where he sang gospel music and recorded a CD. He died of a heart attack in Alaska on March 9, 2006.

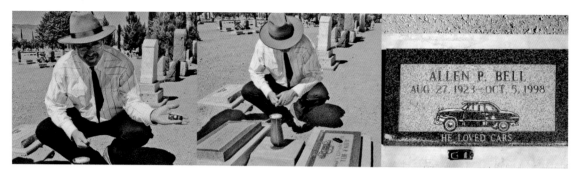

His gravestone says, "He loved cars," and that he did. Here I am placing a replica of the 1955 Thunderbird I got in Swea City all those years before, on my dad's gravestone. The last time I visited, it was still there.

KINGMAN IN THE REARVIEW

As I write this, it's been 16 years since my father died. I have a strong hunch that parts of this book would make him uncomfortable, such as when I said he "walked away" from the Phillips 66 in Swea City. I tried to be as honest as I can about him, not to denigrate him but to give substance to his virtues, which in my mind, were plenty.

My mother, on the other hand, would no doubt hate her portrayal in its entirety. She has been gone 10 years, and the last part of her life was shrouded in dementia and some bitterness. As for her only son, she grieved at my leaving the church, and she clung to a narrow version of my career.

Once, when my kids were young and she was visiting, she invited a woman she had met through her church over to our house. My mother was bragging on my work in *Arizona Highways* as if that was the only thing I had ever done.

Finally, the woman said, "Are you Bob Boze Bell?" I admitted I was. She mentioned how much she enjoyed my work in *New Times*, and I got up to go get her one of my compilation cartoon books, *Low Blows*. My mother ran down the hall and grabbed my arm: "Don't show her that book!" she said in a dramatic way, totally out of proportion to the situation. I went back to the living room, sat down, and told the woman I couldn't find one.

Still, I loved them both in the only way a good son can— completely.

In 2010, my friend Scott O'Connor turned me on to a singer named Slaid Cleaves. In an intimate Redwood forest setting north of San Francisco, among Scott's closest friends, Slaid played "Cry," his signature song.

I did. And these were the lyrics that got me:

Cry for your mama
Cry for your dad
Cry for everything you know they never had
The love they never had

That hit home, and to this day I can't hear that damn song without tearing up. My mom and dad did their best with what they had and they gave me everything they could.

Today, they are buried in the same Kingman cemetery, some 50 yards apart. My father, who claimed he would never come back to "this hell-hole," is now resting there for eternity. My mother fled Kingman in 1970 and lived in countless other towns and states with her second husband, Lou Cady. She, too, is now back home where she belongs.

Sometimes, when the wind is blowing just right and the dust swirls across their headstones, I can hear my dad say, "We gotta make time, Kid."

And in giving me the 15 minutes at the Longhorn Museum in 1959, he gave me the ultimate gift: he made time.

My dad lived the majority of his life on the Mother Road— the better part of six decades—working in numerous gas stations and ending his career at Ford Proving Grounds, where he drove the old and new alignments of Route 66 five days a week for the better part of 20 years. And so Allen P. Bell, by all rights, *is* The 66 Kid.

Above: I was seeking the answer to one riddle when I blindly stumbled upon the answer to another on the beach at Rota, Spain.

Right: A popular rock music magazine in Spain with the title Route 66, in Spanish.

WHAT GOES AROUND COMES AROUND!

In March 2013, I found myself on the western edge of the Spanish coast where Columbus set sail on his second journey to the Americas in 1493. As I stood contemplating the bravery of those men, sailing off into the unknown, I mulled over all the changes their mission would bring to the New World: the arrival of the horse and cattle, the rise of the vaquero, and, ultimately, the cowboy. I must say I was overwhelmed by the momentous history that happened on this very spot.

After meditating for a good 20 minutes, I turned to leave. And there, on the beach behind me, I saw The Route 66 Bar.

What goes around, comes around. I had come so far to discover the source of one legend, only to stumble upon the fruits of another. I finally got it—why that narrow two-lane blacktop I grew up on has captured the imagination of the world.

I brought this story home with me and, at a subsequent history talk, a young man approached me, said he was a fan, and asked this question: "What was more satisfying, the road to finding the answer, or arriving at the answer?"

And so I told him.

The road is the only thing.

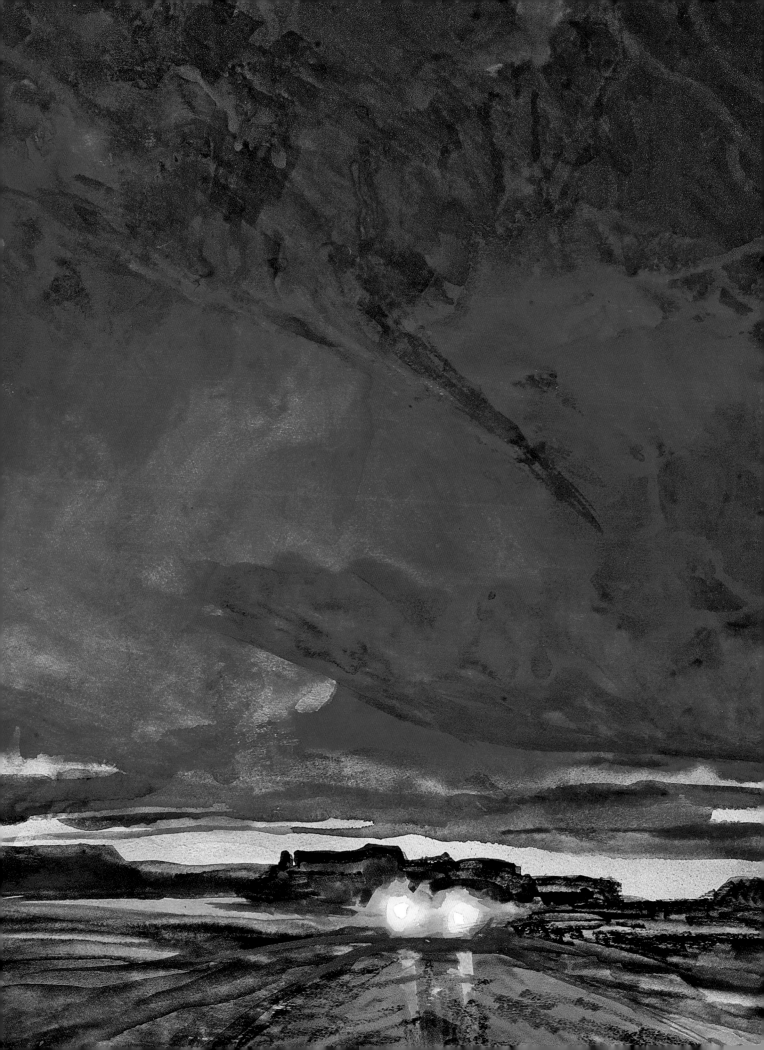

"We all grew up on Route 66 and we are all a little bent."

–TRUDY PEART BURRUS

DEDICATED TO

Weston Allen Bortscheller

When the road ends, keep going.

WHERE CREDIT IS DUE

Well-bent Graphic Designer

Dan Harshberger

Factory-authorized Word Mechanic

Charlie Waters

Production Manager & Head Gardener

Robert Ray

The Mapinator

Gus Walker

Custom Lettering

Bob Steinhilber

Voyageur Press Acquisitions Editor

Dennis Pernu

Voyageur Press Art Director

Cindy Samargia Laun

Senior Unpaid Intern

Jon Nelson

Research

Gay Mathis

Mohave County Archival Photos

Courtesy of The Mohave Museum

Special thanks to **Diane Potter** for the use of her spectacular Route 66 postcard collection. Thanks to **Ray Bonham** for the use of his wonderful Little League collection. Also, thanks to **David Spindel** for the use of the Hugh O'Brian birthday photos. **Olive Mondello** for the use of her photo collection. **Ralph Rippe** for the photo of **Ed Mell** and me. BBB Wedding Photographer **Gary Boulanger**. Chief Yellowhorse photo courtesy **Terrance Moore**.

Thanks to the Kingman crew who gave their time, their knowledge, and their stories: **Mike Torres, Bebe Torres, Marshall Swanson, Kenny Peterson, Jennie Torres, Jean Reynolds, Jan PreFontaine, Rachele Bonza, Linda Smith, Jim Hinckley, Chuck Cook, Andy Sansom, Tap Lou Duncan Weir, Bryce Ware, Michele Gilpin Bonham, Trudy Peart Burrus, Mary Kay Hokanson, Bill Porter, Karen Johnson Collins, Johnny Waters, Jay Gates III.**

Also, thanks to **Wendell Link** of Swea City, Iowa, for the identification of the Swea City Gang.